C000072261

New minimalist architecture

HDi

HARPER
DESIGN
international

An Imprint of HarperCollins*Publishers*

Author
Eduard Petterson

Editorial Director
Nacho Asensio

Coordination
Sofia Cheviakoff

Texts
Sofia Cheviakoff
Martha Torres
Marta Eiriz
Patricia Bueno

Translation
Peter Miller

English Correction
Mark Parent

Design and layout
David Maynar
Mar Nieto

Production
Juanjo Rodríguez Novel

Copyright 2004 © AtriumGroup

Editorial Project
Books Factory
books@booksfactory.org

First Published in the United States by: Harper Design International.
an imprint of HarperCollins Publishers
10 East 53rd Street
New York, NY 10033
Fax: +1 212 207-7654
www.harpercollins.com

In Association with: Atrium Group de ediciones y publicaciones, S. L.
c/ Ganduxer 112
08022 BARCELONA
Tel: +34 932 540 099
Fax: +34 932 118 139
e-mail: atrium@atriumgroup.org
www.atriumbooks.com

Library of Congress Cataloging-in-Publication Data
Petterson, Eduard.
 New minimalist architecture / Eduard Petterson.
 p. cm.
 ISBN 0-06-059917-0 (hardcover)
 D.L.B: B-47857-03
 1. Minimal architecture. 2. Architecture, Modern--20th century. 3. Architecture, Modern--21st
century. I. Title.
 NA682.M55P47 2004
 729'.09'045--dc22

 2003022193

HarperCollins books may be purchased for educational, business, or sales promotional use. For
information, please write: Special Markets Department, HarperCollins Publishers Inc., 10 East 53rd
Street, New York, NY 10022.

First Printing, 2003
Printed in Spain

All rights reserved. No part of this publication may be reproduced by any means or procedure, including photocopying, data-processing, and distribution of samples by renting or by public loan, without the express written authorization of the holders of the copyright, under the sanctions of the international laws currently in force.

New minimalist architecture

Minimalism is an artistic movement that attempts to reduce a work of art to the minimum number of colors, values, shapes, lines, and textures. It does not attempt to represent or symbolize any other object or experience. The basic premise is to create art that does not mean anything but that still has an artistic value. It is also called ABC art, minimal art, reductivism, or rejective art. Among the precursors of this movement could be included the Russian suprematists like Kasimir Malevich (1878–1935). There is a parallel with Dada art in respect to the lack of meaning of the work. But the real difference lies in the artistic value of the object, which is nonexistent in Dada. At any rate, minimalism has lasted for several decades and is still considered to exert a great influence on not only contemporary art but also other disciplines such as music, dance, design, and architecture.

Contents

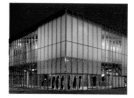
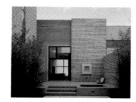
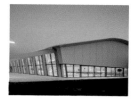
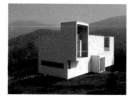

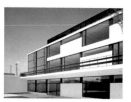
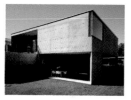
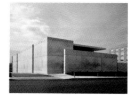
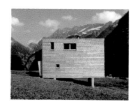
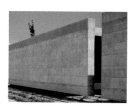
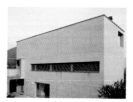

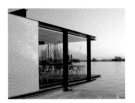
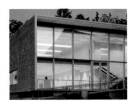
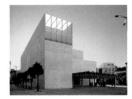
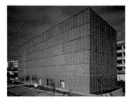
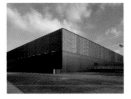
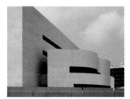
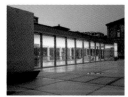
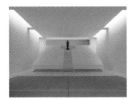
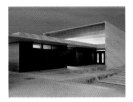

MINIMAL ART, MINIMALISM

The origins go back to the sixties, and like Pop Art (Andy Warhol), it was a reaction to the emotion and expression belonging to Abstract Expressionism. Minimalism was particularly dominant in sculpture, where the works of Sol Le Witt, Donald Judd, Carl Andre, and Dan Flavin are worthy of mention. In painting, the works of Frank Stella and Ellsworth Kelly are noteworthy.

Soon this creative approach began to win over followers among contemporary architects. Consequently, the architectural roots can be found, to a greater or lesser degree, in minimalism. One must not forget, however, that modernity also dictated the way architects worked in the second half of the twentieth century. Mies van der Rohe, Gunnard Asplund, and Adolf Loos were faithful exponents of the most staunch disdain for ornamentation and anything that would have a disguising effect or even evoke any idea apart from the architectural work itself. "Less in more," van der Rohe's famous phrase, emphasizes the idea of giving maximum power to an architectural space by means of the suppression of any accessories. In this way, the fewer aesthetic elements that make up a work, the more eloquent it will be.

Minimalism is not an economical strategy (in terms of budget) for conditioning or designing a space. It is economical as far as plastic and aesthetic resources are concerned, and it is in this economizing where its strength lies. By expressing fewer ideas, it is possible to emphasize them more strongly. The admirer's attention is not distracted by secondary aesthetic resources. In many cases, it is necessary to make use of complicated technical or design resources, state-of-the-art technologies, or fine materials (which consequently make the work more expensive) to achieve the desired plastic purity.

Minimalism often takes great advantage of light both to highlight the qualities of a material and to afford dynamism to a space, or to imbue it with a characteristic of abstraction, like unreality. Large windows and translucent parameters allow light to enter, in a diffuse form. As a consequence, shadows become blurred and objects tend to appear suspended. As a result, the relationship between the objects and the space they occupy, acquires a certain air of irreality. On certain occasions, natural light produces a pattern in the space, and its changing position lets us know of the passing of time or the change of season.

The way materials are used is also noteworthy. Architects carefully select wood, stone, plaster, or concrete, depending on what they wish to express. Apart from exalting the plastic qualities of the materials, they also take advantage of the materials' technical properties.

House in Besazio

☞ **Giovanni Guscetti** | Collaborators: Fabrizio Giovannini, Giancarlo Rusconi

▦ **Besazio (Ticino Canton), Switzerland** | Surface area: 2,798 square feet, plot: 18,836 square feet| Date: 2001

📷 **Filippo Simonetti**

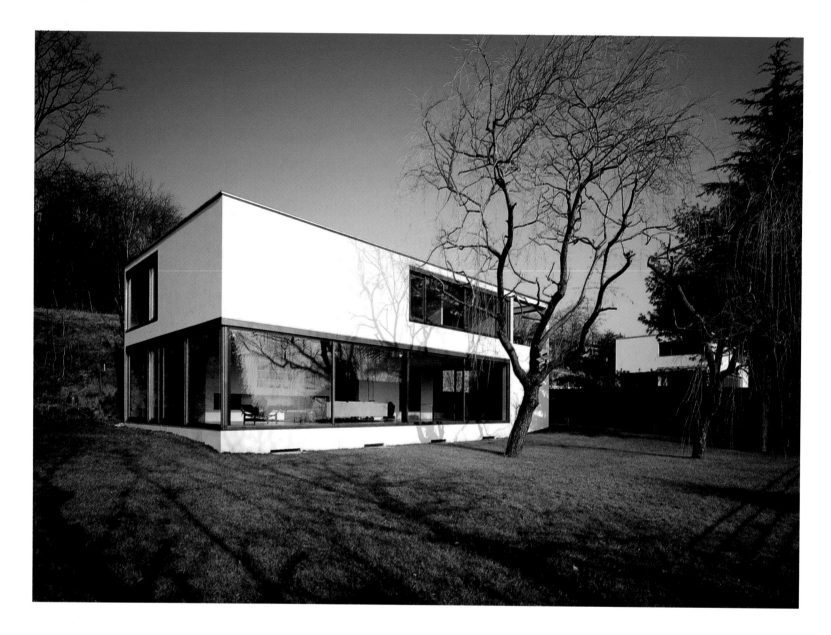

The plot is located at the easternmost edge of the residential area in the Besazio commune, in the Mendrisiotto region. In this area, the buildings are varied, of good quality, and well-spaced from each other. The land between the houses is home to the typical vegetation of this area. The compatibility of the house with the luxuriant vegetation became the main theme of the project. An in-depth study of the different trees and bushes gave way to the different locations of the house in the plot. There is a maple tree within the confines of the house. The idea is an attempt to "tame" a small piece of nature. Since the tree is left intact, it is even more striking. The tree, situated in the courtyard of the house, intensifies the relationship with the exterior.

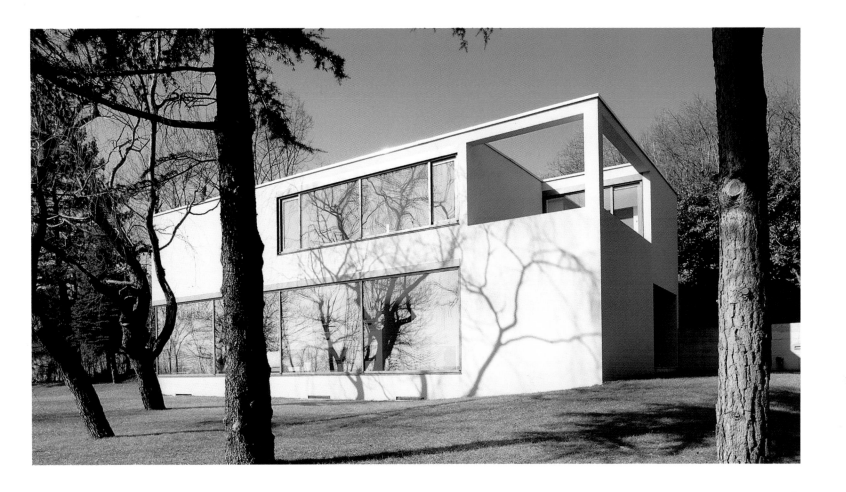

The location of the house takes into account the function of nature . Thus, a strong interior-exterior relationship is established.

An attempt was made to fit the building into its surroundings so the nature of the place was only slightly altered. The house lies on terrain that keeps the same appearance that it had before the construction of the house.

From the outside, the house looks like a perfect parallelepiped that is only perforated by two horizontal apertures, which correspond to the windows of the living room and the bedrooms. The composition is based on the balance between the solid wall surfaces and the voids represented by the windows, which slide open over each other.

The glass doors are almost flush with the exterior surface of the walls. This eliminates any trace of shadows on the façade, which actually becomes a glassed surface. This feature makes the frameless perforation that leads to the main courtyard stand out even more.

The ground floor is characterized by its simplicity and linearity. The structural elements are reduced to the minimum: the exterior enclosure and the central wall. On the ground floor, this main dividing wall clearly separates the house into two parts: the entryway and the kitchen on one side and the living room and the courtyard on the other.

The choice of materials is also in harmony with this quest for minimalism and simplicity. The façades are covered with thermal insulation over which a fine-grain mineral stucco was applied. The window frames are thermal-lacquered aluminum. Plaster was chosen for the interior wall surfaces, Spanish ceramics on the ground floor, and gray beech wood for the flooring on the top floor.

On designing the furniture, an attempt was made to integrate it into the architecture of the house, so as to make the largest possible surface area available for use and to afford a general feeling of spaciousness.

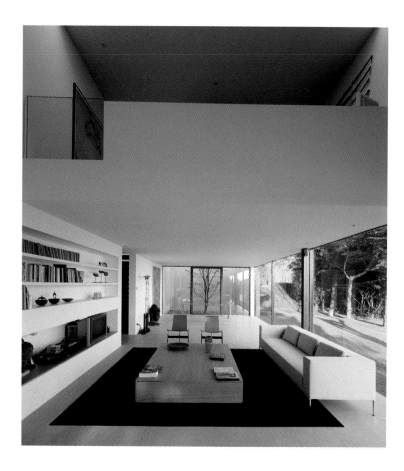 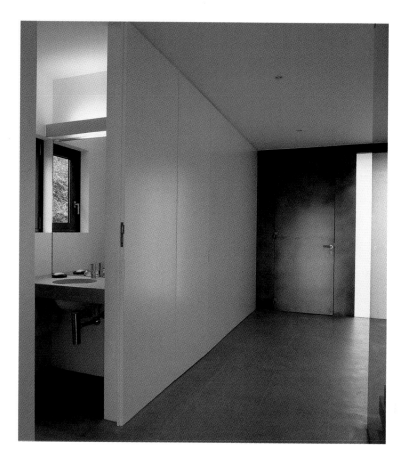

In the living room, the shelves become integrated into the architecture of the house, which increases the sensation of space.

Section of the house where the inclusion of the patio stands out, which is not visible from the exterior.

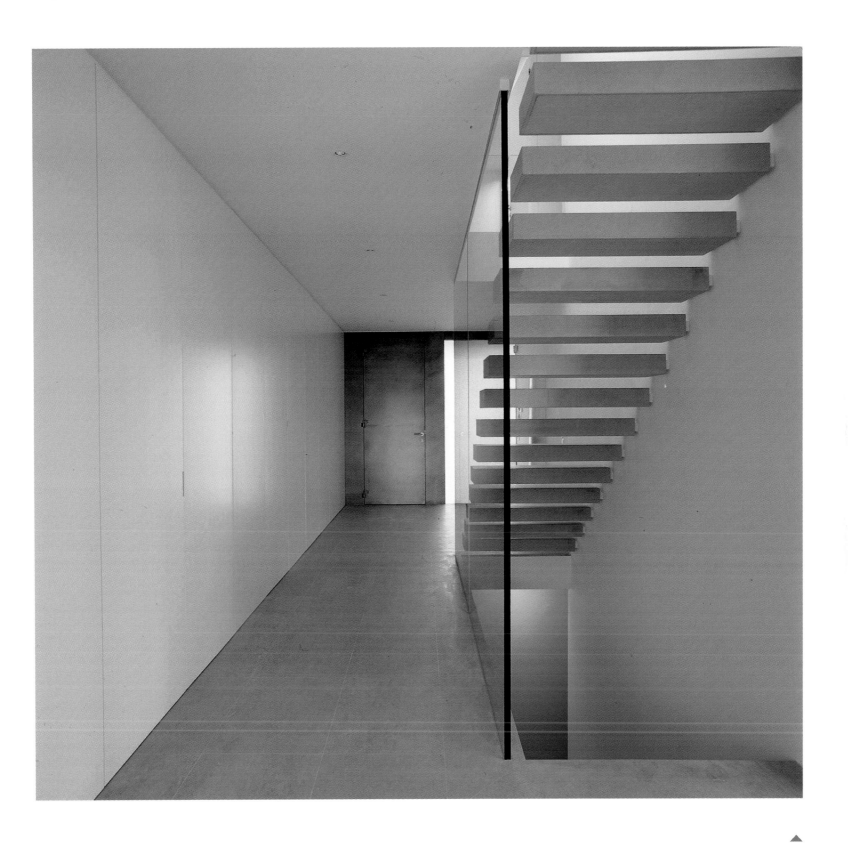

The stairs leading up to the bedrooms stand out, due to their lightness. This is achieved by having the stairs without risers and by the glass protection wall.

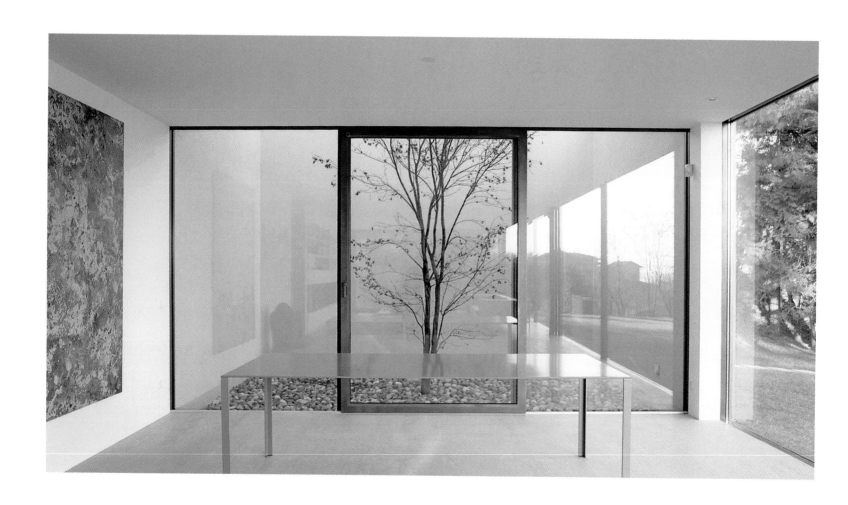

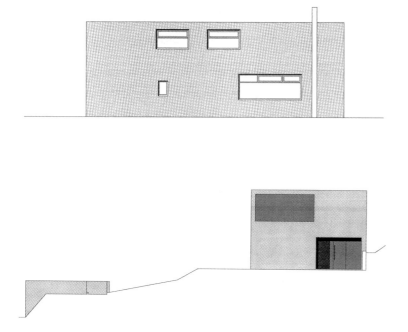

Plan of the rear and the side façades, where you can see the aperture to the exterior dealt with in a different way.

A central wall divides the lower floor into two parts: the vestibule and the kitchen on one side and the living room and the patio on the other.

A study area has been built on the upper floor. From the separator wall, a table extends out at table height and forms a right angle.

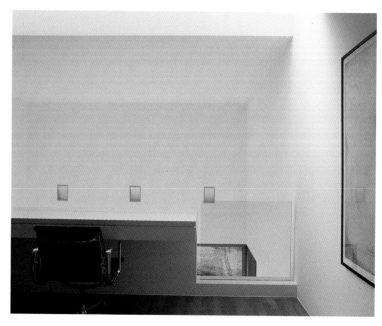

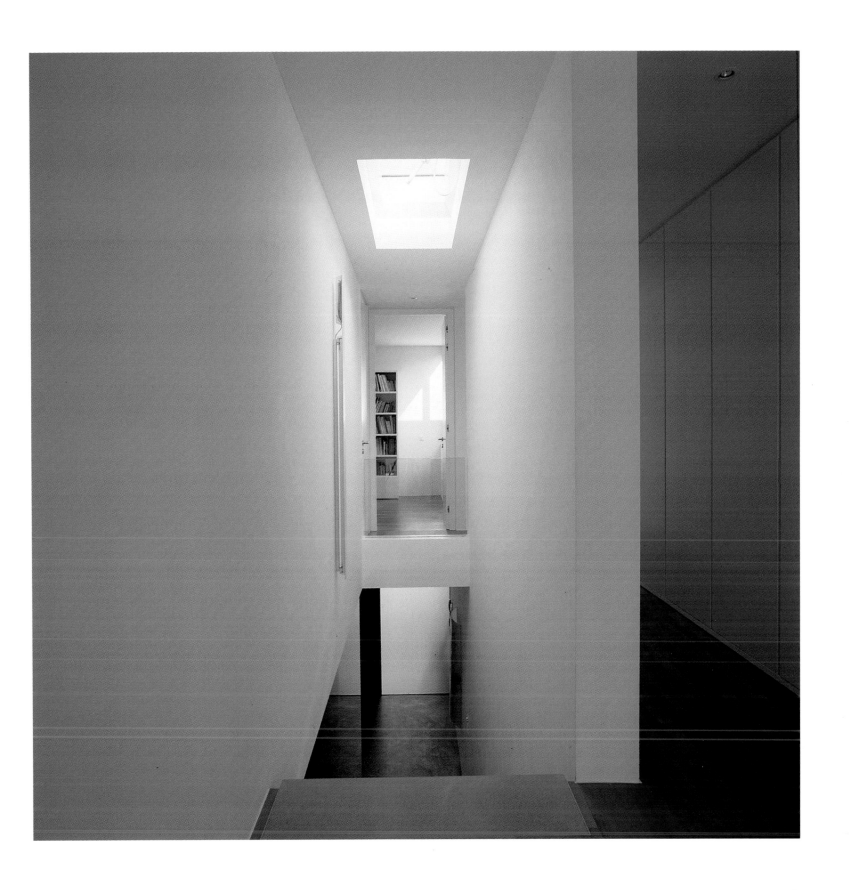

The search for light and its free flow all around is achieved by means of the skylight and the absence of partitions.

L'Eclat theater, refurbishment

Dominique Jakob, Brendan MacFarlane | Collaborators: Patrice Gardera (project and construction); Bruno Douliery, Olivier Leroy, Patricia Alves (project); Claude Polycarpe

Pont–Audemer, Normandy, France | Surface area: 17,222 square feet | Date: 2001

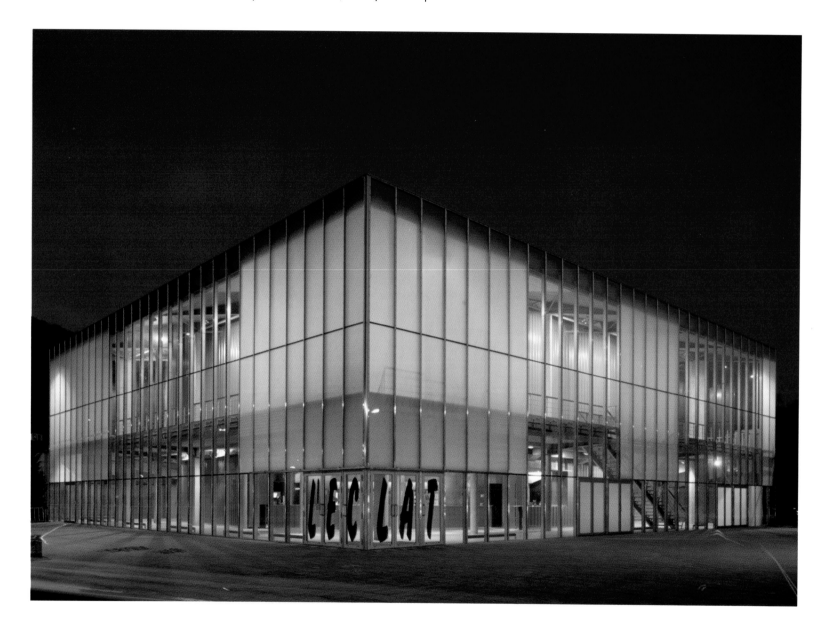

Pont Audemer is a town in Normandy that still preserves small, wooden-frame houses with gabled roofs, which lie at the edge of picturesque canals. At the end of the sixties, Maurice Novarina, one of the architects entrusted with the reconstruction of the area after World War II, erected a concert hall where a previous one had been. It was a Spartan prism made of concrete and glass which housed an auditorium on the upper floor. In the restoration, they maintained the original concrete structure, but it was enveloped with a façade. There was a 6.5 foot gap between this structure and the façade. They also maintained the two-floor distribution. The building envelope was radically changed as were

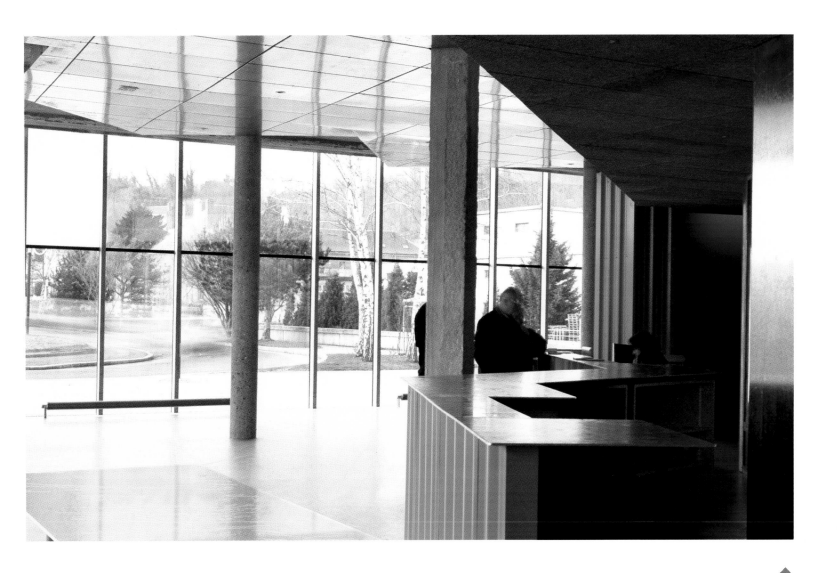

The renovation meant the total overhaul of the exterior appearance of the building, although the original concrete structure was preserved.

some important interior elements. The main objectives of the restoration included the improvement of the air-conditioning and heating systems. Also, they wanted to afford greater flexibility to the programming and to reduce the size of the stage that had been designed overly large. The stage was kept in the corner, but they doubled the depth by adding an extension that protruded into the auditorium. There is a new proscenium made of rectangular panels that can be removed and stowed away underneath the stage.

Another important modification was the addition of an 18-inch-thick wall, which envelopes the 360 seats in the audience. This new "shell" makes the hall cozier, acts as a divider between the auditorium and the vestibule of the upper floor, and houses the

heating and air-conditioning systems. The wall covering is slate gray in the auditorium. The acoustic ceiling tiles are installed so that they do not conceal the structural elements.

The exterior façade is like a delicate skin that envelops the building in an interplay of transparent and translucent glass. The vertical structure holds up the glass panels. It provides a minimum need for horizontal joints, and what is needed is resolved with structural silicone. The façade is separated from the structure of the building, like a curtain unfold before a stage.

The ticket booth and the walls of the lobby are covered with a bright, metallic orange. It is the same color, though not quite as bright, that is used on the farm buildings in this area.

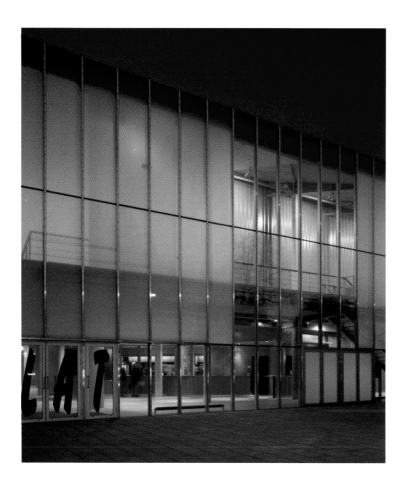 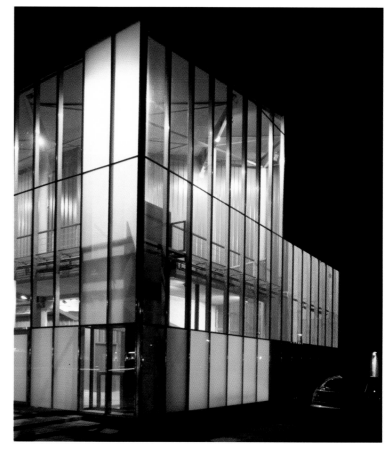

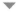

The glass on the façade gives the structure a light appearance and converts the building into a luminous cube.

Longitudinal cross section of the auditorium situated at the upper level.

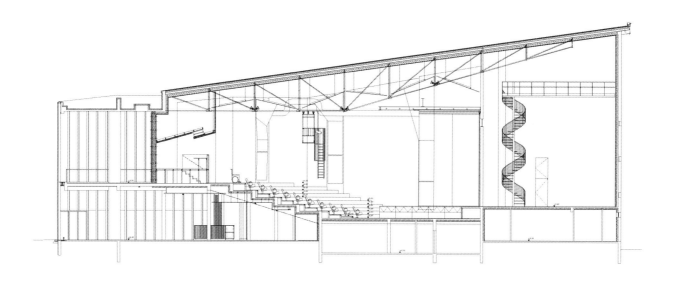

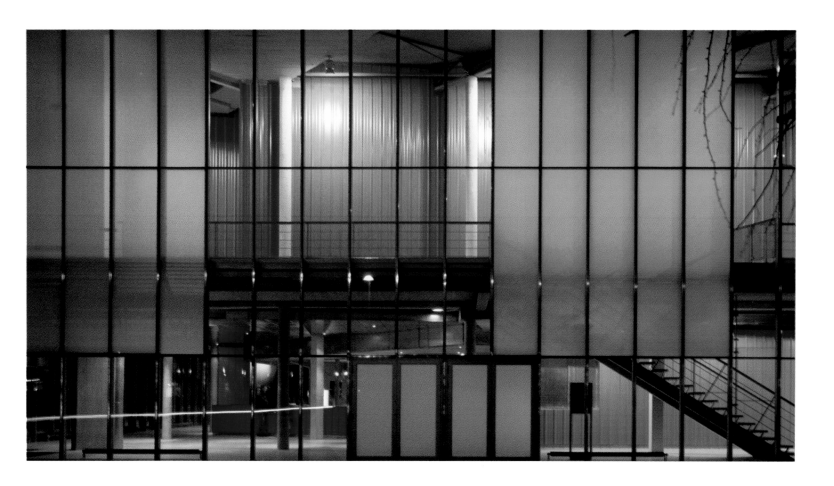

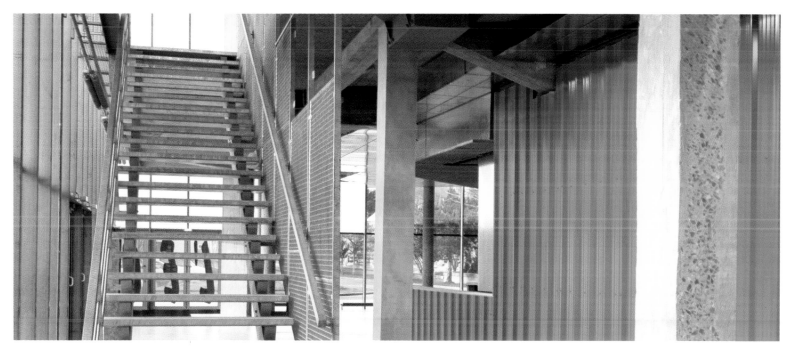

The glass on the four façades combines different degrees of opacity. The translucent glass lets light in but keeps the interior of the building from being seen from the street.

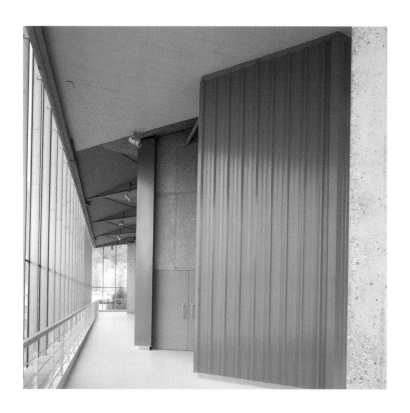 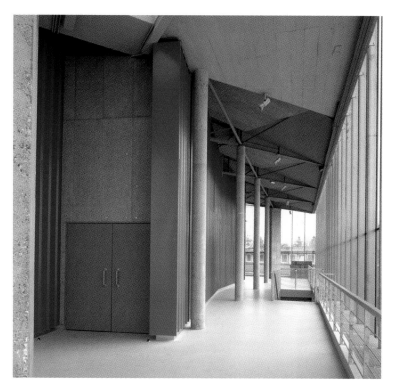

The new exterior skin increases the usable surface of the building and creates additional spaces, in the shape of a prism, around the original structure.

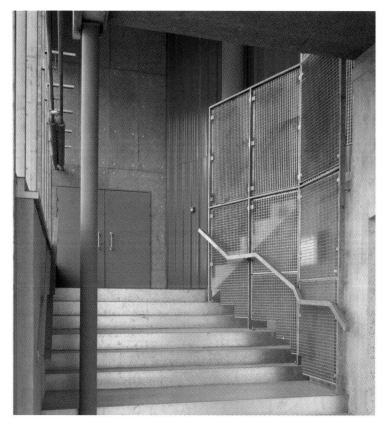

Light floods the rooms that are up against the exterior perimeter. The construction, designed by Maurice Novarina, is separated from the contours by about 6.5 feet.

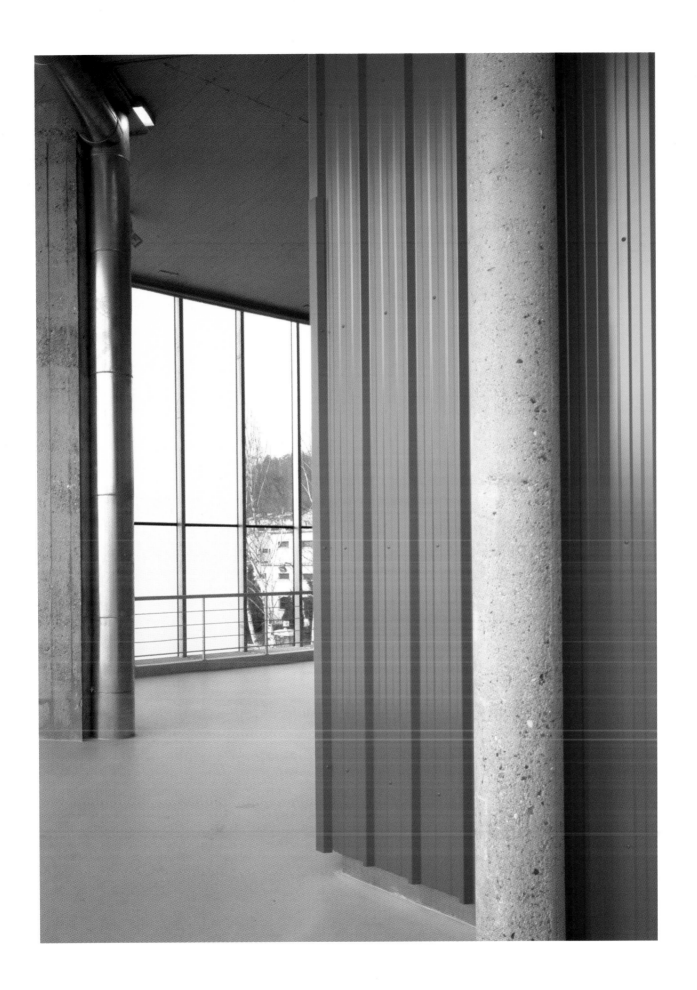

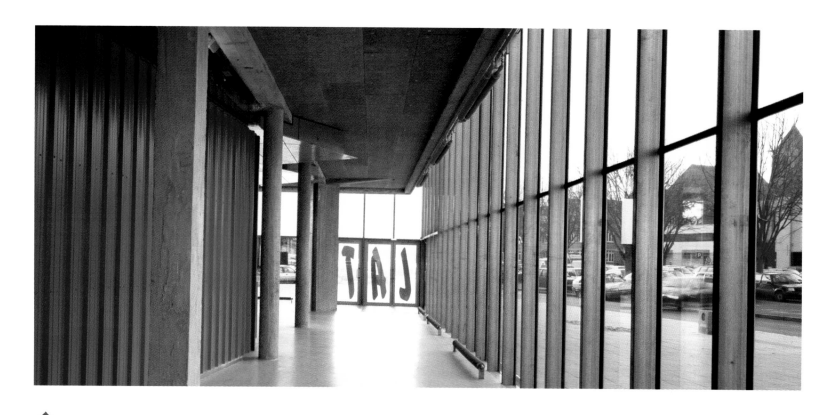

▲

The skeleton that holds up the glass panes allows a minimum of horizontal joints, which are resolved with structural silicone.

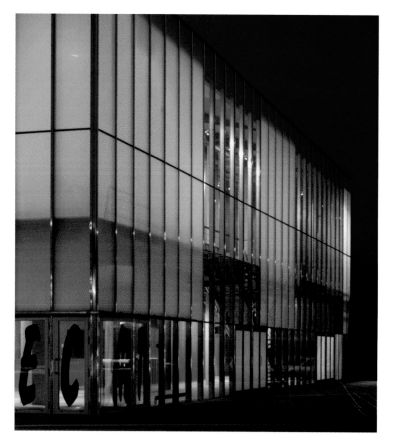

◀

Almost touching the ground, the name of the building appears written on the panes of glass that make up the lower part of the façade.

▶

The translucent and transparent glass panes provide the appearance of alternating shapes and colors, which creates an exterior appearance dominated by soft contrasts.

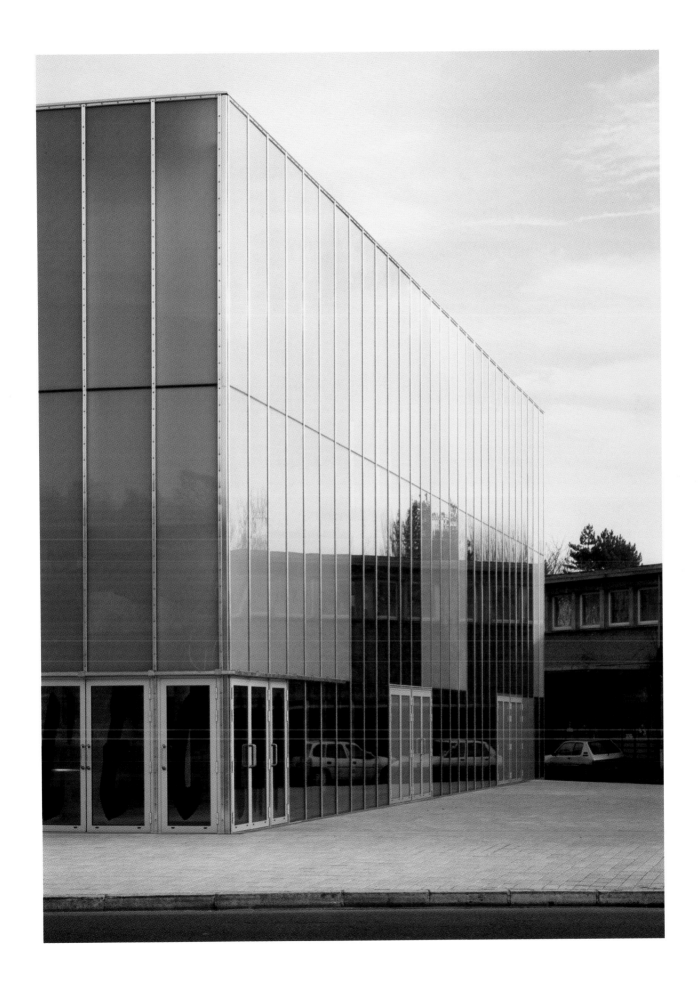

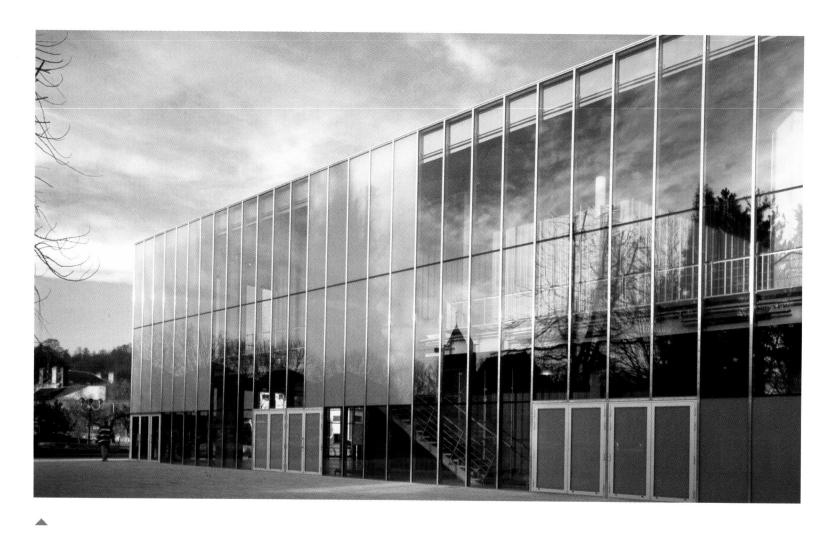

From the street, it is easy to see that it is a two-story structure. The glass allows for a flowing visual communication between the interior and the exterior.

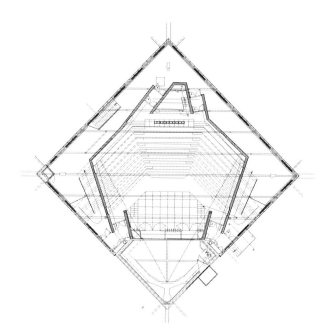

Novarina's prism-shaped construction remains hidden in the interior of the cube, designed by Jacob and Macfarlane.

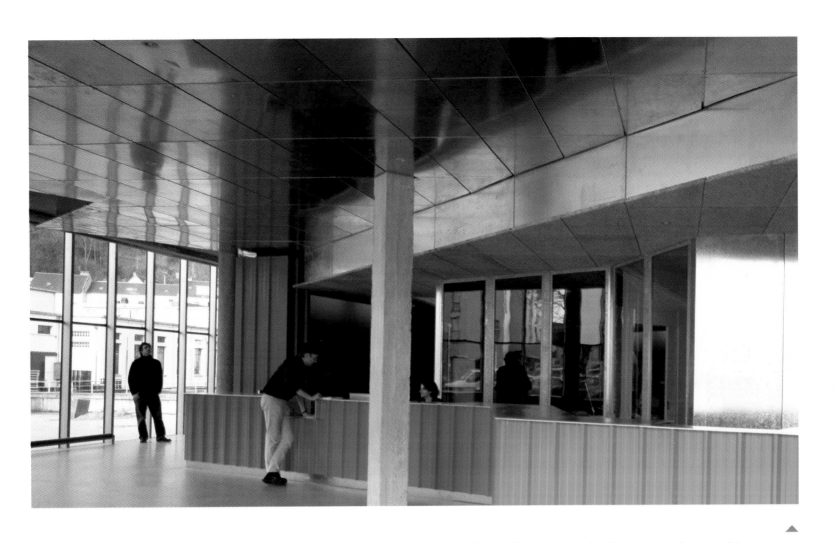

The orange-colored metal covering creates a cheerful atmosphere, which partially overcomes the chromatic uniformity of the concrete.

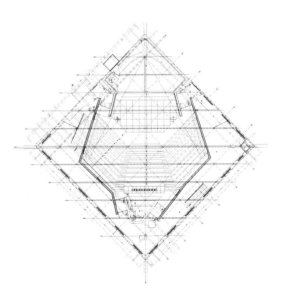

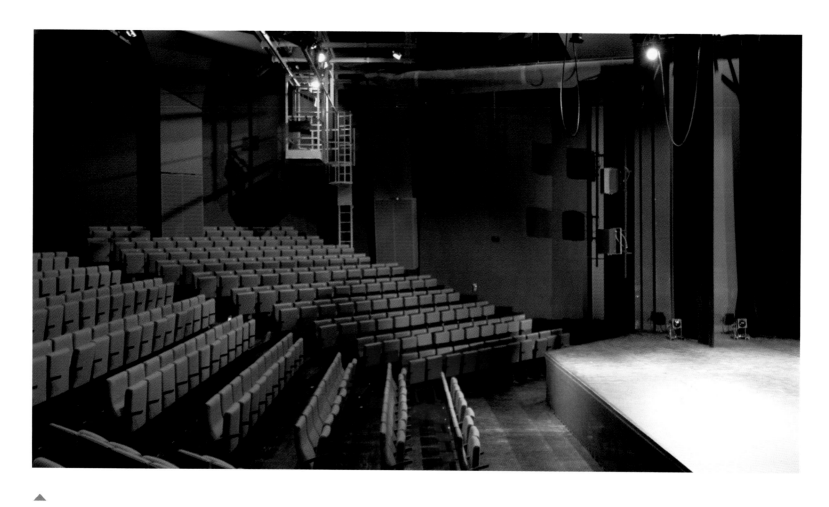

An acoustic wall surrounds the seating area of the auditorium. This wall also thermally conditions the area. The stage, which is situated in the corner, gains depth due to an extension sticking out into the hall.

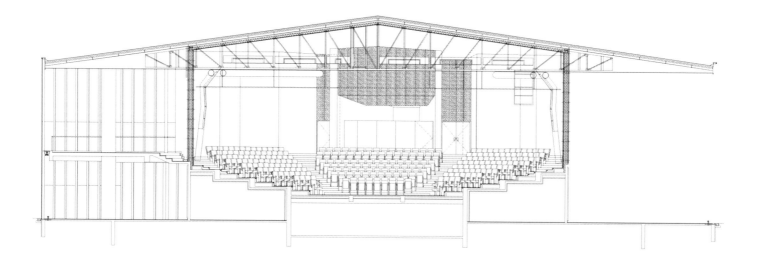

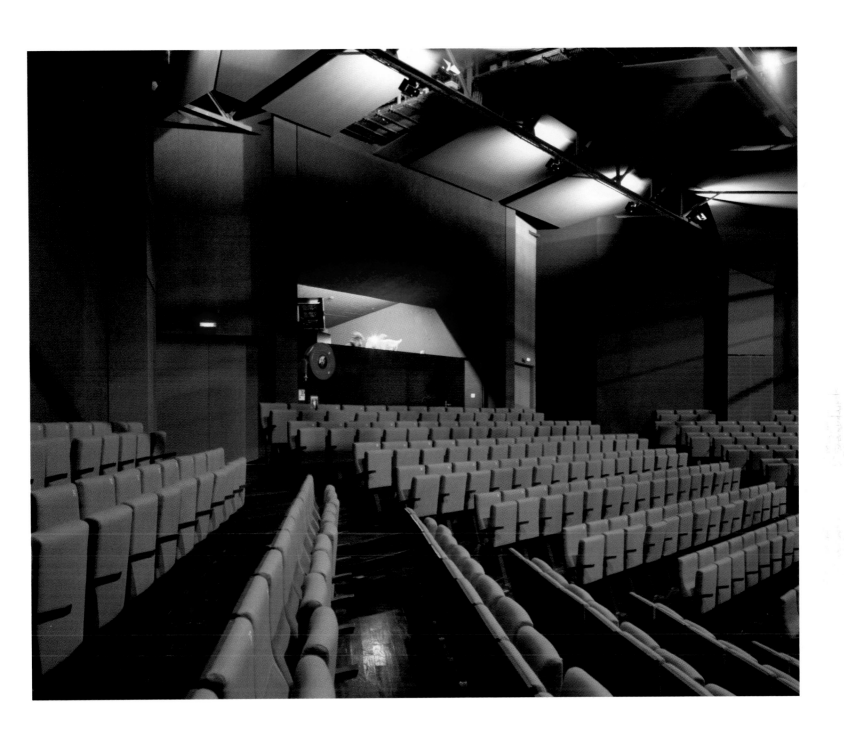

Slate gray floods the halls and creates a sober, unstriking atmosphere. As a result, the spectators' attention will be centered on the music, the stage, and what is happening there.

SoMa house

☞ **Jim Jennings** | Collaborators: Paul Burgin, Ross Hummel, Michael Lin, Troy Schaum, Melina Visone

▦ **San Francisco, California, United States** | Date: 2002

📷 **Sharon Risedorph**

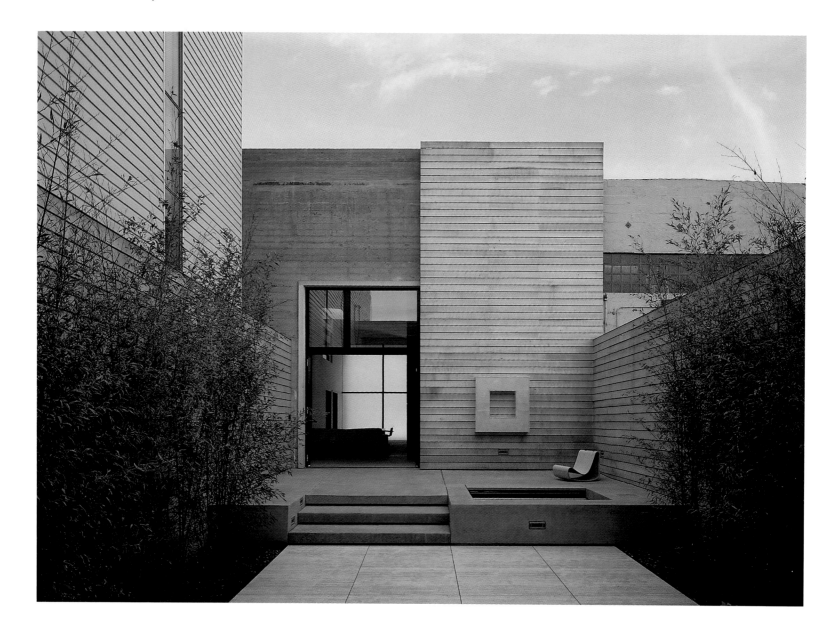

Private, free-standing residences, are not common in the South Market (SoMa) district of San Francisco. It is a transition zone between an industrial and a commercial area, where most of the housing can be found in old warehouses converted into dwellings. The project is also unique in that the design is meant to be both a dwelling and offices for the two clients, where public and private life are combined in a shielded yet open urban setting. They replaced most of the preexisting structure but left a few reminders of the past, such as the concrete side walls and some of the foundations of the former old commercial building. The two-story house has a surface area of 4,499 square feet. It is one of the first in a

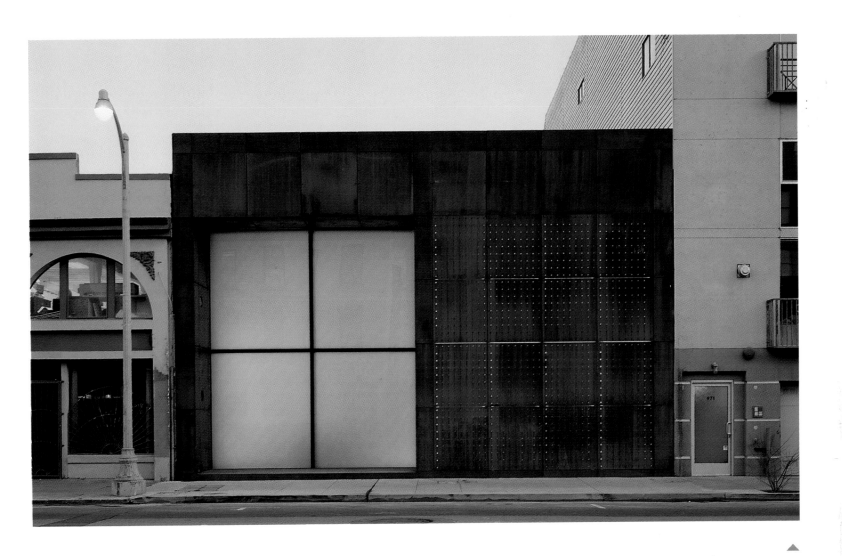

The dwelling is located in an industrial and commercial area and as a consequence, the facade has to be camouflaged into the surroundings, to a certain extent.

series of projects to redevelop the neighborhood. The façade consists almost entirely of perforated Corten steel. The color of the metal sheets changes with the process of the oxidation. Set back into the sheets, there is a wall that consists of a grid of four translucent glass panels, which creates a gentle counterpoint to the steel and contributes to the inscrutability of the façade.

The role of the perforated steel is fundamental in the interior. Like the effect in a camera obscura, the images enter in through the fenestella-like holes and are inverted and projected onto a flat pane of glass behind the steel.

The house is made up of two boxes that are separated by a spacious patio. The rear structure, which is smaller and has a garage and a gymnasium, is used as a guest house. The heart of the structure is a 20-foot-high space that opens out to the patio

and runs the length of one of the halves of the building. It holds the dining room and living room. This airy, expansive space with a vaulted ceiling is the primary circulation area. The other half of the building contains the kitchen, the pantry, and a studio on the lower floor. You are afforded access to the two main bedrooms, which are not identical, by means of a bare concrete staircase.

The light from the north, which filters in through the translucent glass on the façade, becomes balanced with the brighter, southern light that shines in through the large window on the patio. To deal with the mass of a wall in the living room area, the aesthetic stratagem was to incorporate strips of translucent glass, which carry the light to the main rooms where it is transformed, into a sculptural relief.

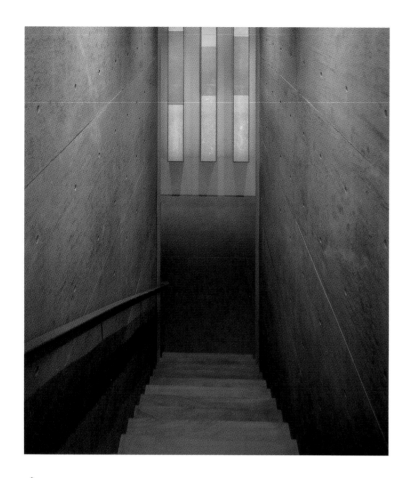

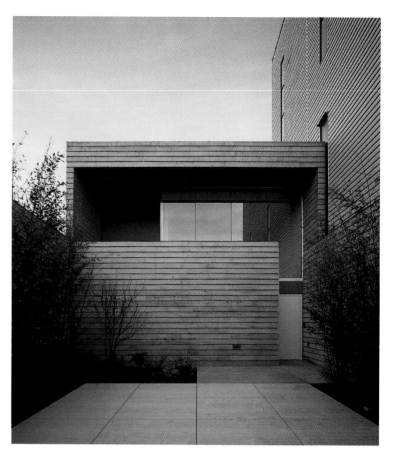

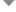

The stairs that lead up to the main bedrooms are made of bare concrete, which fits in well with the industrial aesthetics of the area.

The house is made up of two boxes separated by a broad interior patio, which is the principal source of entry of natural light.

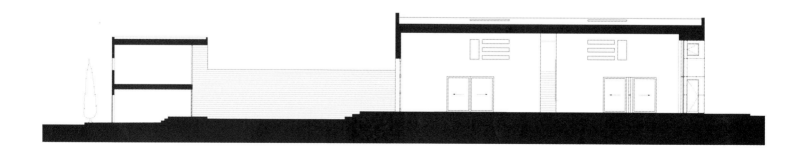

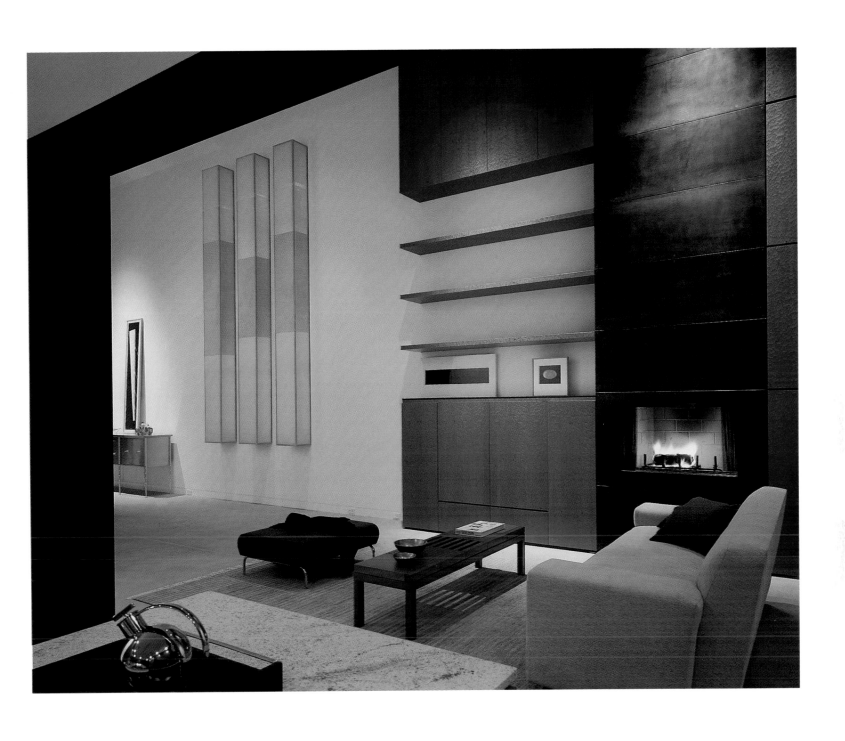

In the living room, three original light strips stand out. They are made of translucent glass and take on a sculptural air.

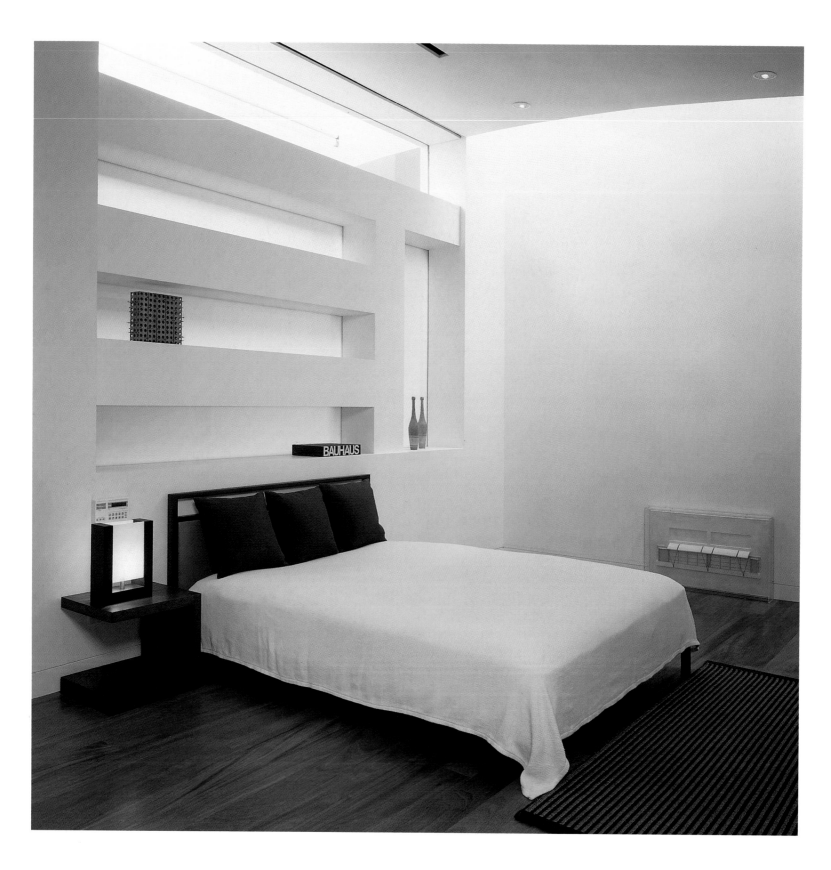

In one of the bedrooms, the same composition scheme as in the living room is repeated in the reverse, since the strips are horizontal and are set into the wall.

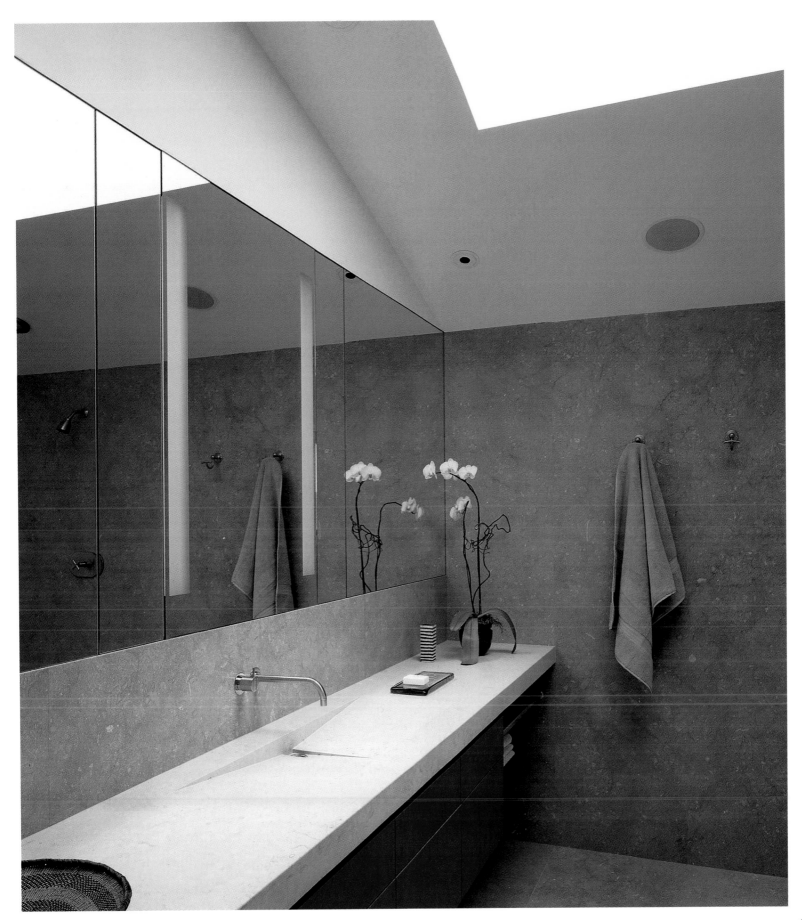

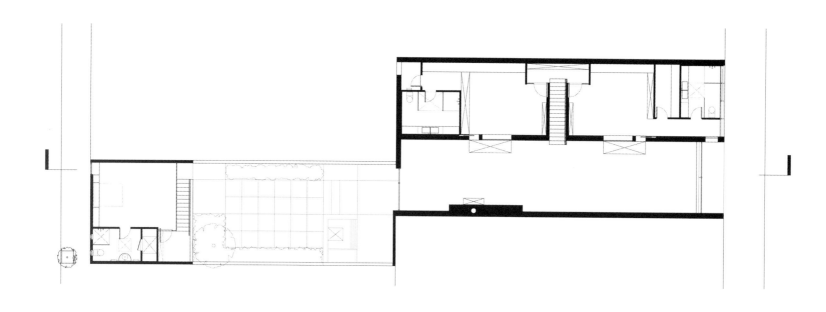

The principal structure of the house is divided into two equal parts: In one, we find the living room and the dining room, and in the other, the kitchen, the study, and the pantry.

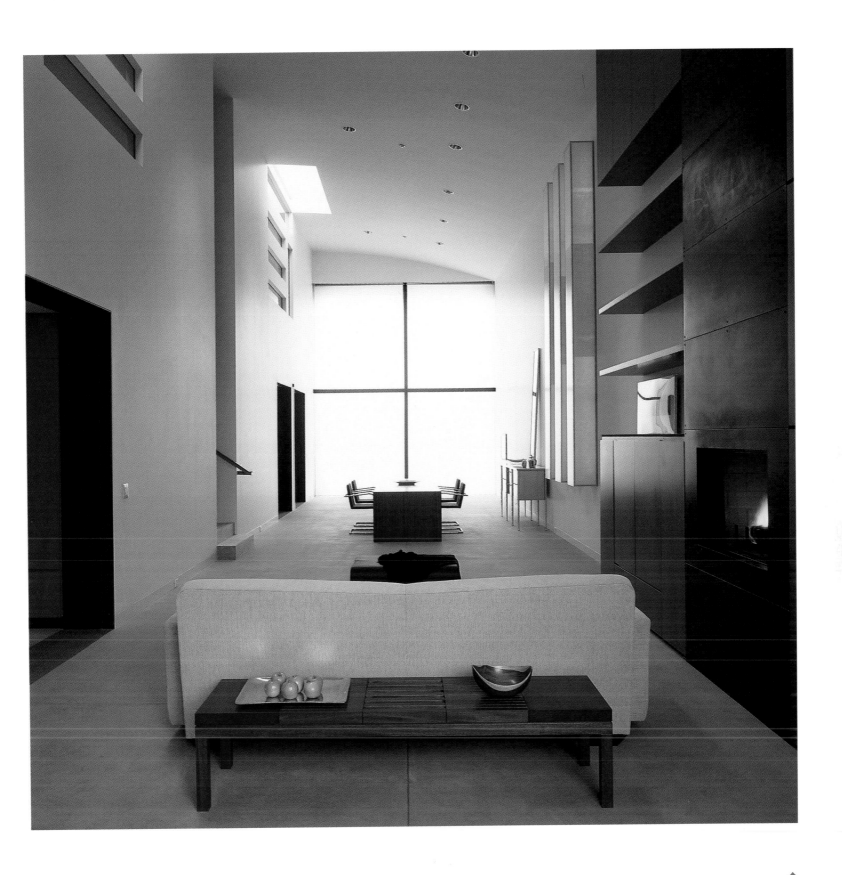

The area of the living room and dining room receives light from the north, which enters from the parameter of translucent glass of the street façade, and from the south, which enters from the patio.

Swimming pool in Vilafranca

⌒⊛ **Mario Corea, Francisco Gallardo** | Collaborators: Claudio González, Emiliano López Mata, Gabi Kemme

▦ **Vilafranca del Penedès, Cataluña, España** | Surface area: 1,507 square feet| Date: 1998

📷 **Jordi Miralles**

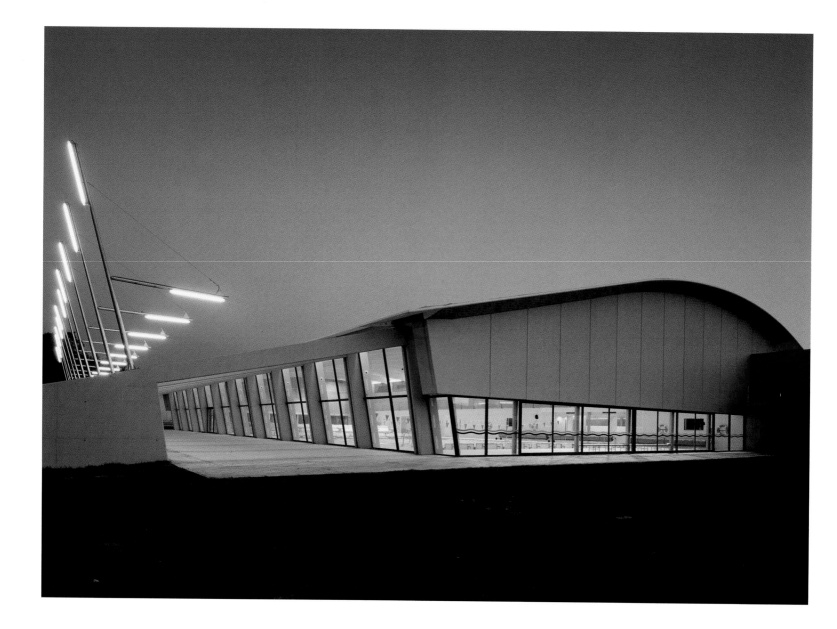

The objective of the project was to consolidate a sports installation area while at the same time helping to further urbanize the complex. Also, they wanted to take full advantage of the material means, equipment, and structures already available in the existing installations. Therefore, they tried to consolidate the already existing pool area as they created the aquatic complex to diversify the aquatic uses. The construction by stages was a fundamental aspect of the planning of the project. For this reason, the building was organized around three main areas that could be developed independently and be complemented by the common access module. On choosing the materials, they attempted to satisfy func-

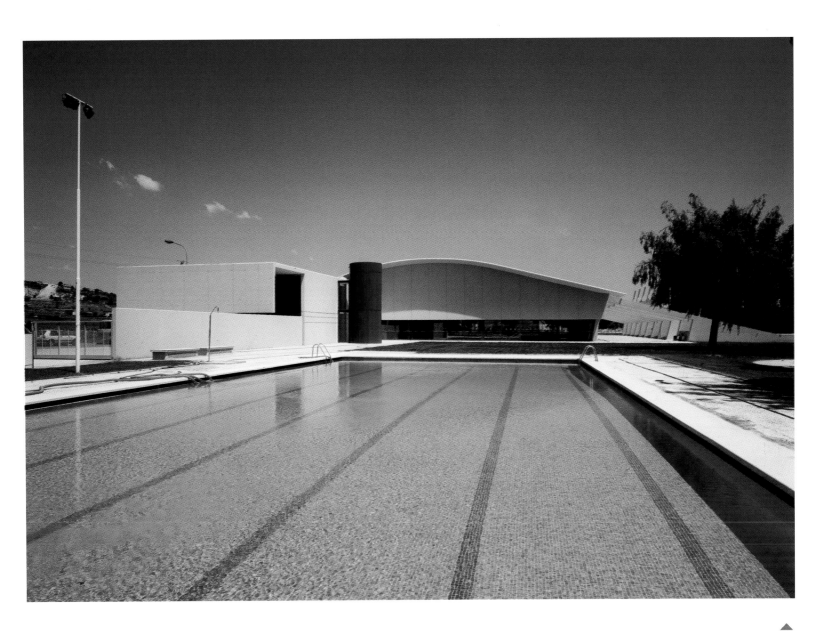

In the already existing sports installations, the construction of the new pavilion contributes to the urban organization of the complex.

tional and aesthetic concerns as well as energy-saving concerns proper to a public service installation.

With the exception of the roof beams in the swimming pool areas, which are made of plywood, the structure consists of reinforced concrete. The curved roof is a "sandwich" type, which is to say that the lower, interior part is grooved sheets of wood; the middle is thermal, insulation fiberglass; and the exterior is made up of sheets of prelacquered aluminum.

From the main street, you can see the main entrance, which is a large glass box that comes out from a concrete structure. A roof of the same material comes out at a 90° angle to form the porch over the entrance. All of the services are housed in the elongated building situated next to the largest pool. On the opposite façade, the beams are held up by concrete elements that are repeated, which creates an exterior space full of porticos. Three exterior swimming pools complete the complex.

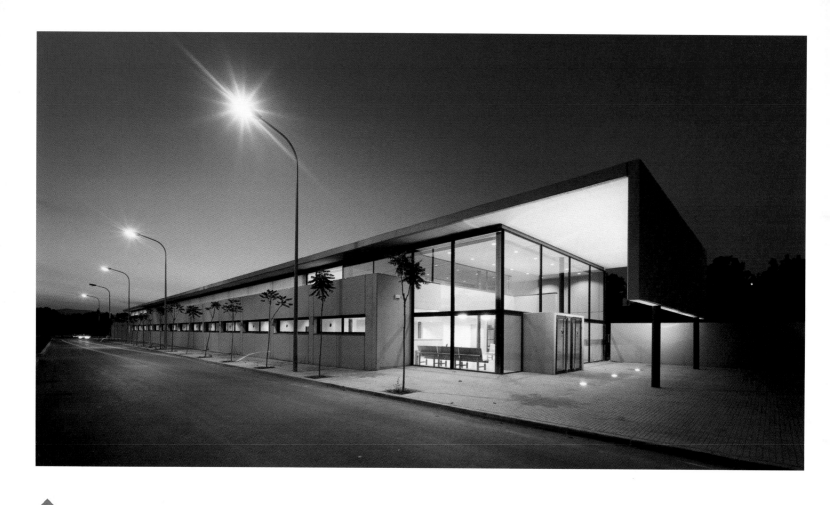

▲

The structure, with the elongated proportions, has the entrance and is the connecting area of all the other areas of the complex.

The execution of the construction in stages determined the initial plan of the project: three distinct atmospheres with three different, independently functioning activities.

▼

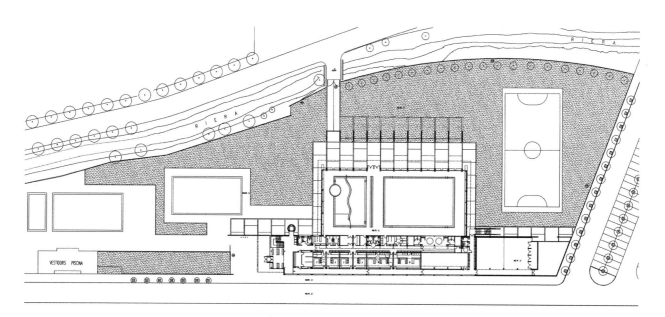

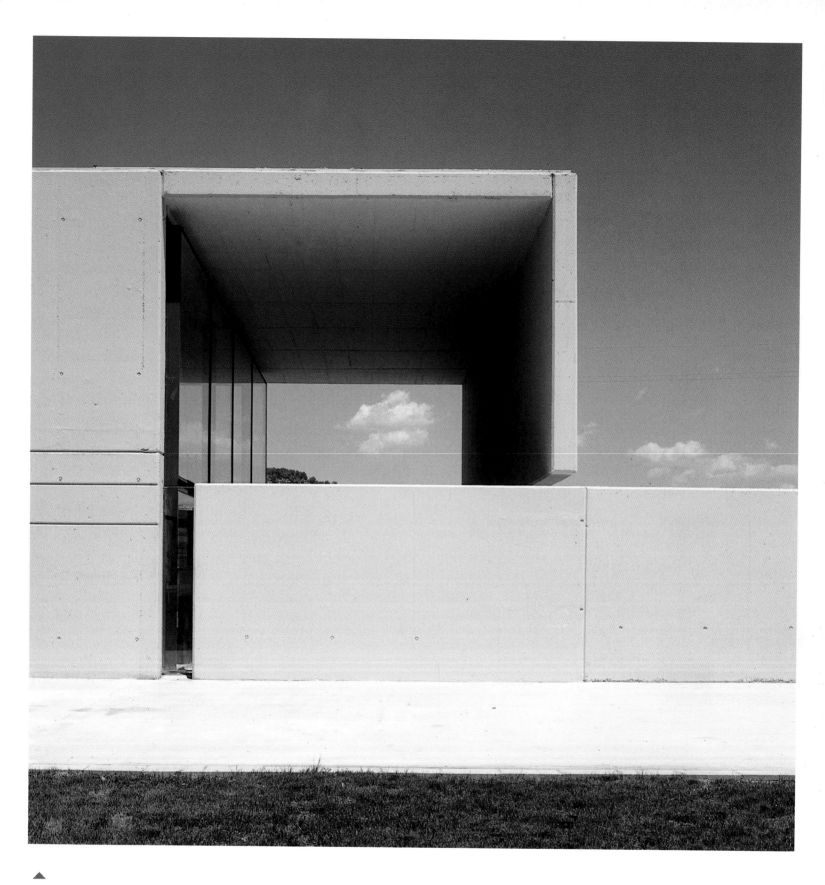

The contrast between the straight lines and the curve of the swimming pool generates an interesting formal composition.

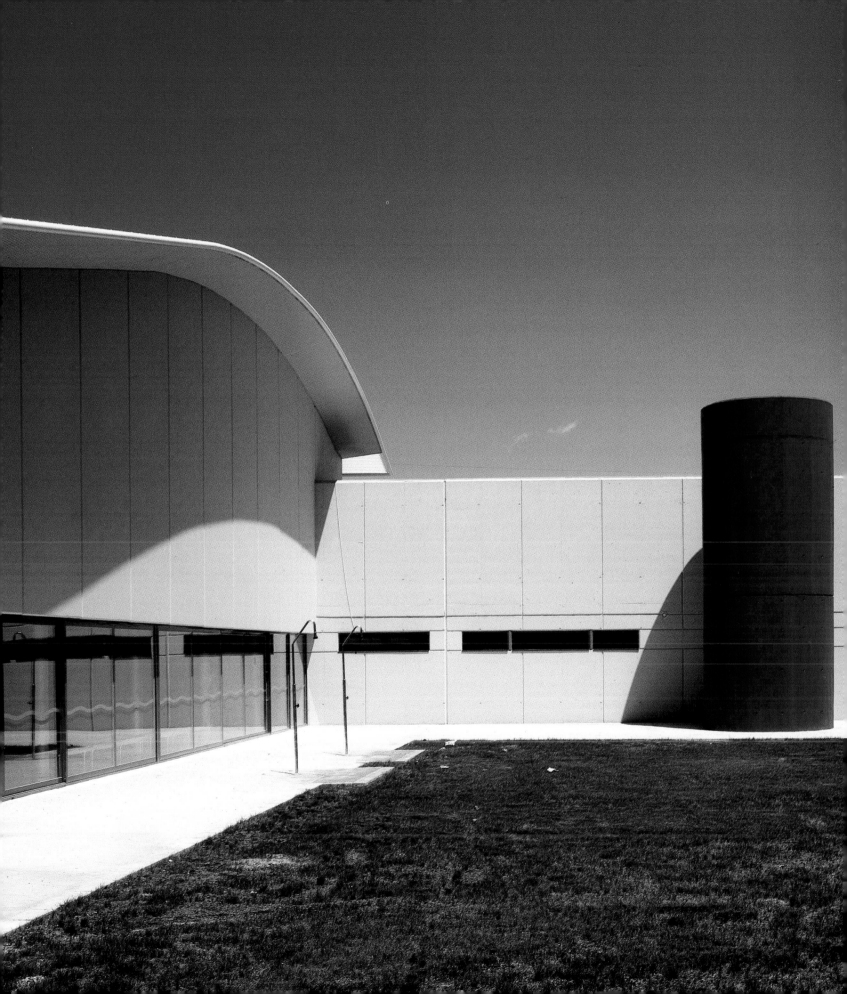

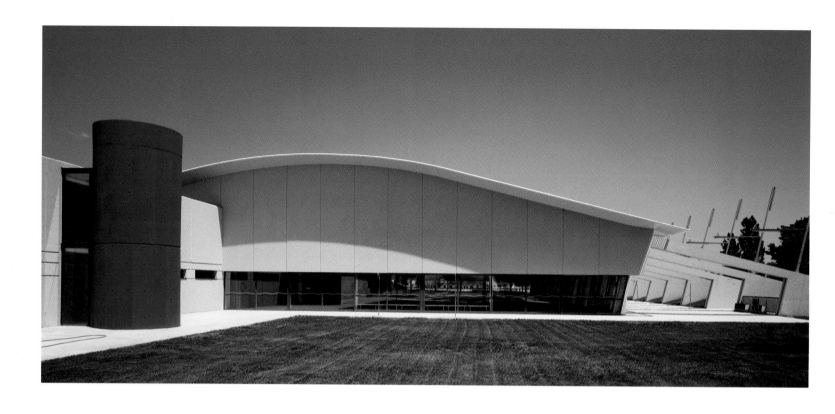

The structural plan is based on reinforced concrete, with a variation in the pool cover, since the beams are made of wood.

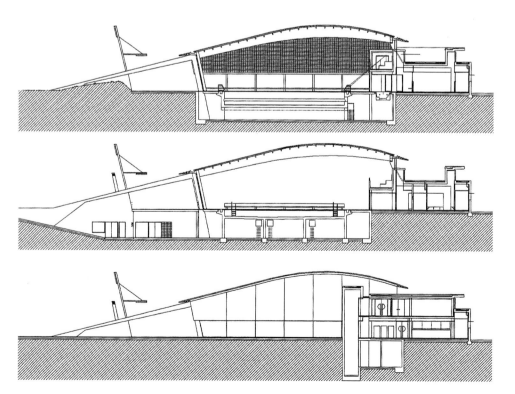

In this section, the formal equilibrium of the project is confirmed. The curve is delicately placed on a volume with orthogonal lines.

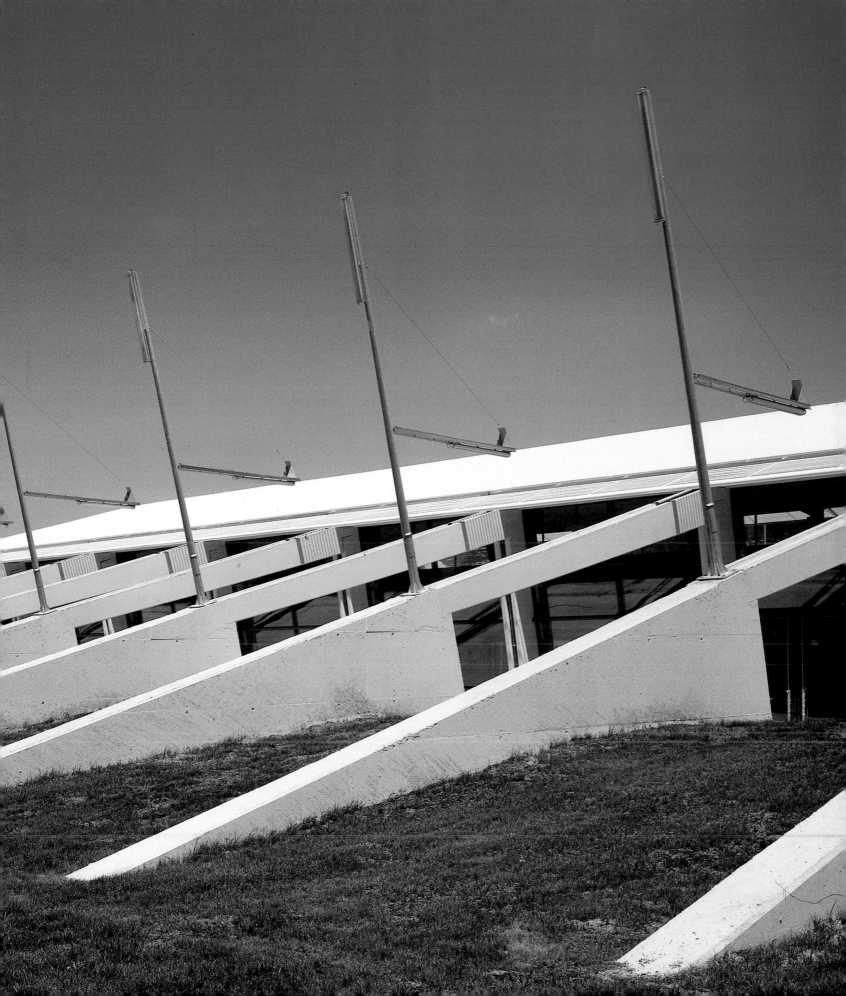

House in Las Palmas

- **Sebastián Irarrázaval D., Guillermo Acuña R.** | Collaborators: Jorge Bernat, constructor
- **Las Palmas, Region V, Chile** | Surface area: 1,507 square feet
- **Guy Wenborne**

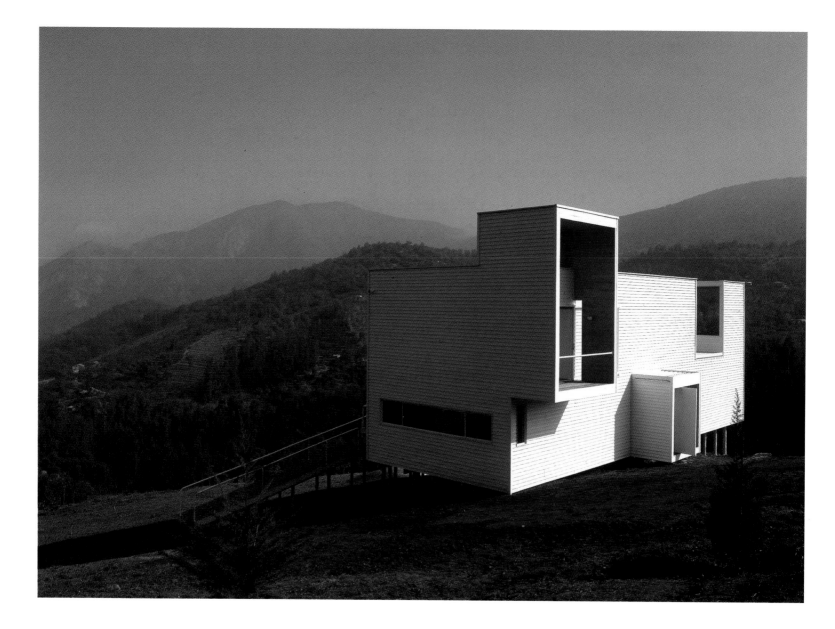

This house was built far from the city, so close supervision was not possible. Due to this limitation, a simple, cubic design was chosen. On the other hand, a limited budget obliged the architects to opt for an economical and fast construction system. For this reason, they decided on a system that is very well developed in the USA and Canada, and is beginning to be used in Chile in Georgian-style homes of North American inspiration. This system consists of a galvanized iron structure of uprights and beams, plywood, and a PVC imitation-wood covering on the exterior.

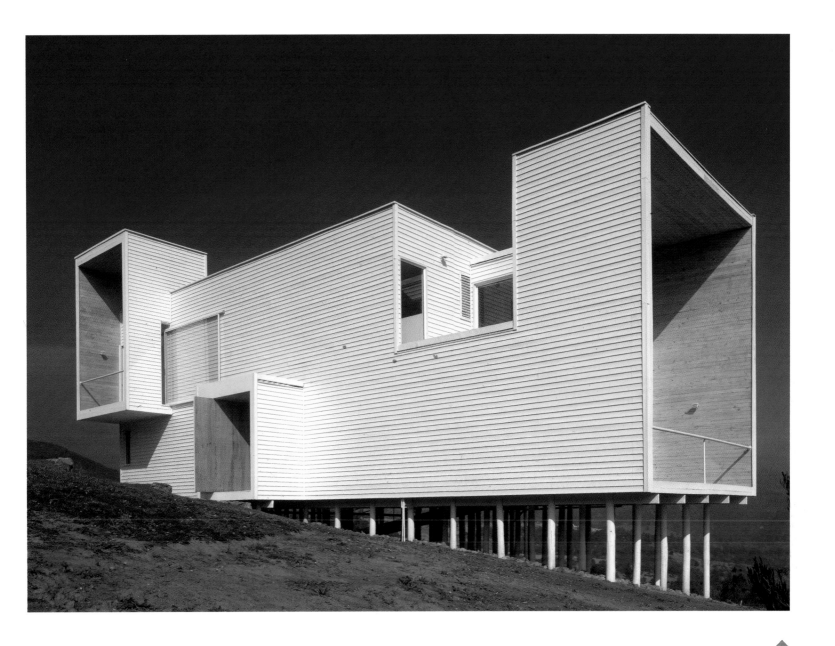

The use of a PVC covering, which is an imitation wood texture, means the breaking of prejudices that exist concerning the use of imitations.

The architects were interested in freeing themselves from the prejudices that exist against imitations, in this case, the imitation-wood exterior covering. On the other hand, they were enthusiastic about using this house as a prototype for prefabricated, low-cost housing. And in the same way as imported-style houses, which can be seen on the coast, these could be brought in from the United States in a kit.

The exact location of the house was decided upon after the project was commissioned. The original idea was of a table on top of piles, raised from the ground. The connection to the ground is by means of a ramp, which was designed at the end when the finishing touches were being added.

It is an elongated design that consists of two floors and that places the bedrooms at both ends. The relation with the exterior is through the cube-shape voids whose interior is finished with pinewood. These cubes are like the lens of the house, which are focused on specific views and zoom in on the distant landscape.

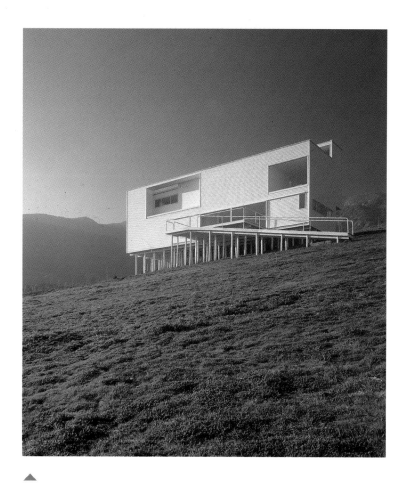
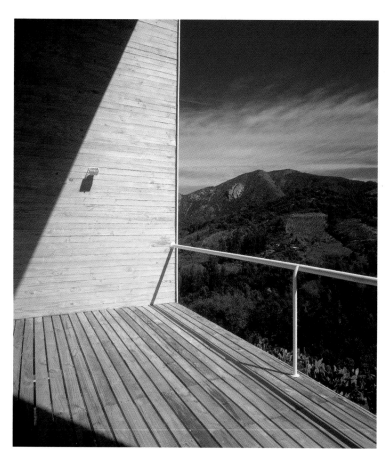

The construction plan was determined before the location was decided, so it was designed as a table on top of piles, raised from the ground.

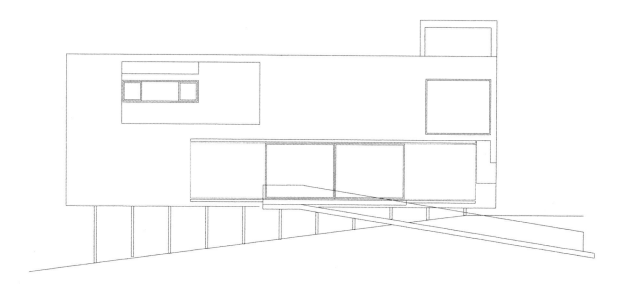

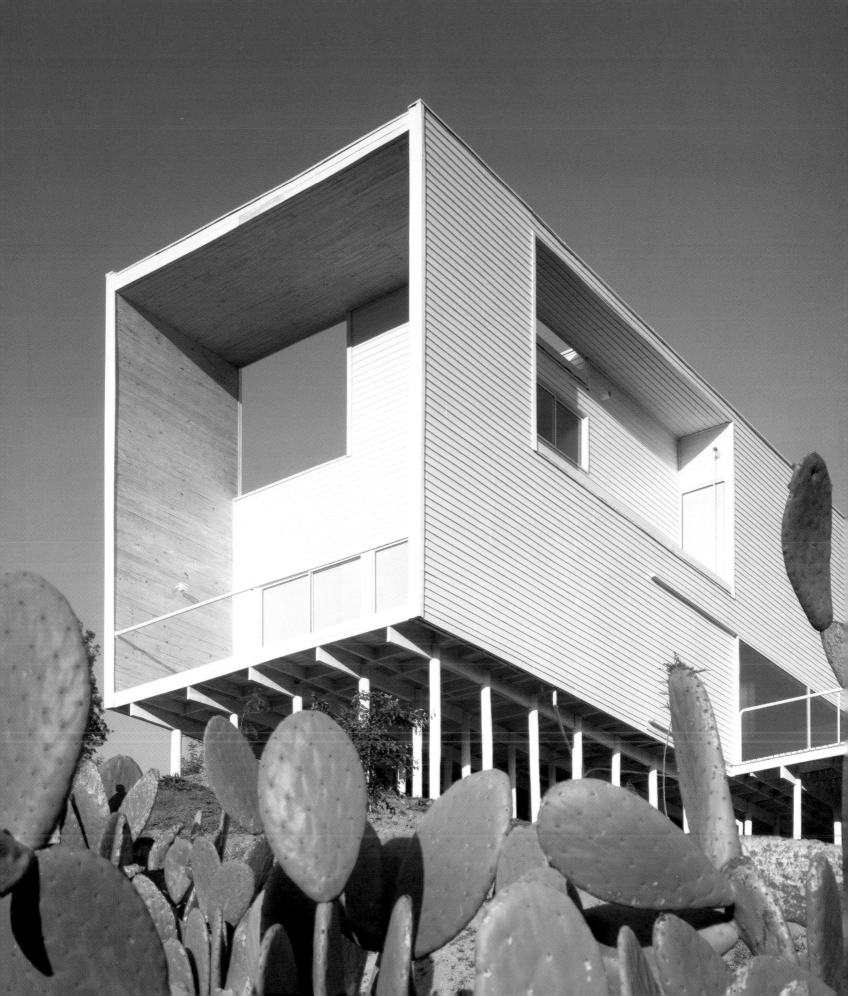

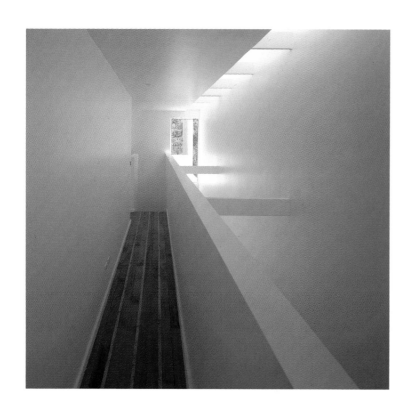
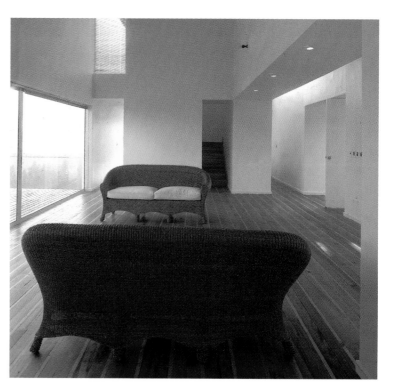
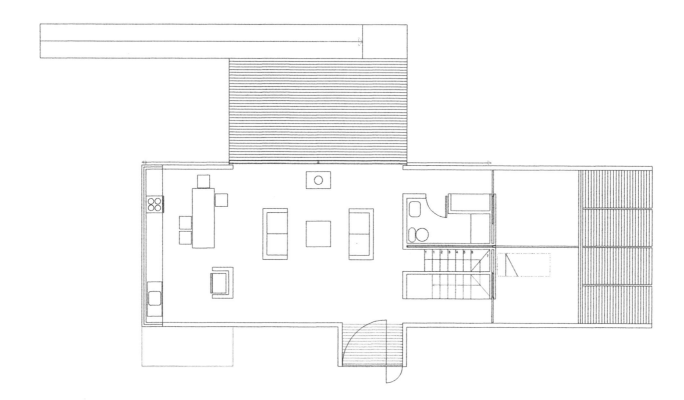

The corridor that connects the two floors of the house is illuminated, due to a skylight that runs the entire length of it.

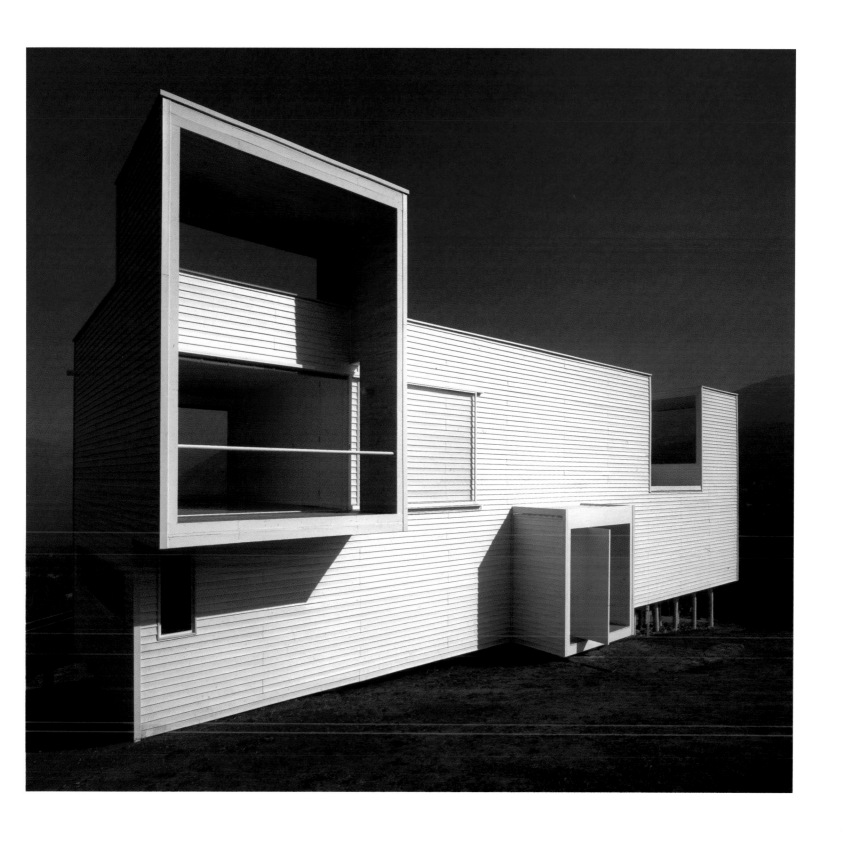

On the façades, there are filled and empty spaces, which create a play of cubic shapes.

Fully school

☞ **Bonnard & Woeffray, Monthey** | Collaborator Laurent Savioz

▦ **Fully/Valais, Switzerland** | Date: 2001

📷 **Hannes Henz**

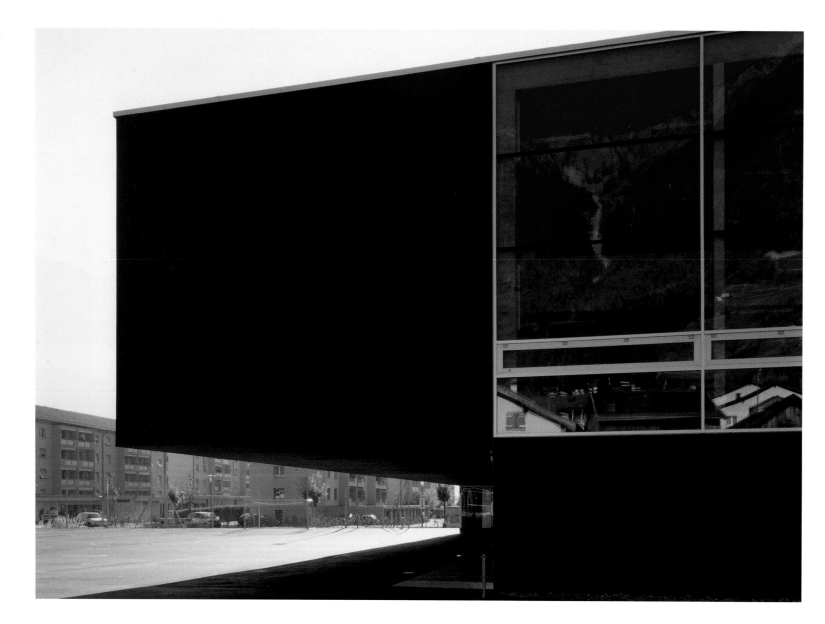

Fully is a town located near Martigny in the Rhone Valley, toward the north where the horizontal line of the plain rises and becomes the foothills of the mountain. It is a privileged place in the middle of vineyards and hazelnut tree orchards. The school was built on this majestic stage. The countryside exerts an influence on the geometry of the project; the colors and light are inspired from the landscape. Designed as a dark-colored monolith, the building consists of three floors. The floor plan is almost orthogonal but has a slight angle; the two classroom wings on the upper floors

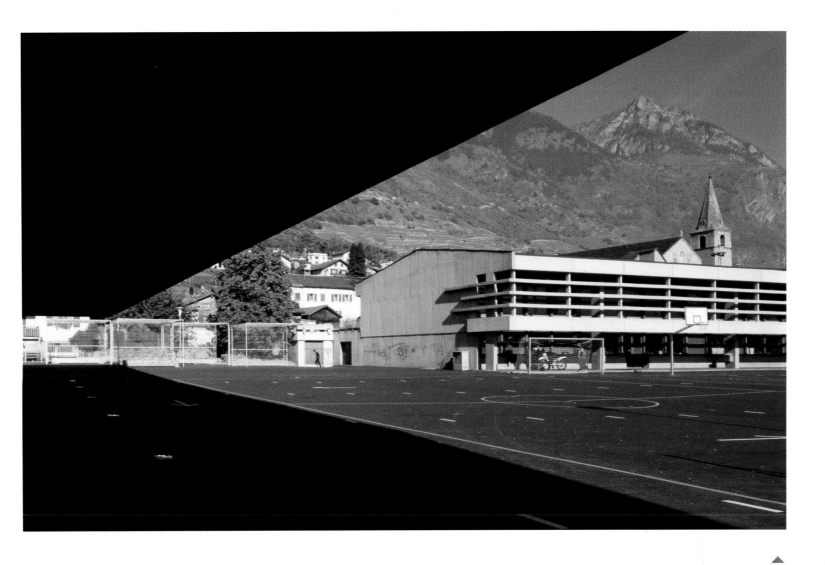

On the east façade, part of the volume is removed, leaving a broad projection. Its weight is sustained by the transversal walls.

diverge slightly and form a trapezoidal corridor. The spatial layout is dynamic and produces a very interesting phenomenological experience of perspective and perception.

The corridor becomes a common room at its widest extreme. Here, the widening of the floor plan and the corridor on the second floor come together over a large void and form a large lobby. A big, vertical window covers this double height and affords a view of the steep slope of the mountain. This evokes a close connection between the heart of the building and the surrounding landscape.

The relationship with the mountains is replaced on the ground floor by one with the urban atmosphere. The patio delineates the exterior common areas and seems to slip under the monolithic

structure. This interior–exterior relationship is achieved thanks to the elimination of part of the volume. On the east side instead of a classroom wing, there is a very large overhang without any visible structures to hold it up. The weight is sustained by the side walls of the classroom wings. This structural arrangement allows the construction and structural approach of the north façade to be ignored—a checkerboard-type area of solids and voids that touch each other. This composition reveals the construction system—concrete load-bearing walls combined with a peripheral insulating face.

In the school interior, the materials accentuate the spatial sensations. The aesthetics are expressed in the construction. Bare concrete is used on the walls and ceilings, and similarly, concrete of different colors is used on the floor.

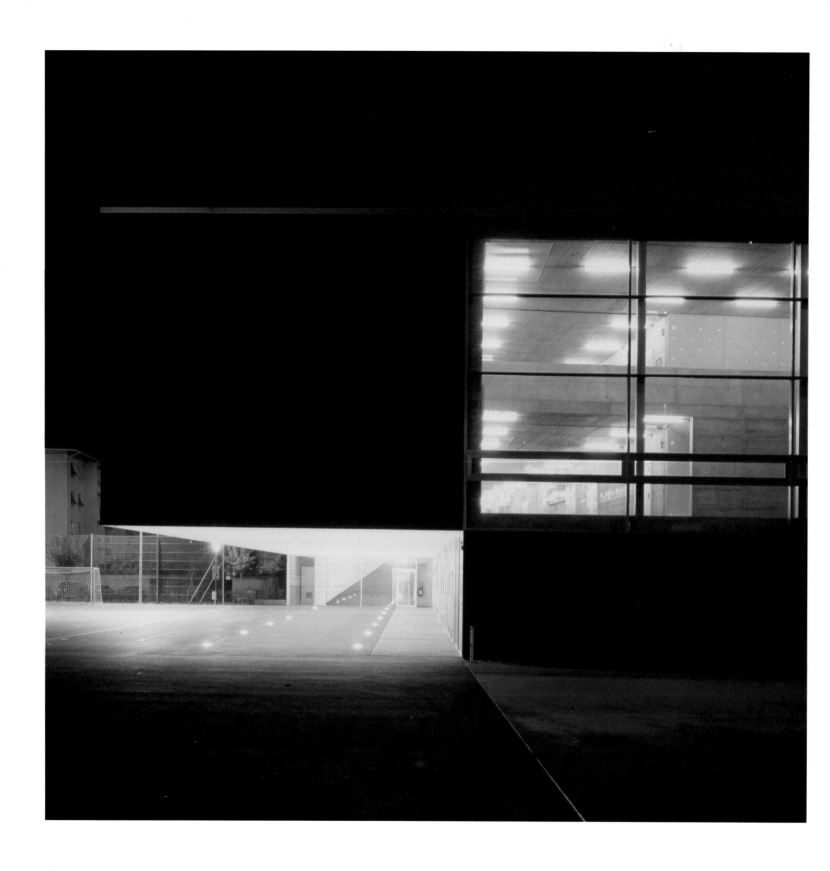

The overhang generates a transition space, which establishes a dialogue between the exterior and the interior.

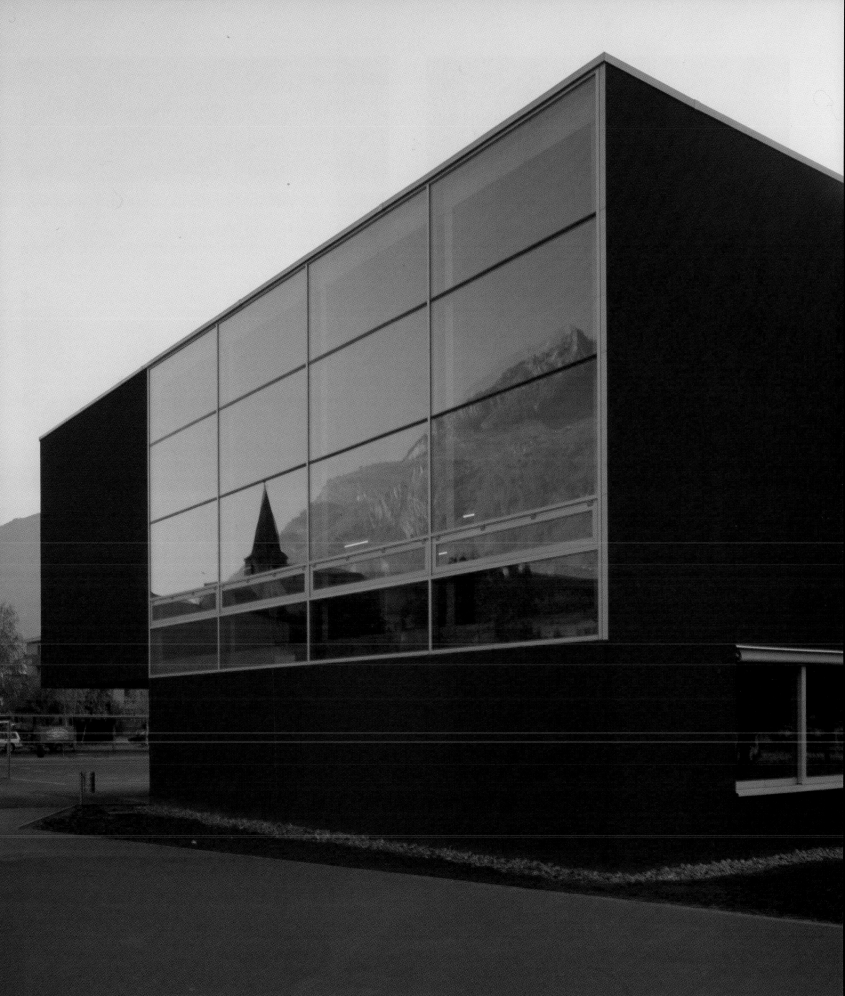

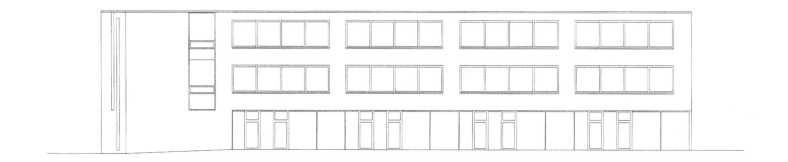

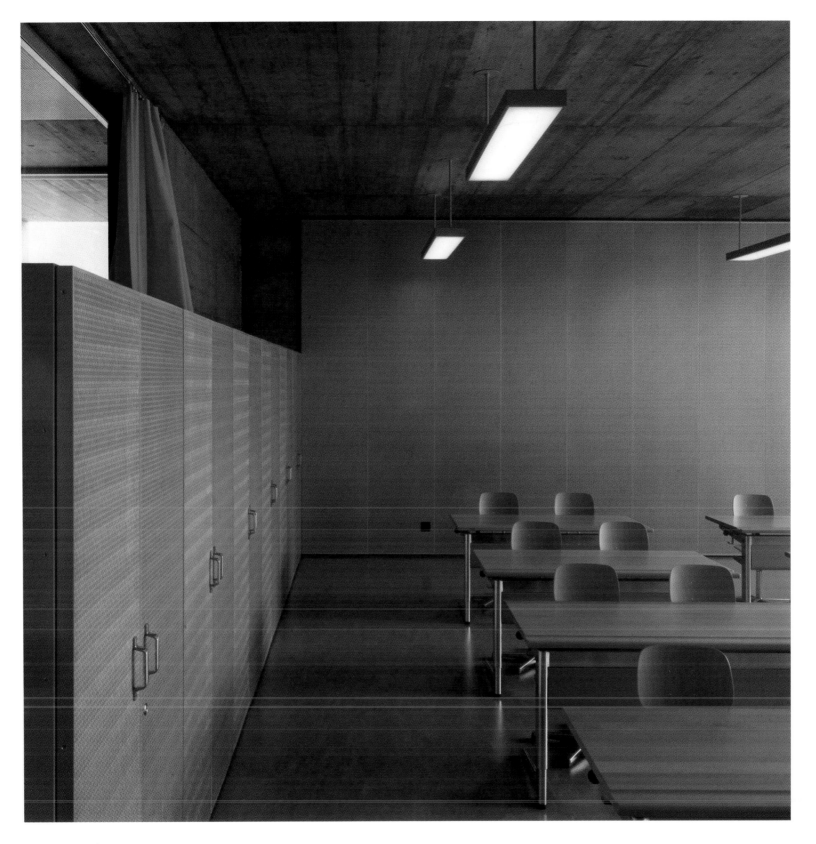

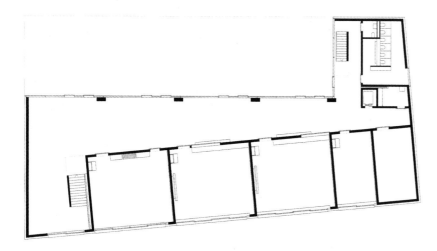

The floor plan has a slight angle. The two blocks that house the classrooms on the upper floors diverge slightly, thus forming a trapezoidal corridor that provides dynamism and creates an interesting play of perspectives.

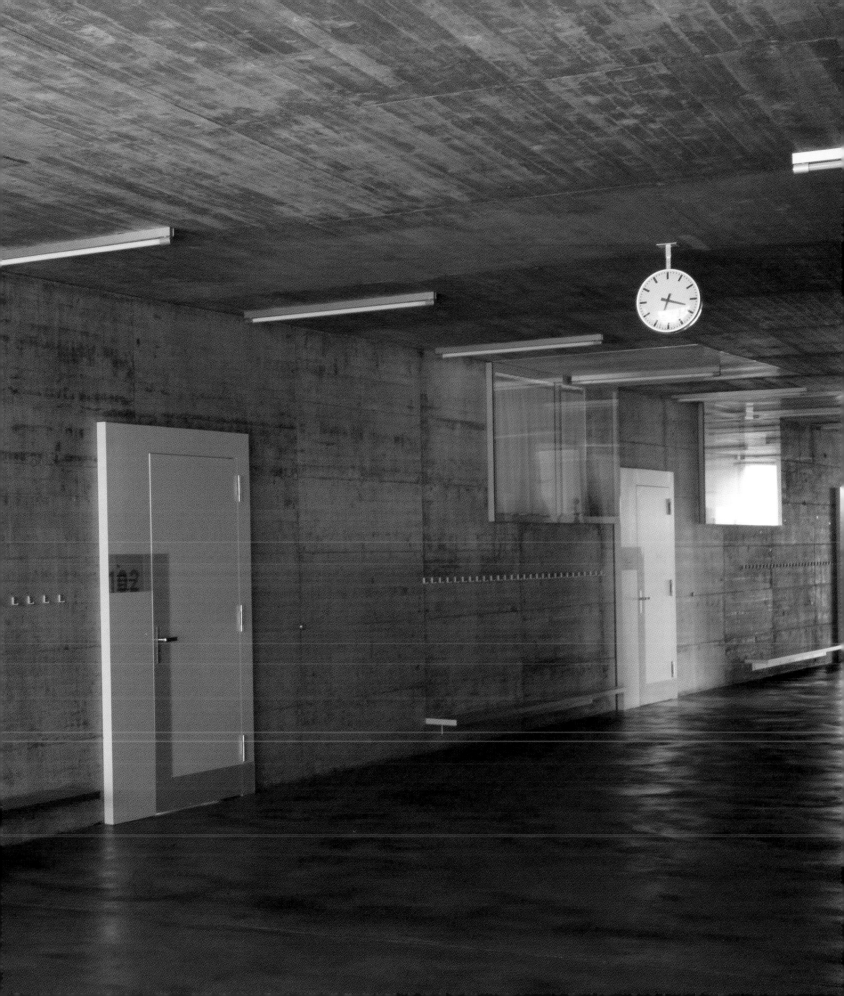

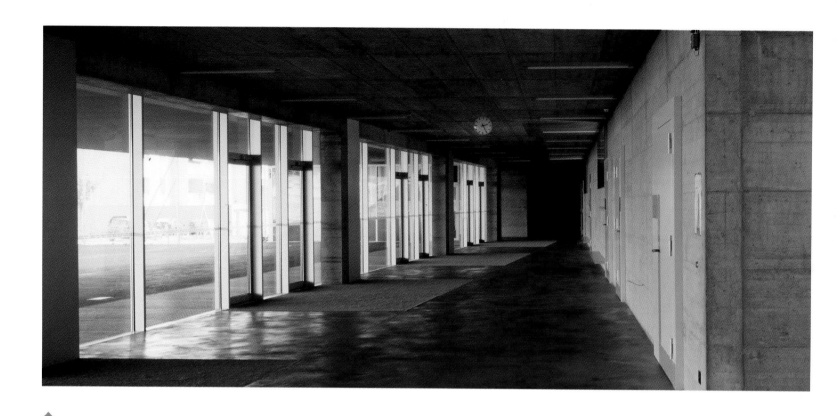

In the school interior, the walls and ceilings are made of bare concrete, whereas the floor is made of concrete painted different colors.

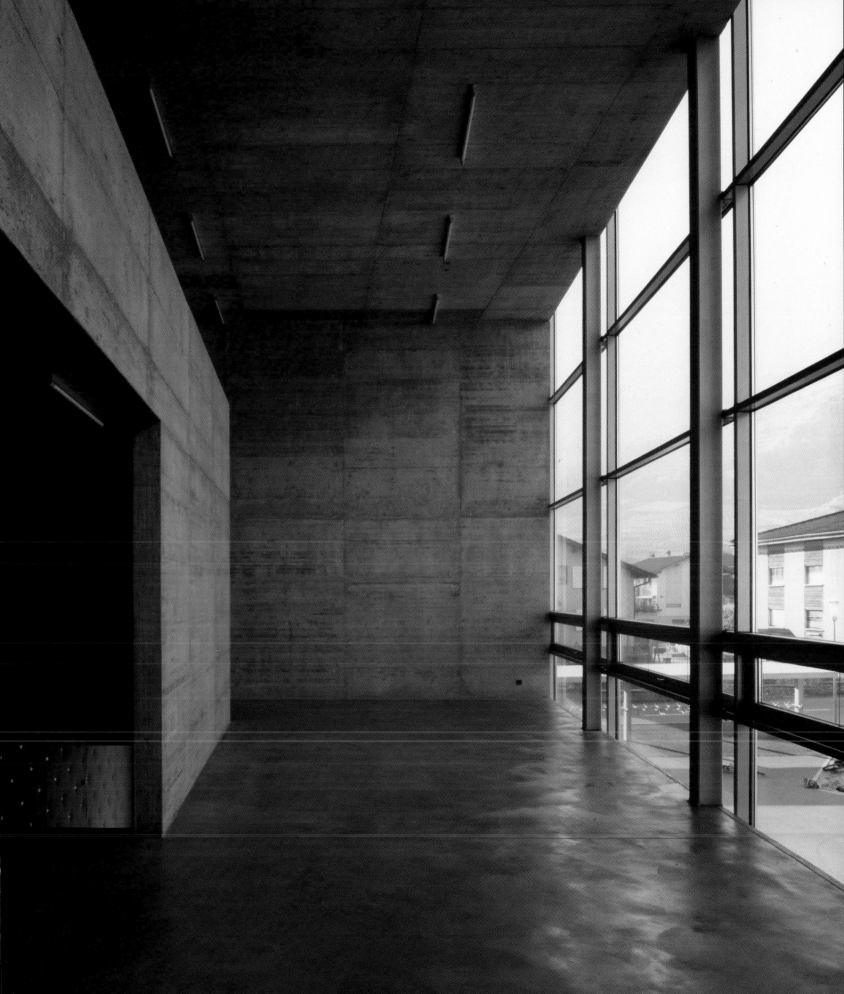

Headquarters of the Decaux multinational

Carlos Ferrater | Collaborators: Olivier Perrier, Carlos Boyer

Mercedes Industrial Estate, Barcelona Road. Madrid, Spain | Date: 2001

Alejo Bagué

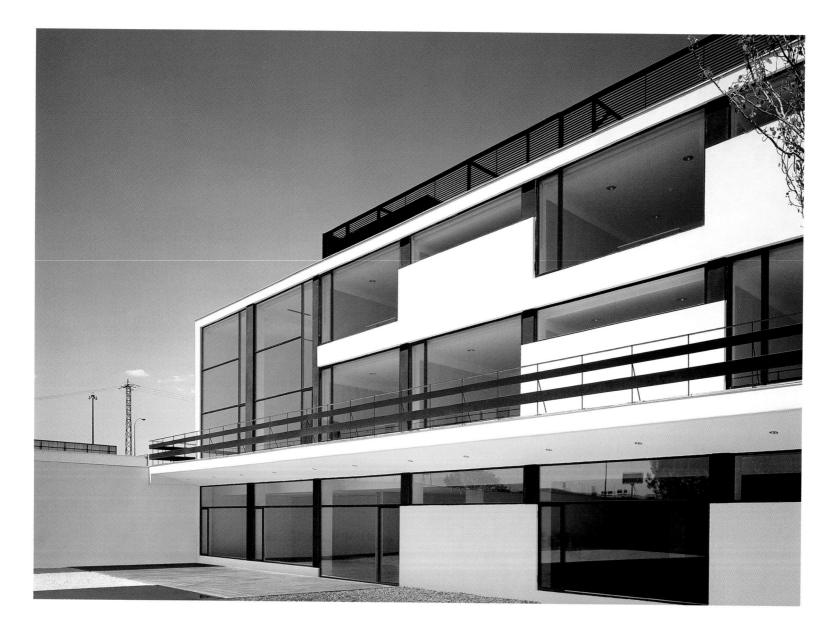

The new headquarters for J.C. Decaux, the international company of urban furniture and furnishings (benches, street lamps, etc.) occupies the old Martini & Rossi factory building. This building was designed by the architect Jaume Ferrater in the 1960s and erected in an industrial area on the outskirts of Madrid. The complex, which is protected by architectural heritage laws, consists of a large building with a structure of arches, an administration wing and a series of warehouses and service spaces. It has great formal elegance and is an expression of contemporary poetry. The project confronts a very contemporary issue: restoring contemporary architecture while still showing a deep respect for preexisting

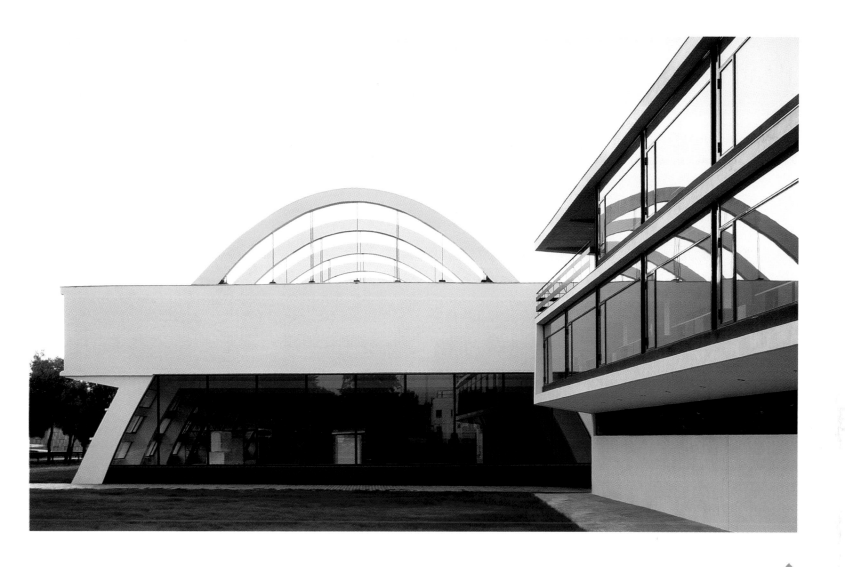

The arches of the vaulted nave contrast with the predominance of the straight and horizontal lines of the building.

architecture of recognized quality. Here, a series of nondestructive work was undertaken in order to adapt the building to the demands of the new user. The project respects the original aesthetics by recuperating the façade, which had become deformed by various modifications. It also created a new central entrance. The interior structure is completely respected except for a few modifications in the interior distribution. A series of openings in the wrought iron structure improve the natural lighting of the area open to the public.

The new entrance opens into the lobby at triple height. This is the nerve center of the building. From here, there is access to the offices that occupy the original administration wing in the large arch-structure building. This building now serves as a showroom and the area for receiving customers and visitors. It also includes a small conference hall and a cafeteria that opens onto a patio and garden. There is a larger garden in the rear, which is more intimate and which can be viewed and enjoyed from the offices.

Administration and management offices are situated on the upper level. It is an overhanging structure. It is connected to the upper part of the showroom and gives the appearance of a light, metal catwalk opened over the space, high up over the lobby.

The purity of the shapes makes the structures become strikingly visual pieces of sculpture.

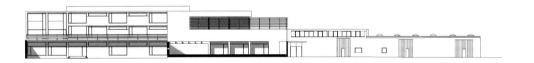

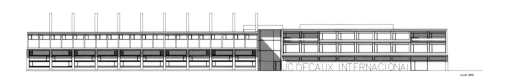

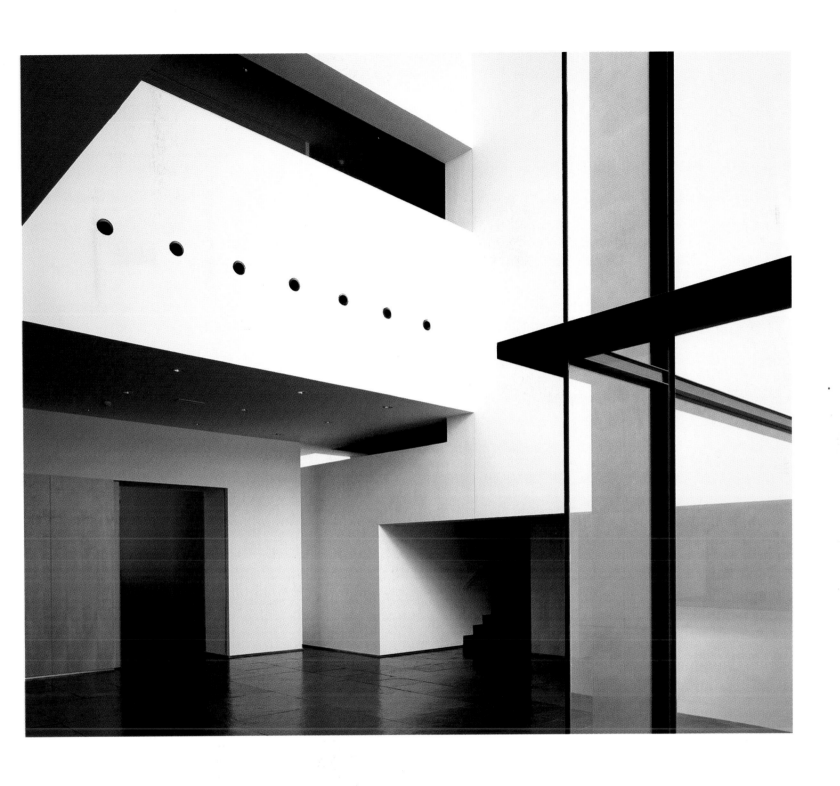

In the exterior as well as the interior, white is the color that defines the spaces.

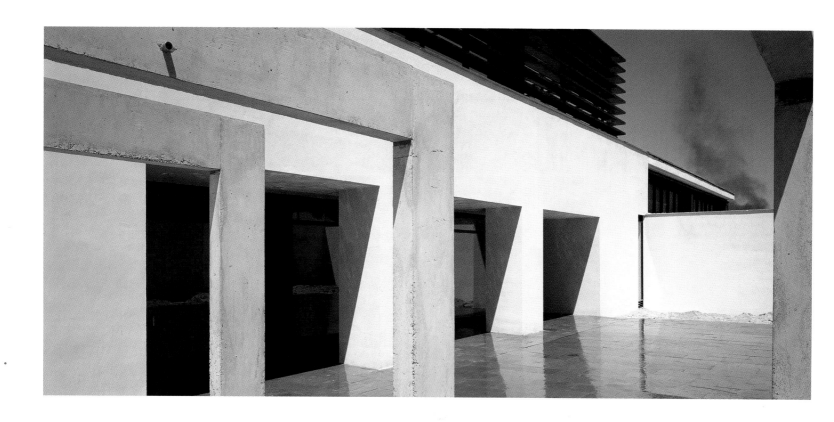

The architects have undertaken work in consonance with the original project, since its architectural quality deserved to be fully recuperated.

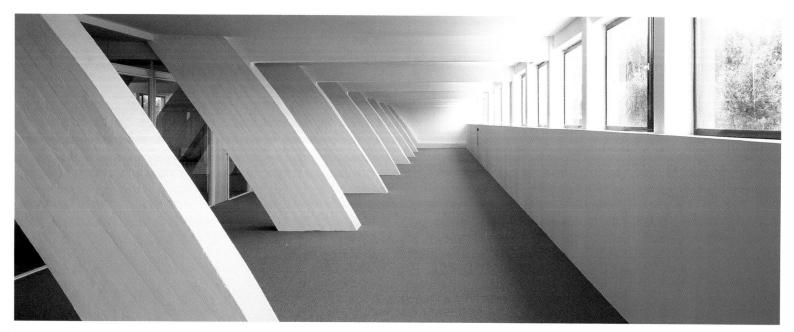

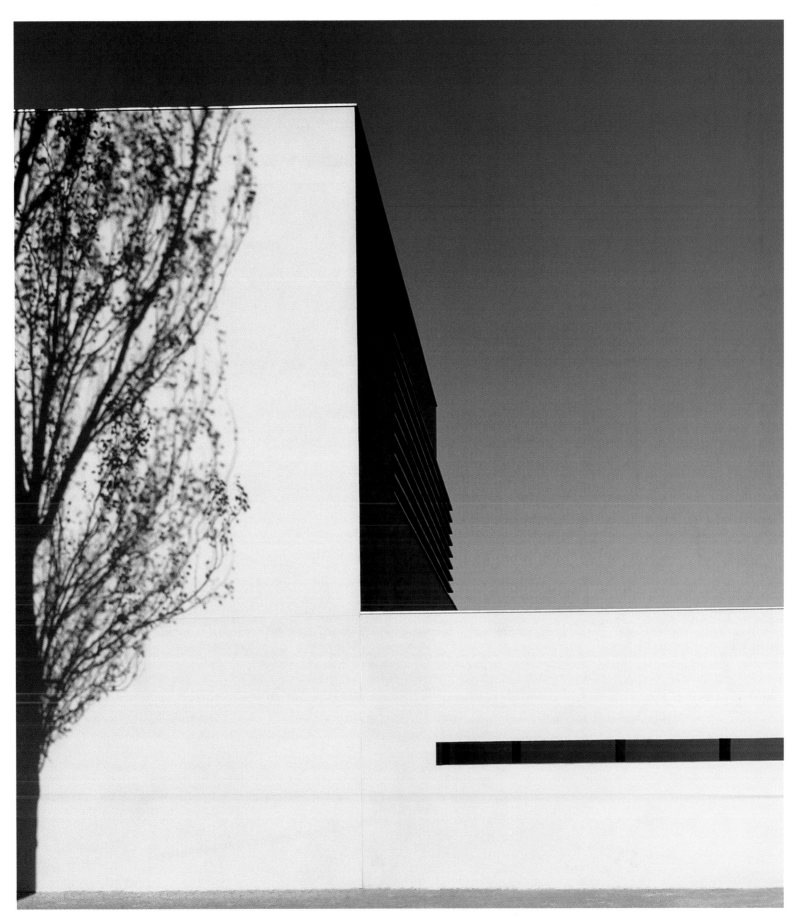

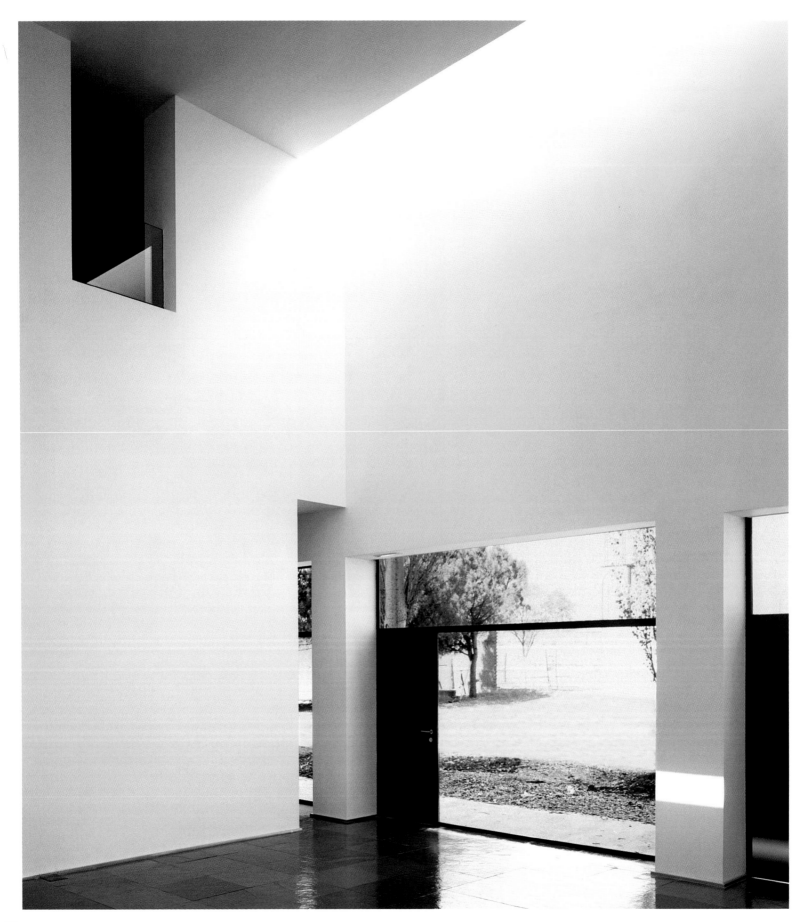

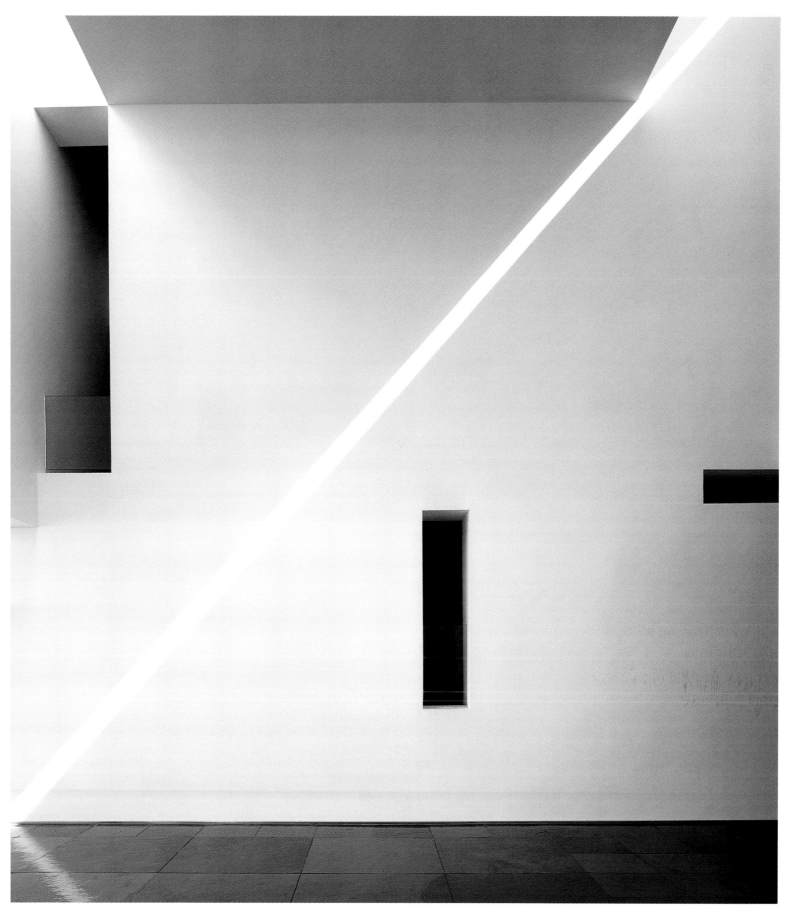

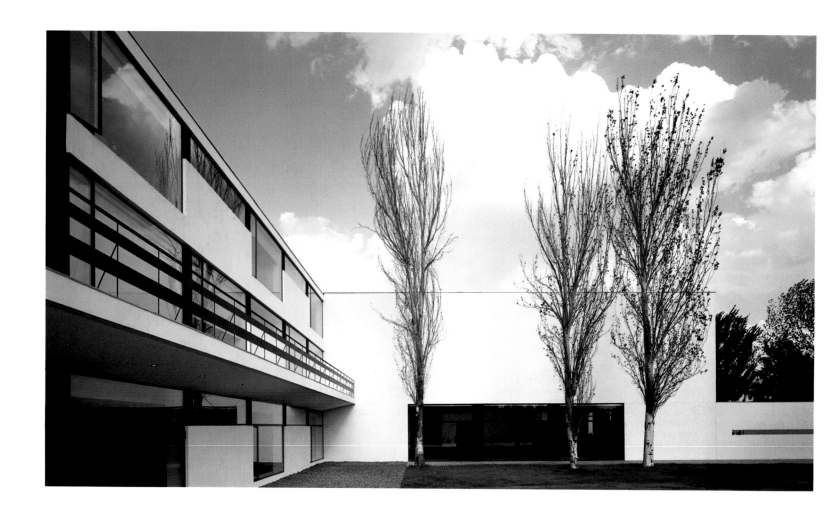

▲

The verticality of the trees contrasts with the horizontality of the building.

◀

Floor plan of the complex.

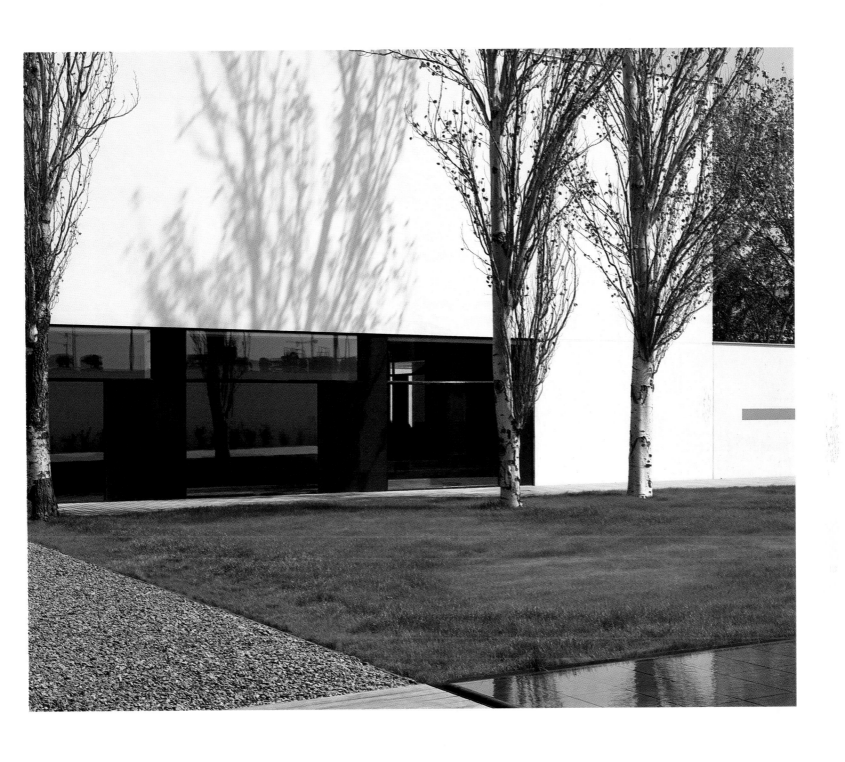

The green areas have been incorporated into the complex as places of transition and privacy.

▲

The furniture responds to the desire to maintain the formal elegance that is conveyed by the shapes of the building convey.

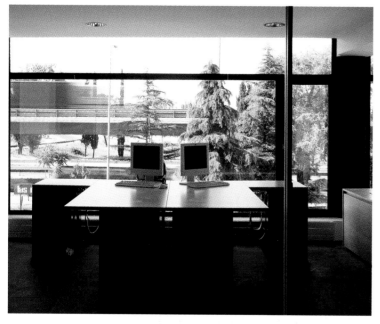

▶

The narrow wall openings let in precisely defined rays of light, which outline luminous paths the length and breadth of the spaces.

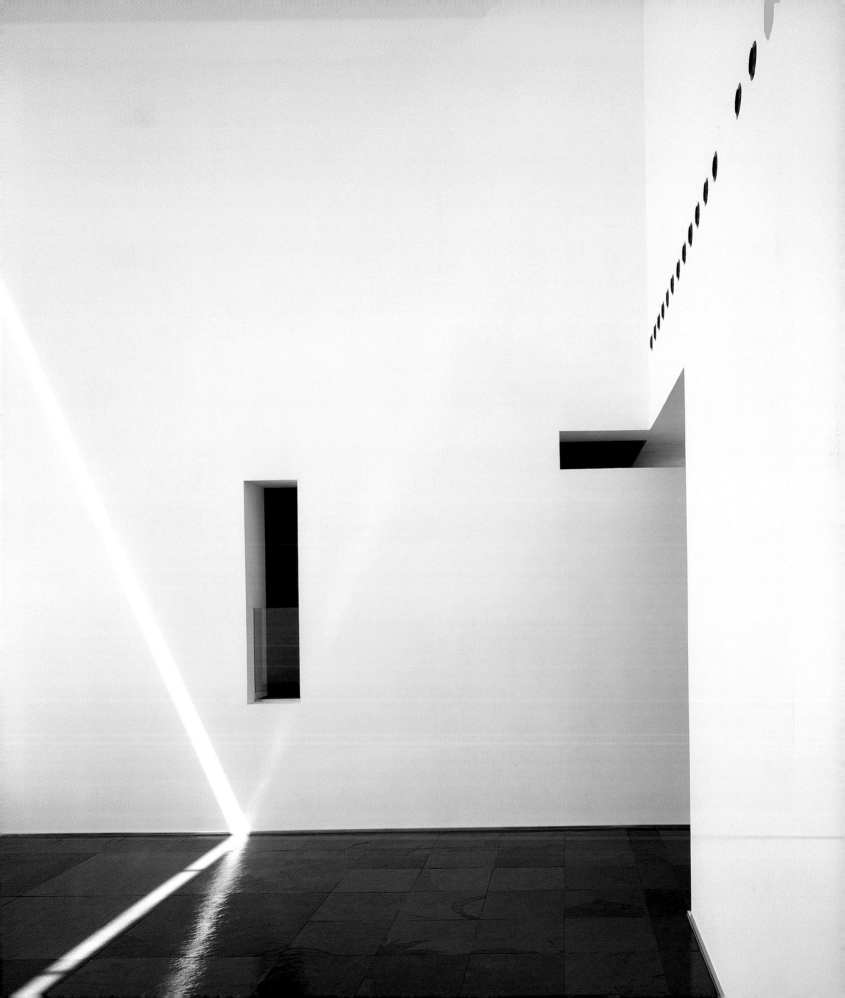

Grassi house

⌨ **Giovanni Guscetti** | Collaborators: Fabrizio Giovannini, Giancarlo Rusconi, Franklin Garbani

▦ **Lugano, Ticino Canton, Switzerland** | Surface area: 2,691 square feet | Date: 2001

📷 **Marco d'Anna**

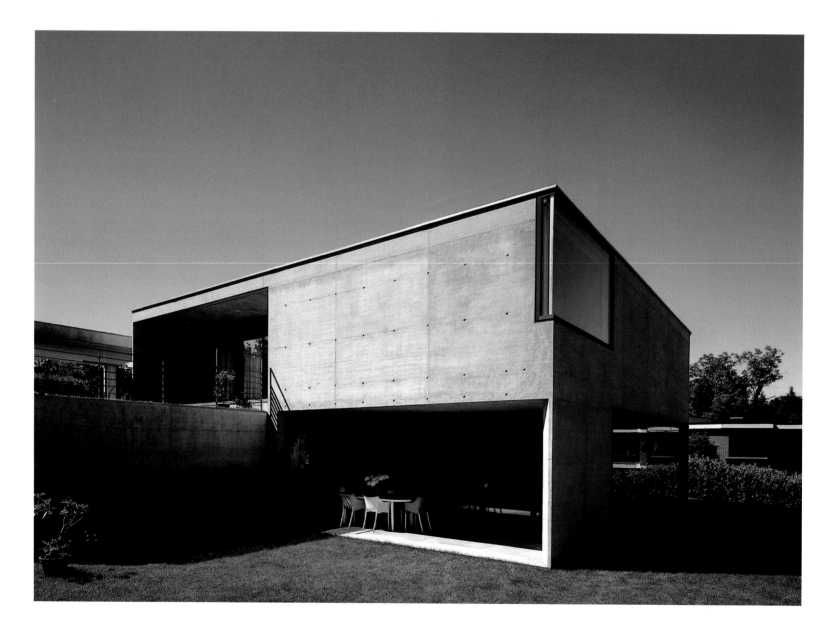

This plot is situated in a high area that overlooks the city of Lugano. From this hill, you are afforded fabulous views: Mount Sant Salvatore to the south, Lake Lugano to the east, and Mount Bre to the northeast. This construction falls within the urban development plan for the east side of the hill. This plan, which was elaborated by the architects Brocchi and Bühring, determines the specific location of a construction, the height and the maximum dimensions, and vehicle access to the entire property. The main theme of this project is the relationship between interior

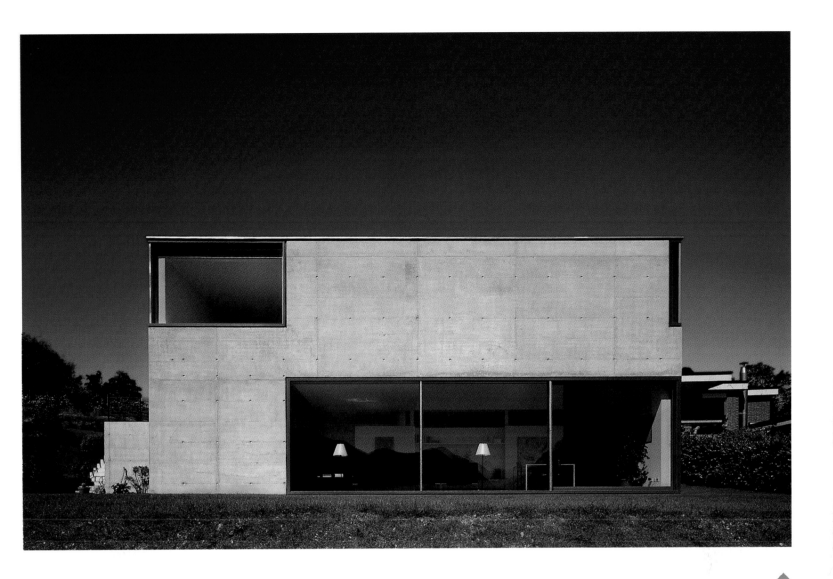

Each façade establishes its own composition criteria, due to the distinct apertures in each one, which results in the uniqueness of each façade of the house.

and exterior. They attempted to attain a close relationship with the most attractive elements in the immediate surroundings. The walls, made of reinforced concrete, have openings in them where the views are especially beautiful. The large apertures, which are flush with the façade, conceal the metal frames. This affords the sensation of not simply windows, but rather of interruptions in the perimeter's enclosure.

This approach gives prominence to the supporting structure, which consists of interlocking, reinforced concrete beams. In tune with the features of this high place overlooking the city, there is no principal façade. Instead, each façade affords its own balanced composition.

The thickness of the basic elements of the house were reduced and eliminated. Consequently, the walls, the ceiling tiles and the corners, and the broad glass surfaces become an integral part of the building envelope. As a result, this abstract volume, the glass and the wall of reinforced concrete, become fused together.

All of the rooms open onto the expansive terraces; the one on the first floor is for the bedrooms, whereas the rooms for daytime utilize the terrace on the ground floor. From the entryway, which is situated on the first floor, you go down to the double-height living room. This layout allows you to immediately appreciate, even from the interior, the simplicity of the house's volume.

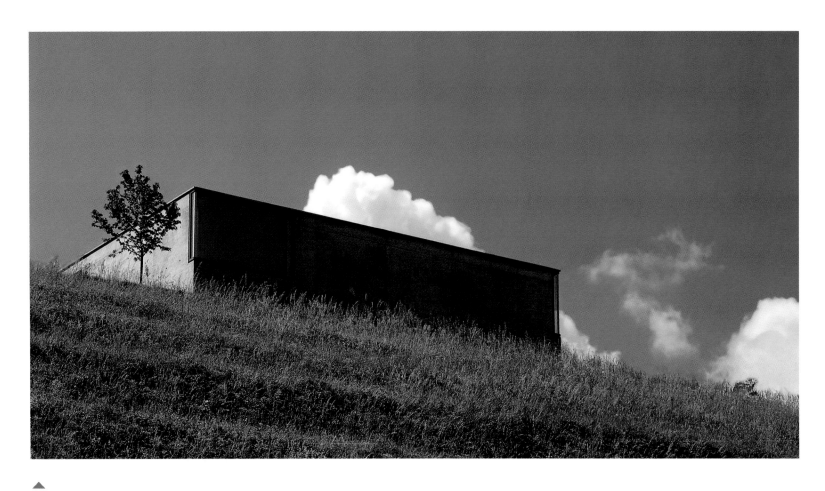

The dwelling is on top of a hill. This location provides the house with splendid views of the surrounding region.

The bedrooms are situated on the first floor, and the rooms of common use, like the split-level living room, are on the lower floor.

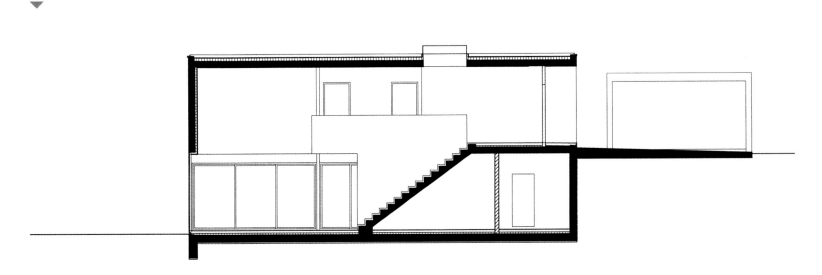

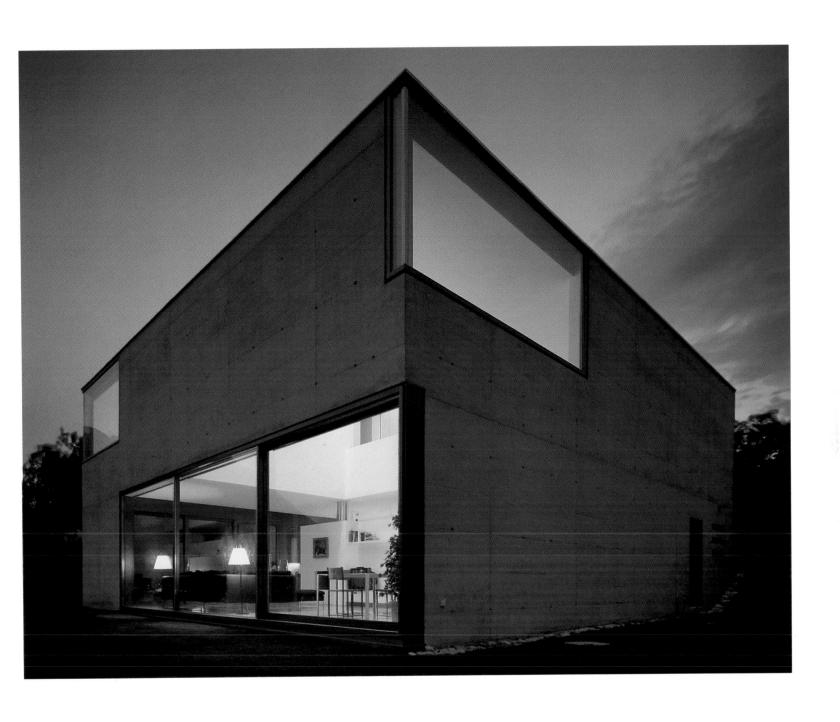

The apertures, which are flush with the façade, conceal the metal frames. Their continuity on the façades makes them seem more like interruptions in the perimeter's enclosure than like windows.

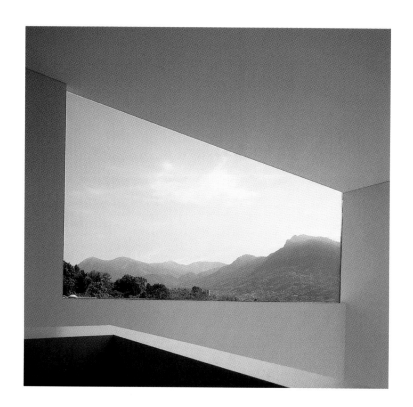
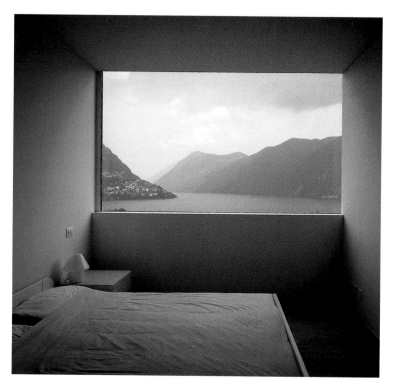

The countryside is the only element that breaks the clean and refined lines of the interior. This permits the surrounding environment to become more of a protagonist and to integrate its presence into the dwelling.

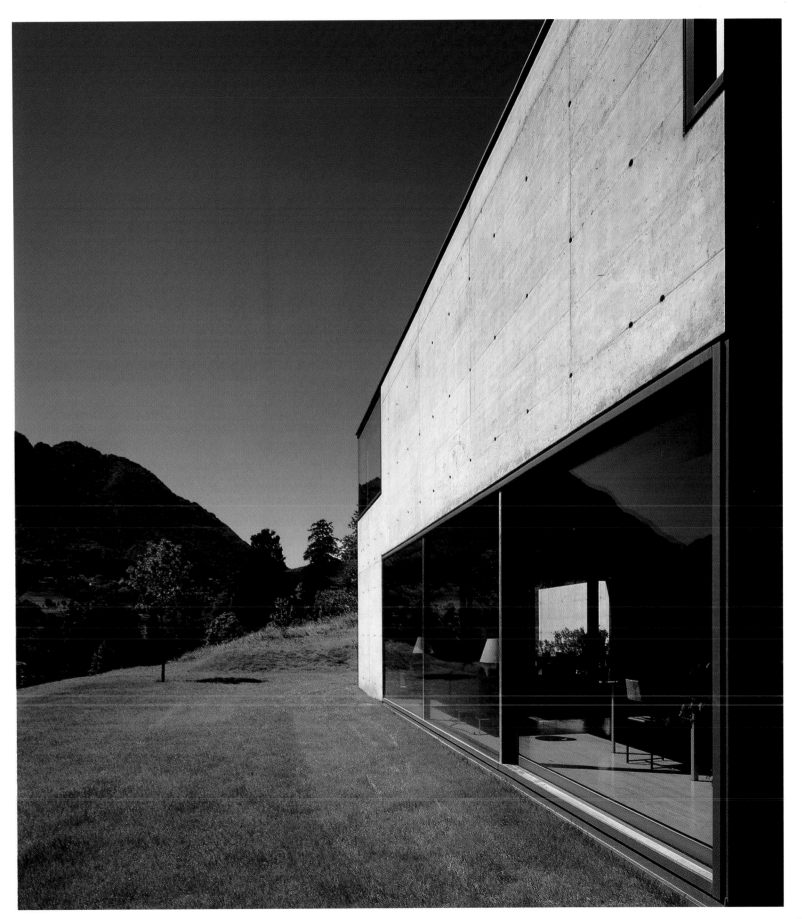

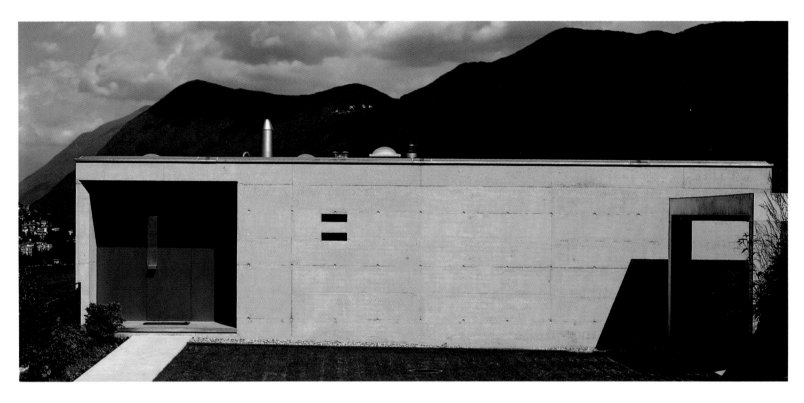

The walls are made of reinforced concrete, a material that gives the house an outstanding, strong, physical appearance.

The structure adapts to the characteristics of the terrain. The window openings are situated at the points in each façade that afford the best views.

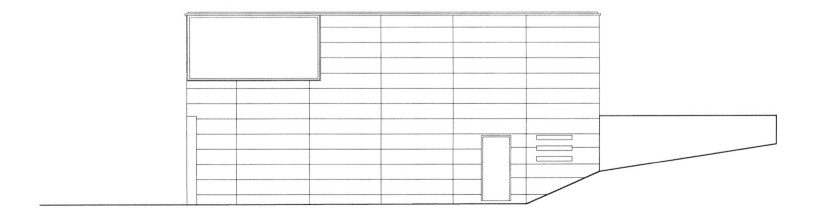

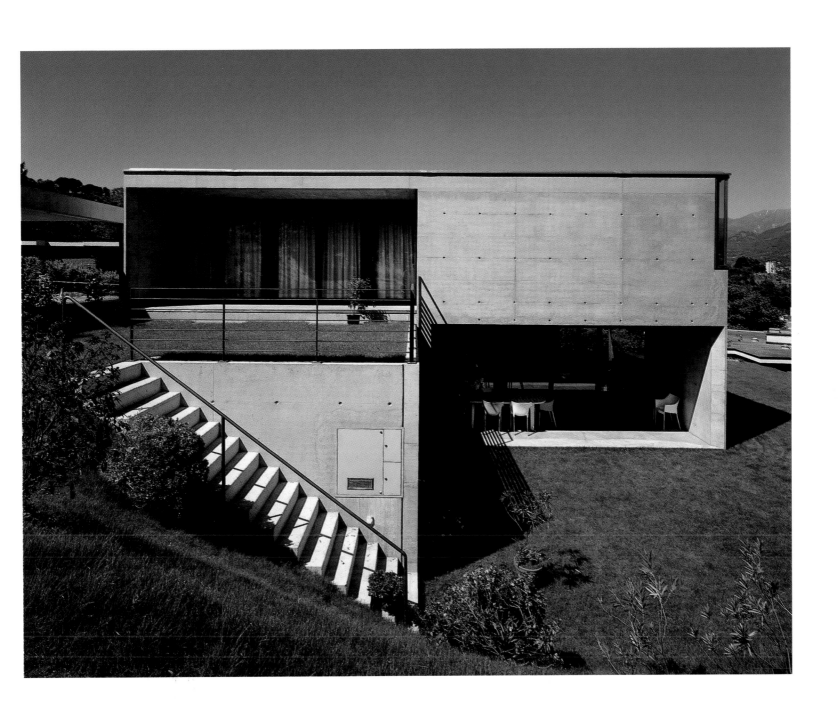

All of the rooms overlook one of the two terraces that encompass the house. The different levels afford different perspectives of the house.

Pulitzer foundation

Tadao Ando | Collaborators: Tadao Ando Architect and Associates

St. Louis, Missouri, United States | Surface area: 25,619 square feet | Date: 1997–2001

Makoto Yamamori

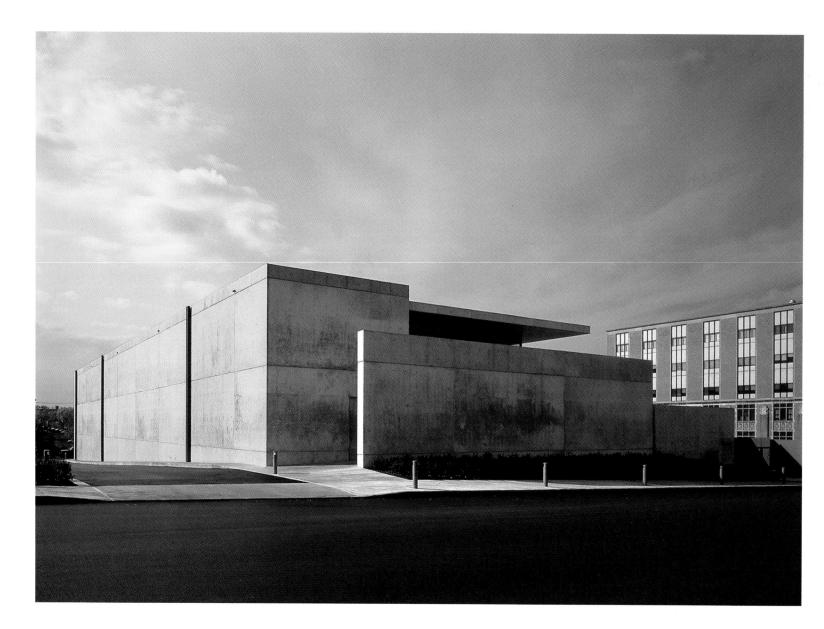

This museum was designed to house the collection of the Pulitzer family, the founders of the famous Pulitzer Prize. The site is situated in St. Louis, Missouri, whose city center has been devastated by years of development in the suburbs. The building occupies a corner of a cultural area presently in development and where the Pulitzer family is playing a key role. It is hoped that this cultural area will become the focal point of the district. Based on the conditions of the environment and following the requirements of the program, the design was developed as a residential scale project with a contemporary art gallery within. The composition is extremely simple. Special attention is paid to designing just

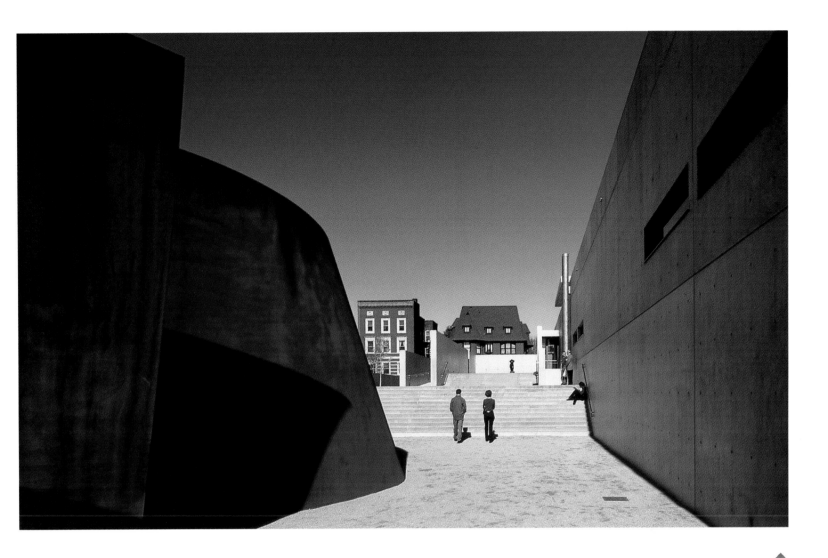

This project is the first public building by Tadao Ando in the United States. From the beginning, it was conceived as a serene composition designed so that you could look at and enjoy works of art. Likewise, the objective was to revitalize the urban environment in St. Louis.

the right proportions for the multiple apertures in order to create tension between the interior and the exterior.

The desired effect was achieved by dividing the space by means of geometric manipulation, and at the same time, by limiting the architectural elements. The building consists of two rectangular volumes. Both are 23.9 feet wide and 210 and 203 feet long, respectively, and of different heights.

The taller one is as tall as it is wide and houses the main gallery. The other is one floor lower and contains the entrance lobby, the library, the offices, the research areas, and other spaces. It is covered with a rooftop garden.

Because of the difference in length of the two buildings, there is an interstitial space covered by large eaves. It acts as a connector and as an access to the museum.

The exterior spaces—the water garden, the rooftop garden, and the numerous terraces—are a continuation of the interior exhibition spaces, and all can be considered as possible exhibition areas for works of modern art. Furthermore, this continuity between interior and exterior establishes a relationship with the natural light that is active in the interior galleries. It is manifested as the expression of the passing of time and the changing of the seasons.

From the beginning, the artists whose works are part of the collection—Ellsworth Kelly and Richard Serra, for example—participated in the design of the foundation. It is hoped that this will be a place of constant stimulus, which will afford a dialogue between the audience, the museum, the works and the artists. It took ten years, from start to finish, to complete the project.

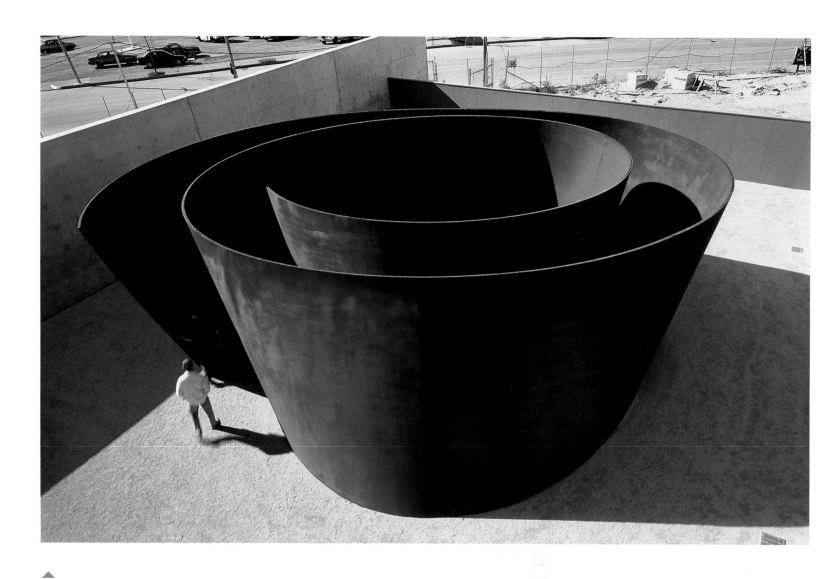

The spiral-shaped sculpture is called *Joe* in honor of Joseph Pulitzer Jr. The monument, the work of Richard Serra, allows for interaction with the visitors who can walk inside it.

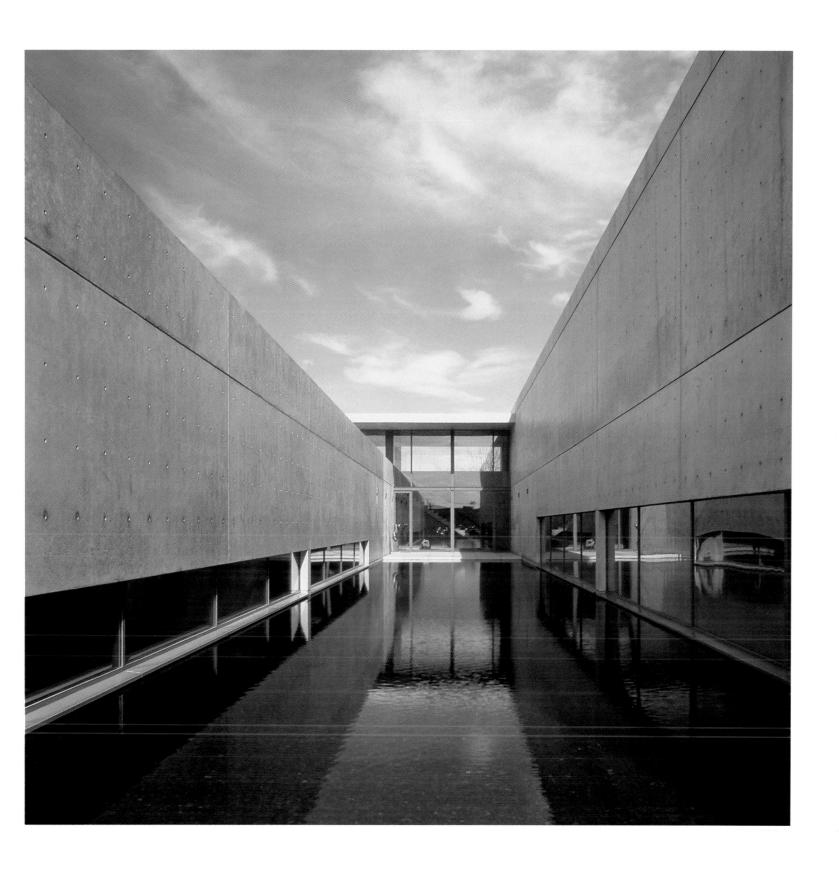

Between the two wings of the building, there is a pool that reflects the façades and acts as a mirror. Its narrow shape accentuates the sensation of length.

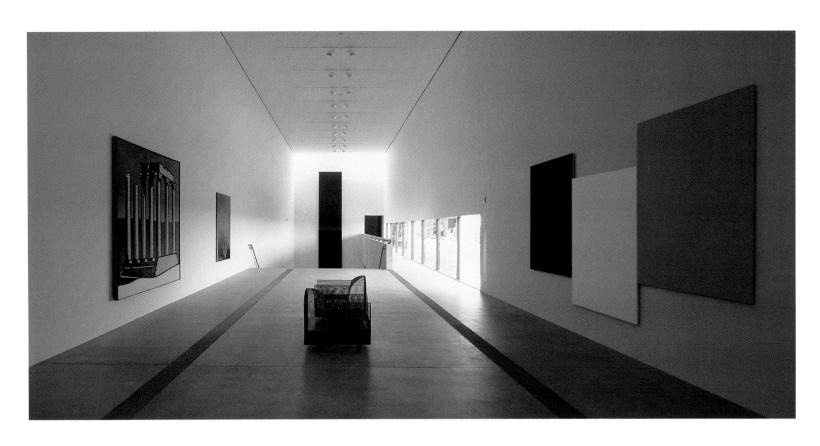

The exhibition halls are a sequence of spaces attempting to achieve the interaction between art and architecture. The natural light that flows into each room reminds us of the passage of time and the seasons.

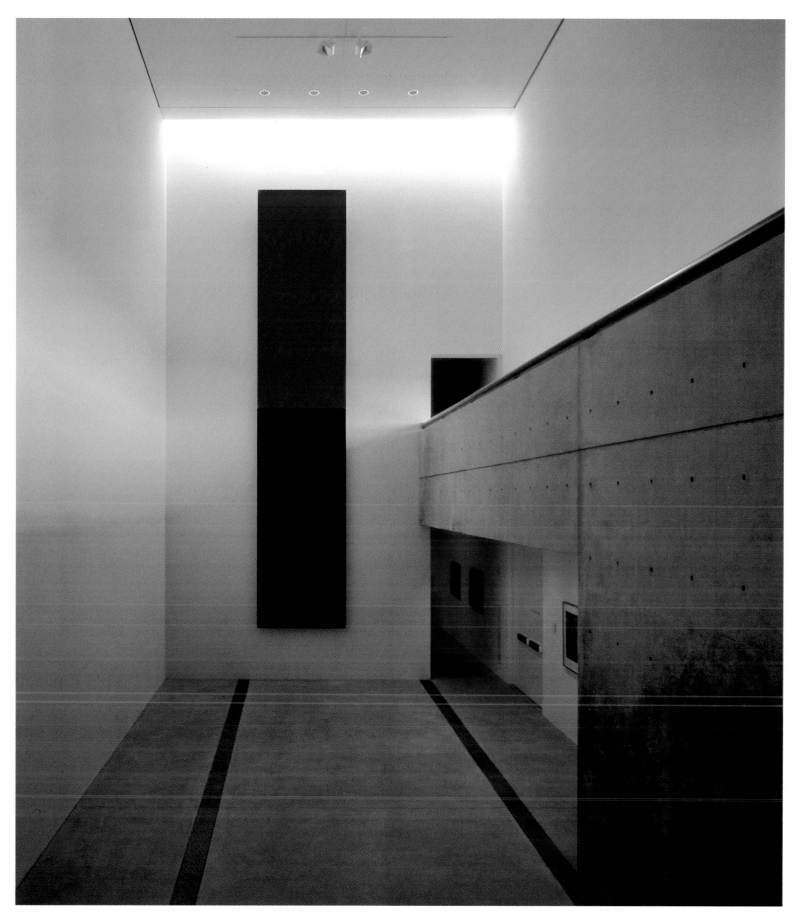

Mountain shelter

☞ **Roberto Briccola**

⊞ **Campo Vallemaggia, Sweiz-Tessin, Switzerland** | Surface area: 516.7 square feet | Date: 1998

📷 **Roberto Briccola**

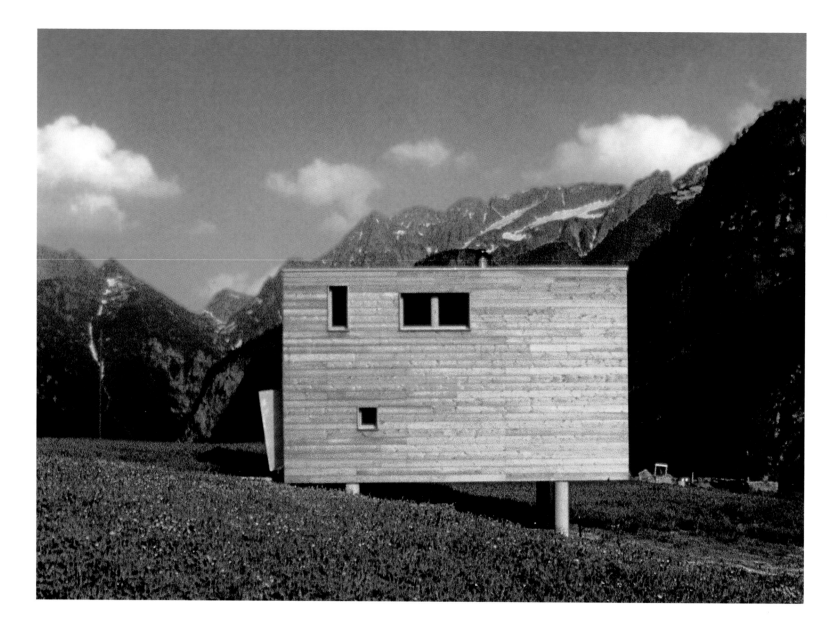

This house was built on a 6,458.5 square foot plot with a gentle slope. It is oriented toward the south and is erected on four concrete piles which minimizes the contact with the ground. It is a compact 13.1 x 31.1 square foot parallelepiped structure made entirely of pinewood. On the outside it is covered with 30 mm thick, untreated, bare planks. The flat roof is duly insulated and waterproofed. The walls are also insulated, and the structure is on the inside. The interior wall covering on both floors consists of thick, three-layer plywood.

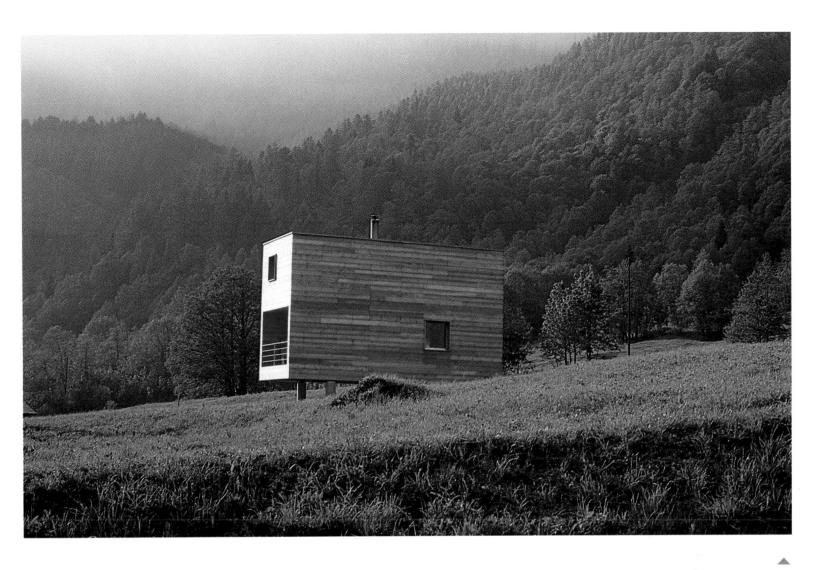

The structure of the house is maintained level since it is built on concrete piles of different heights, which compensate for the slope in the terrain.

The layout of the ground floor is reminiscent of a ship: a kitchen, a dining room, a hearth, and a lounge. This sequence of spaces is finished off with a loggia.

On the top floor, there are two bedrooms and a bathroom. The sliding doors on the children's bedroom allow it to be set off or integrated into the corridor. The entire length of the east wall is outfitted with closets. Thus, this compact 516.7 square foot house is functional and has a simple and fluid spatial relationship.

The kitchen on the western side was designed with the same concepts in mind, and so it affords an ample work area. The small openings are intelligently situated so as to afford the best views of the landscape, whereas the loggia and the large window offer a beautifully framed panorama.

Since the parking area is separated 65.6 feet from the house, the purity of the volume is highlighted. The serenity of the location is accentuated by the fact that the windows open in such a way that you cannot see the neighboring houses.

The bedroom floor is almost monastic and is free of all superfluous details. The beds are built-in like closets. The entire east wall is furnished with closets, which augments the insulation of the wall.

In the dining room, there is a long table like a bed, which was designed in conjunction with the only square opening on the east façade.

The pinewood structure is covered with untreated wooden planks, which are 30 mm thick.

The location of the windows were planned so as to obtain the best views of the countryside from each room. The nonuniformity of the openings in the walls gives the house a sculptural character.

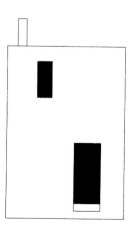

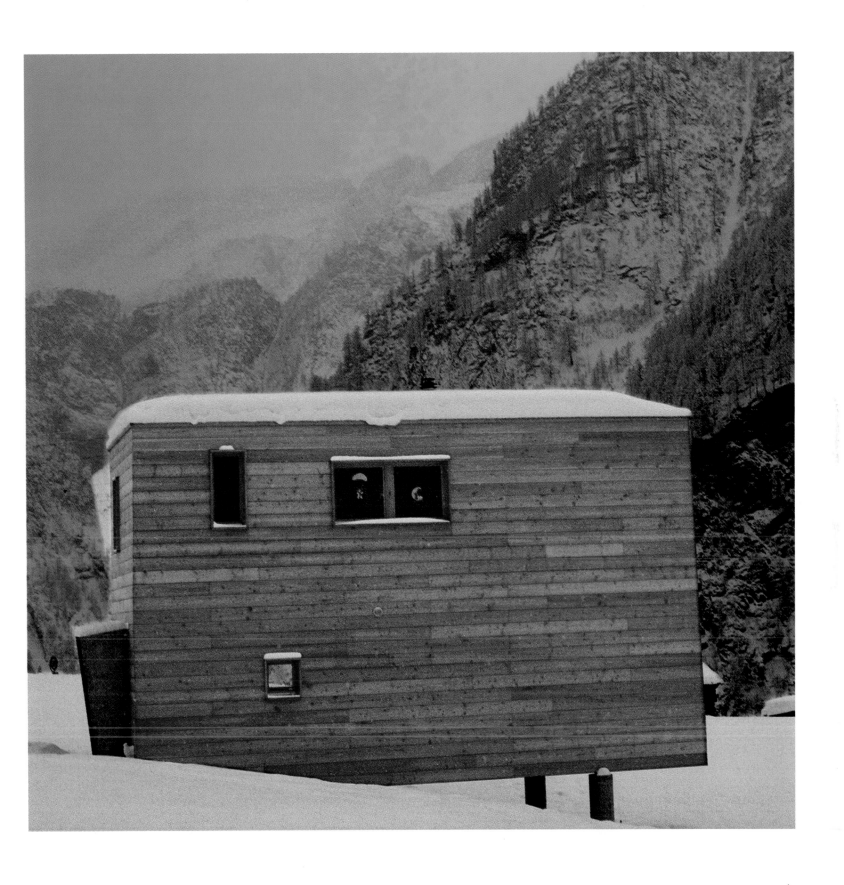

The house is well sealed and protected against the elements due to the fact that it must be able to bear periods of cold weather.

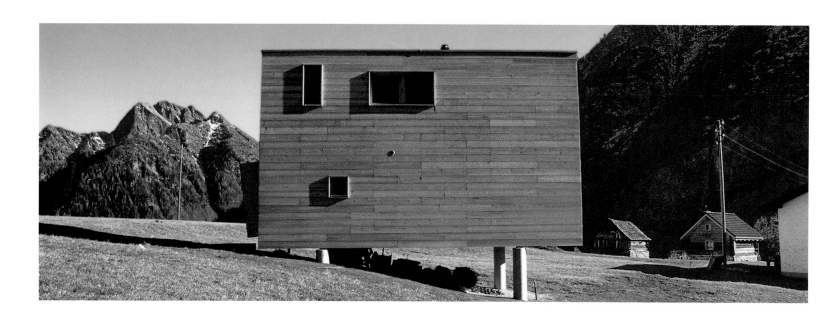

The feeling of isolation and direct contact with nature is well designed. From the windows of the house you cannot see any neighboring houses.

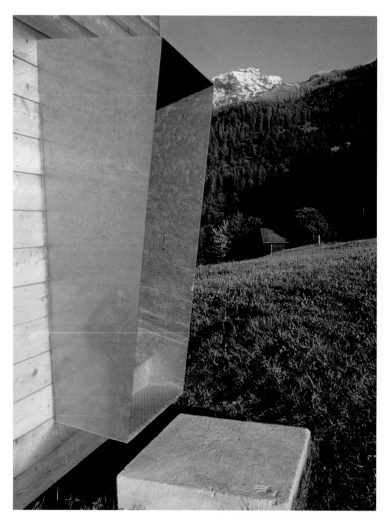

The entrance to the house sticks out from the structure and is separated from the ground. A small block on the terrain acts as a step which allows you to access and enter the dwelling.

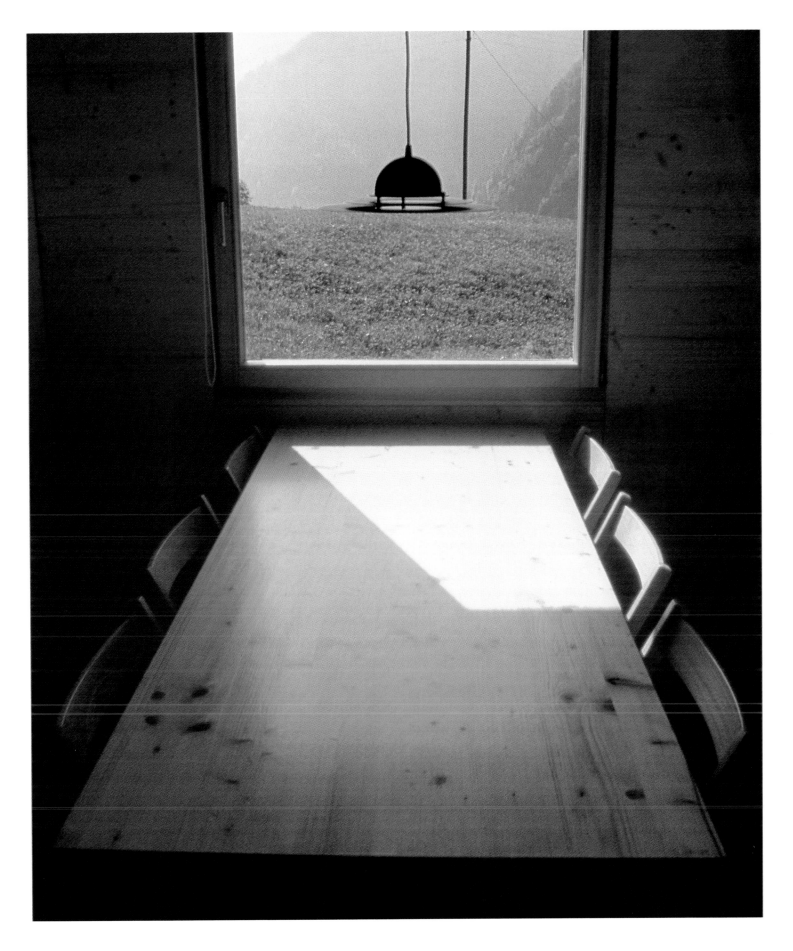

Lecture Hall Block 3, University of Alicante

⌖ **Javier García-Solera** | Collaborators: Déborah Domingo, architect; Marcos Gallud, quantity surveyor; Domingo Sepulcre, structure

▓ **University Campus of San Vicente del Raspeig. Alicante, Spain** | Date: 2000

📷 **Duccio Malagamba**

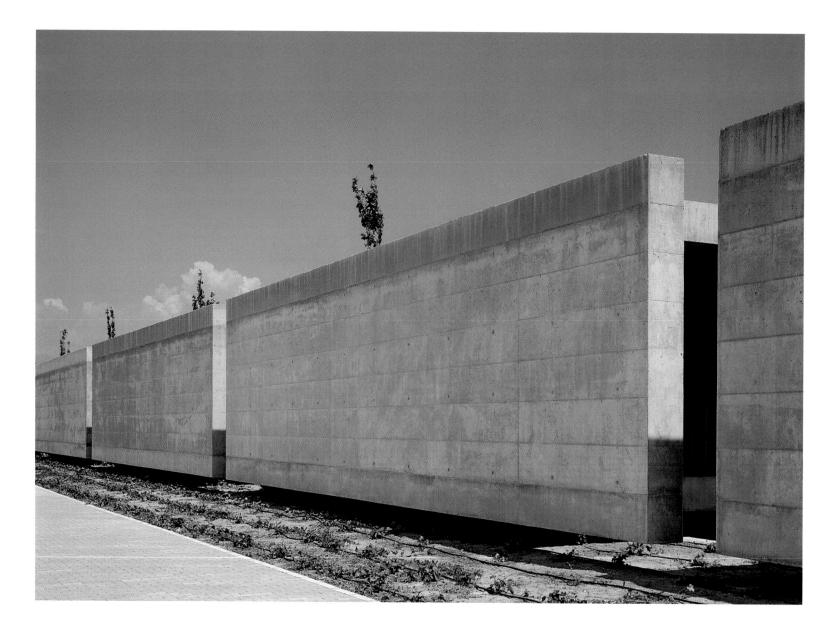

Lecture Hall Block 3 was built on an outlying plot on the southeast end of the University of Alicante campus. The rest of the lecture halls are situated within the university's ring-road on open plots in a green, tree-filled area. They are enmeshed in a vast network of pedestrian walkways, which guarantees peace, silence, and adequate isolation. The plot for Lecture Hall Block 3 was isolated from the rest of the campus and surrounded by a heavily traveled road and large parking areas for the beach. Therefore, there was a need to provide the building with the same things afforded the rest of the lecture halls: park environment, exterior space, air, light, and an atmosphere proper to its intended use.

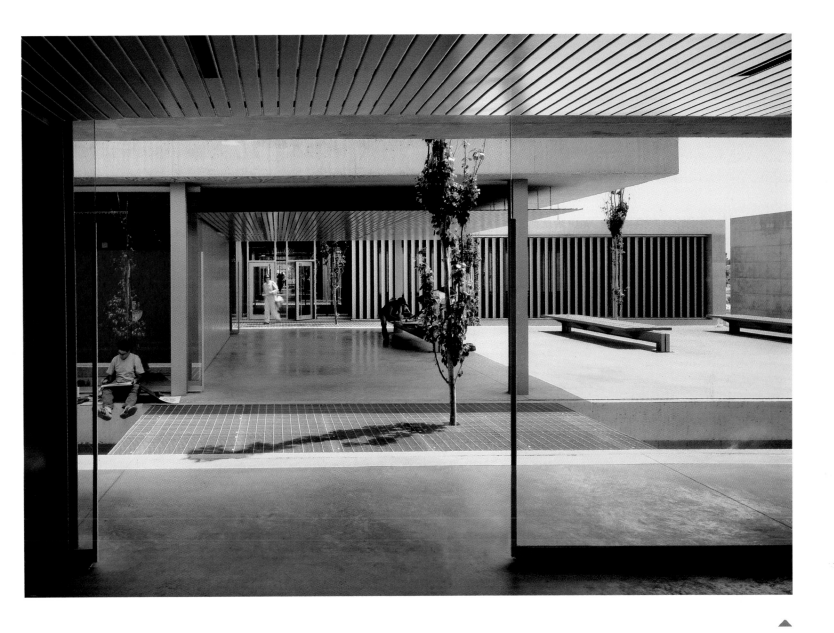

Its location on the edge of the campus ensured the presence of an expansive green zone.

They took advantage of a series of preexisting piles. The structural scheme frees it from a network of supports and allows the shape to be laid out with greater freedom. The structure of walls and slabs opens out from north to south and onto itself in complete transparency. At the same time, it affords sufficient pollution protection coming from the parking areas and the road.

The concept of the project is that of a vast tree-filled extension interspersed with seven buildings that float over the terrain. This affords an architecture that envelops and accompanies while not over-dominating. It is an architecture where interior–exterior is a continuum and which urgently needs the addition of human life in order to be fully realized in order to have a purpose.

The design, assembly, and construction had to be clear and easy due to the short project time (a month and a half) and construction time (six months).

Text: Javier García-Solera, architect.

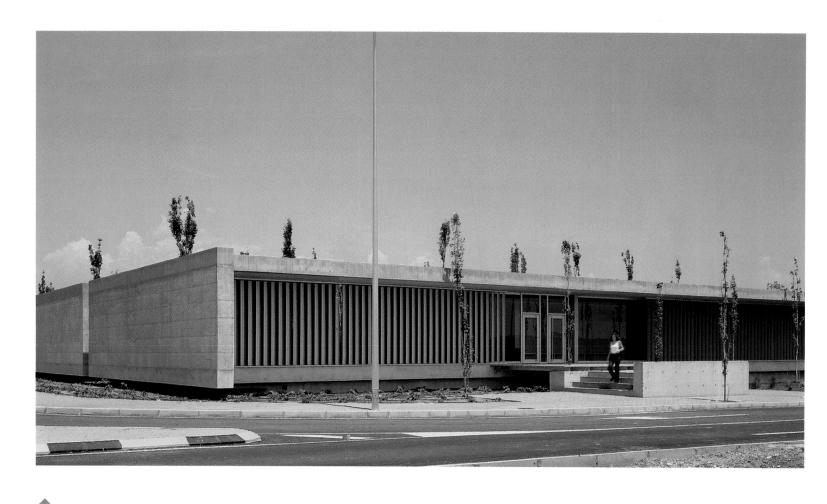

▲

The complex is organized around seven buildings that function independently from the other classroom buildings.

The initial layout of a large green area in which the buildings are interspersed makes for different-sized delimited zones.

▼

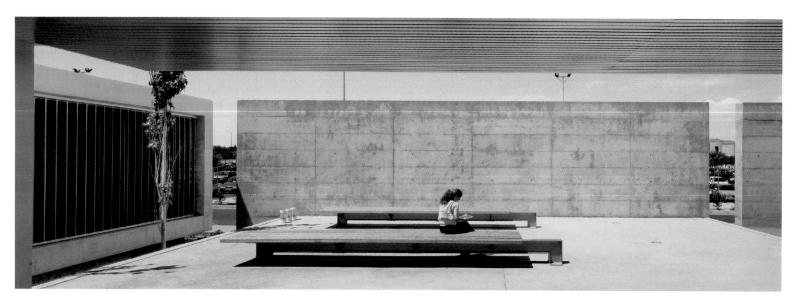

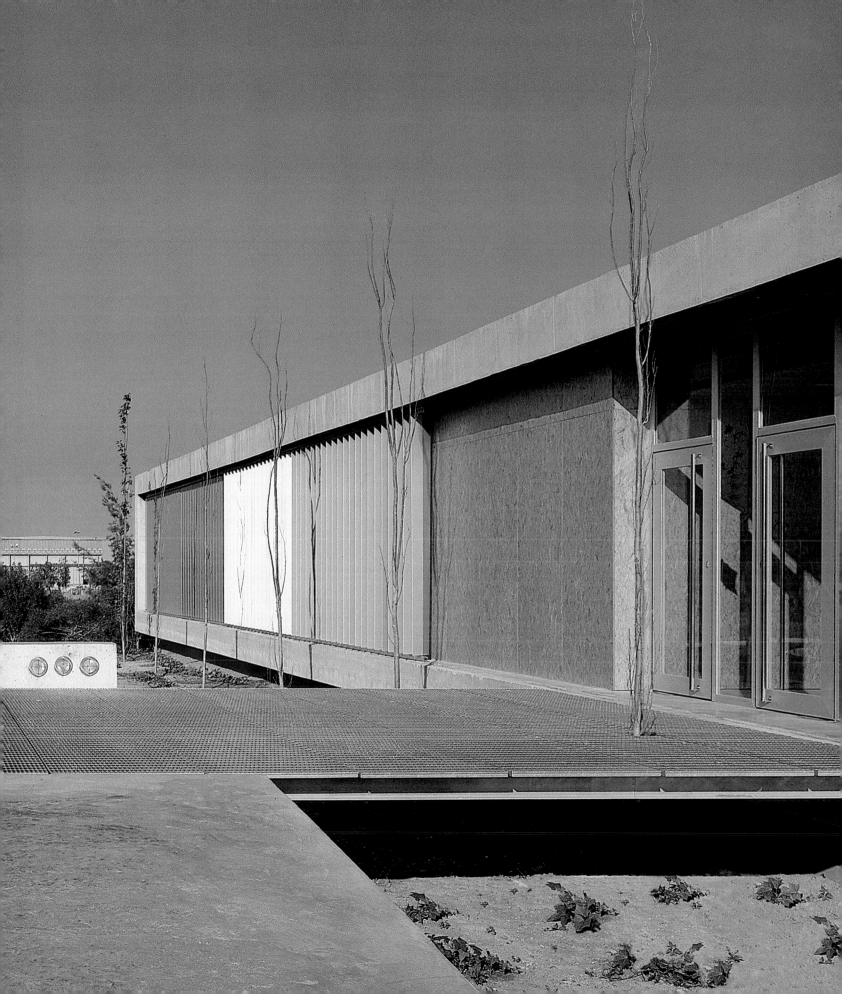

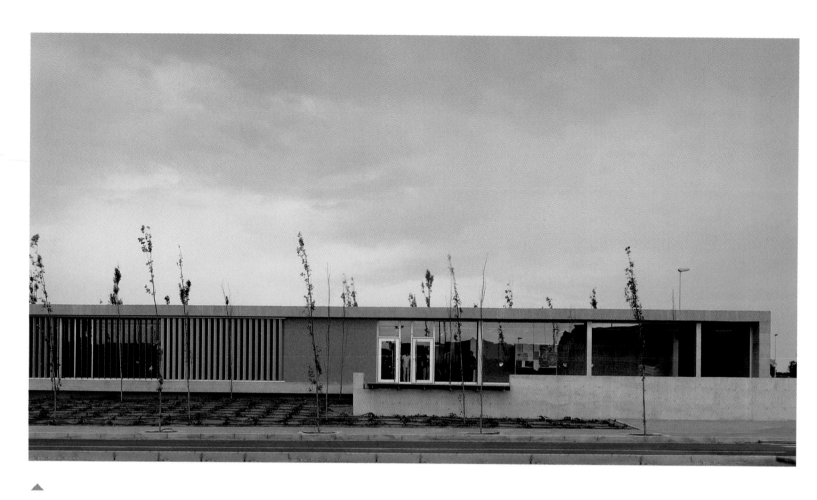

The structural system is based on the group of existing piles, which allows for greater spatial and formal freedom.

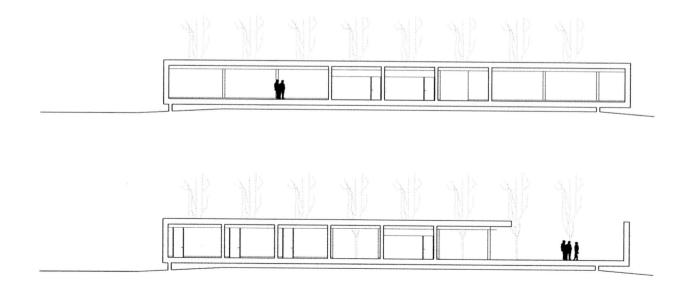

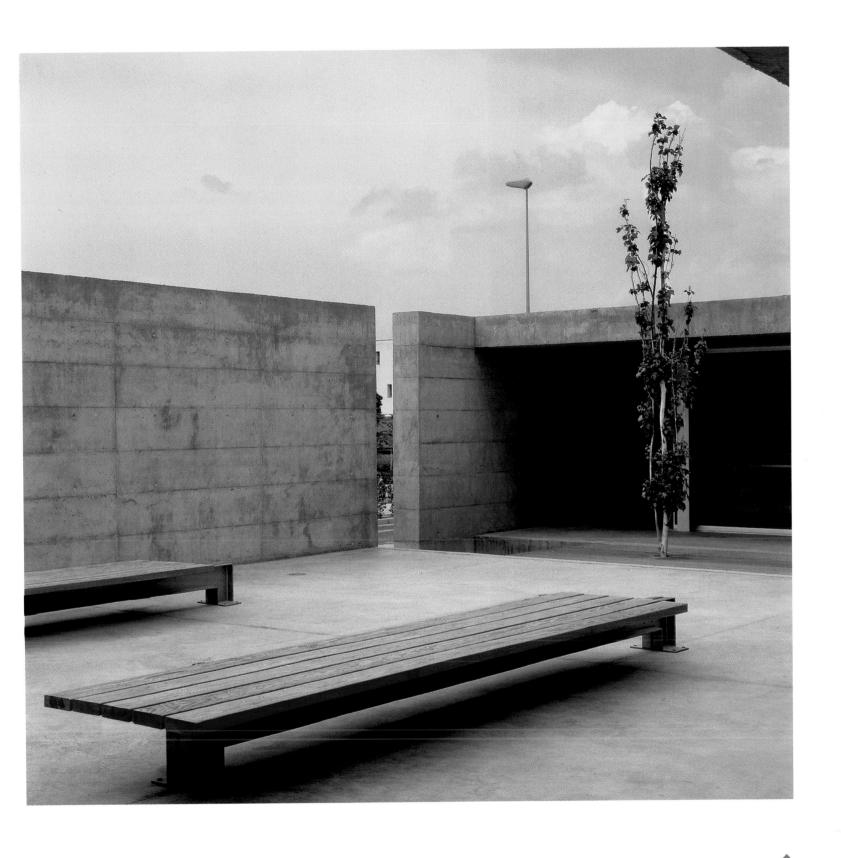

The set of walls and "floating" slabs produce an intimate space in the classrooms. In this way, the project takes on its own exterior space.

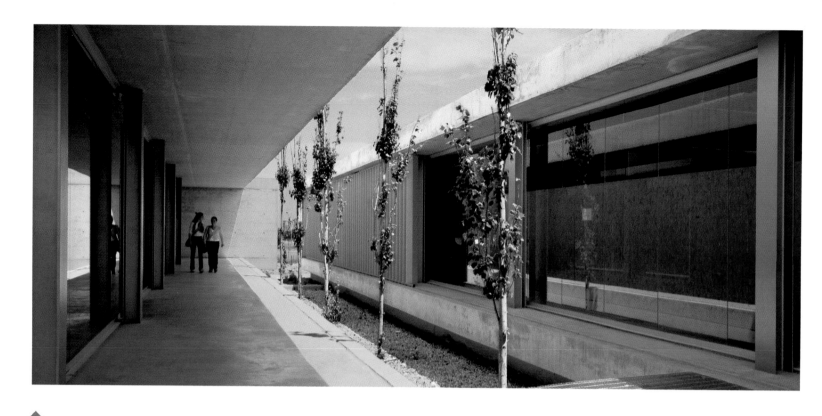

The exterior places delimited by the project have multiple functions that range from green zones to patios, which provide light and ventilation for the classrooms.

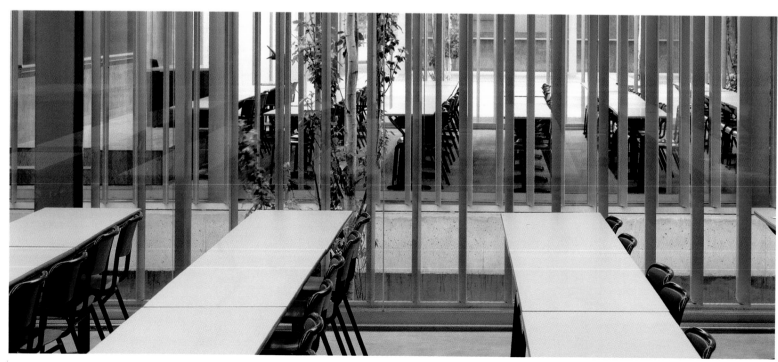

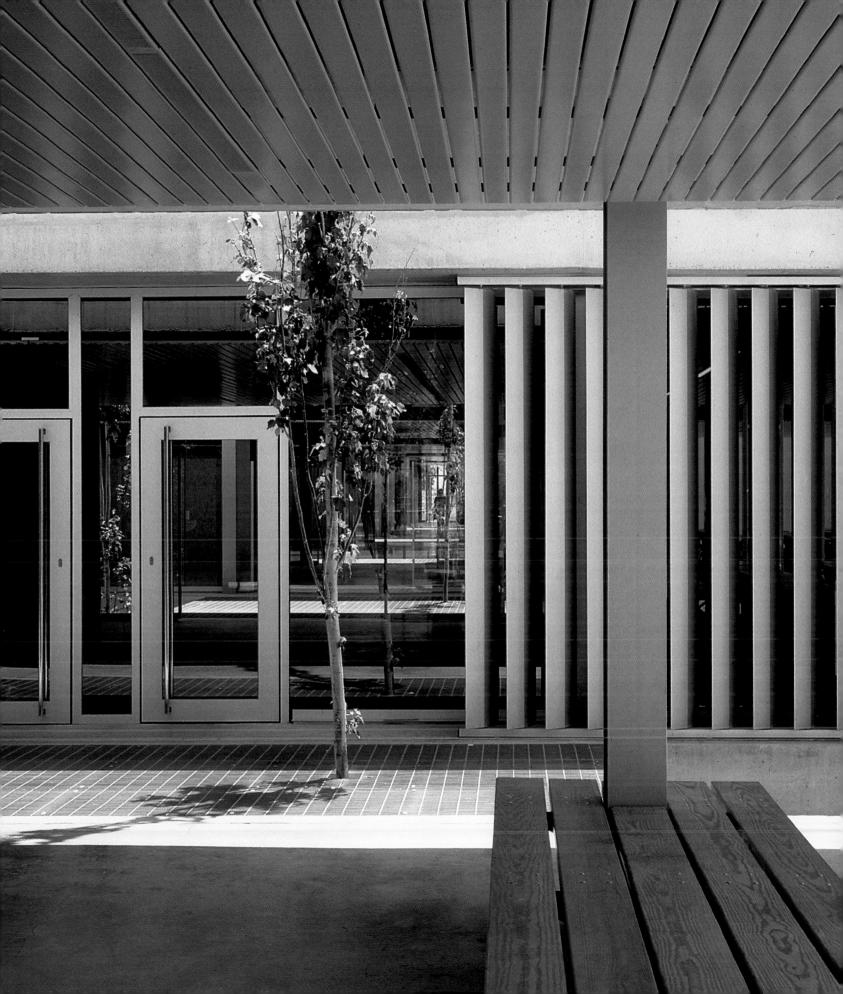

House in Pura

➣ **Sabina Snozzi Groisman, Gustavo Groisman** | Collaborator Raffaele Cammarata

▦ **Mistorni Street, Pura, Ticino Canton, Switzerland** | Surface area: 2,680.3 square feet | Date: 1996

📷 **Filippo Simonetti**

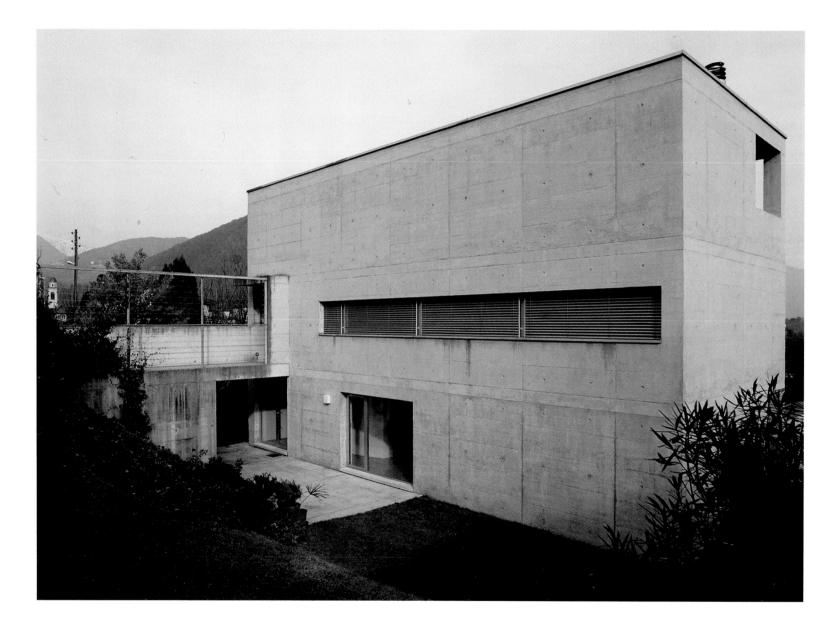

The terrain has a slight slope. A series of terraces begin at the upper part and become less pronounced at the bottom, which is flatter. It is situated between two streets, one at the upper part and one at the lower part. In contrast to the slope, there is a large, elongated, flat, horizontal area at the bottom. The project includes a small square at the top part, which affords access to the house. From here, delimited by a contention wall and a pergola, you cross a bridge that leads to the entrance of the house, which is on the first floor.

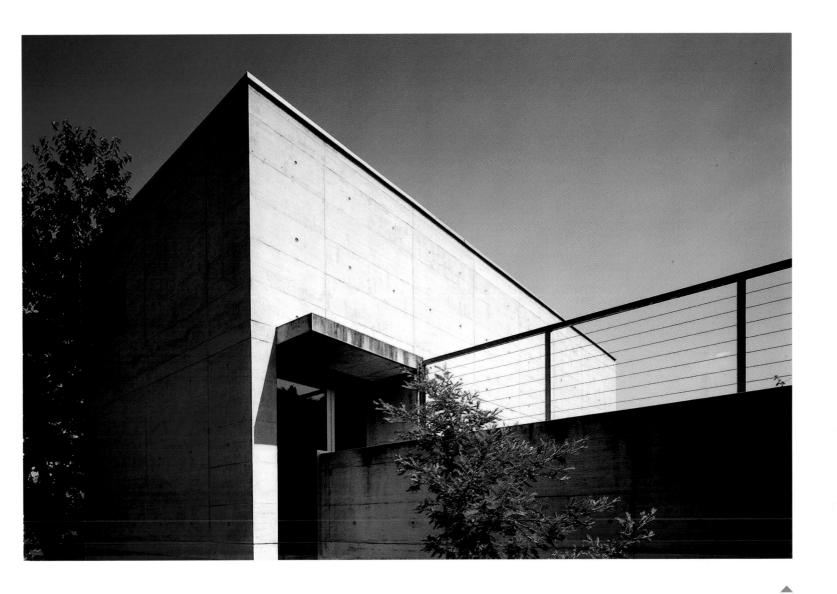

A bridge serves as an access to the house by connecting the street of the upper part to the vestibule situated on the first floor.

This is the circulation hub for the house. From here, a hall leads to the children's room and their studio. A staircase goes up to the parents' area on the third floor. Another starts from a low-ceiling opening and goes down to the common areas on the lower floor. It is a split-level with two very differentiated zones: in one, the living room and the kitchen, which are higher, in the other, the dining room. The dining room opens onto the main garden on the east side through the portico. Here there is the contention wall of a long swimming pool, which ends in a belvedere. This marks the end point of the construction and the start of the terracing.

There is an absence of town planning in the neighborhood where this is inserted. Consequently, the architects decided to give prominence to the peculiarities of the terrain and the surroundings.

This is manifested in the path through the house, which initiates high up in the plaza and finishes in the belvedere at the end of the pool.

The project is made up of three pieces: the house which is a very simple, straight parallelepiped with few apertures; an access bridge; and a large elongated swimming pool, which defies the slope of the terrain.

The box, which makes up the dwelling, consists of three floors and a basement. The circulation is strategically laid out and well-defined. On the first floor where the children's bedrooms are, a long hall was avoided by converting part of it into a lounge area. They designed a long writing table and an accompanying window.

 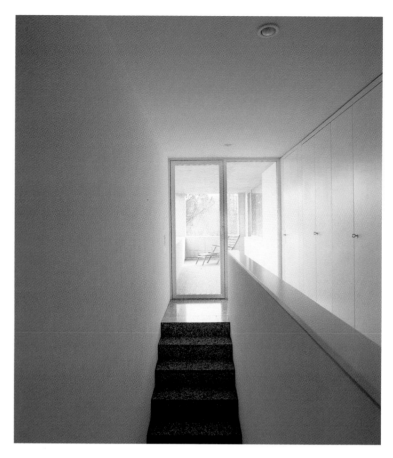

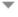

The vestibule serves as the circulation hub of the house by connecting the three floors.

In this perspective, you can observe the slope of the terrain, which is resolved by terracing.

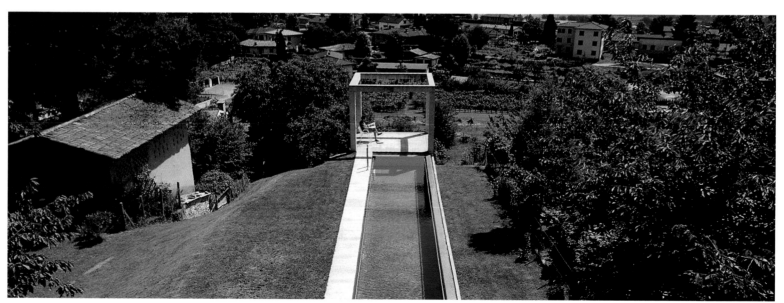

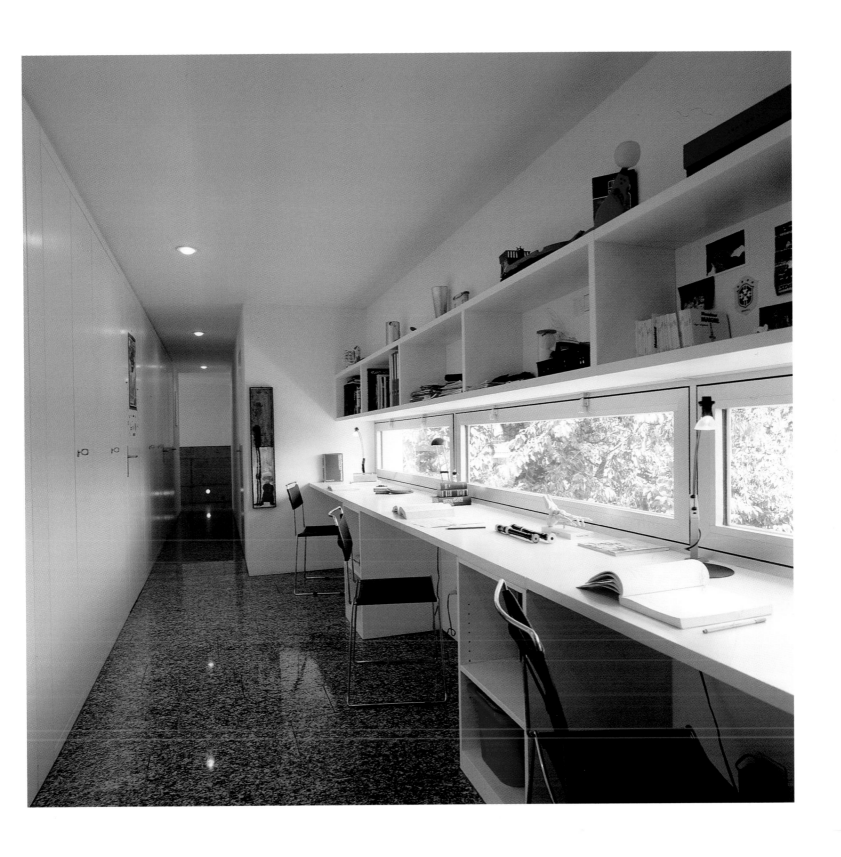

From the vestibule, a hall takes us to the children's studio. Its length is put to good use, as a long desk is installed under the window.

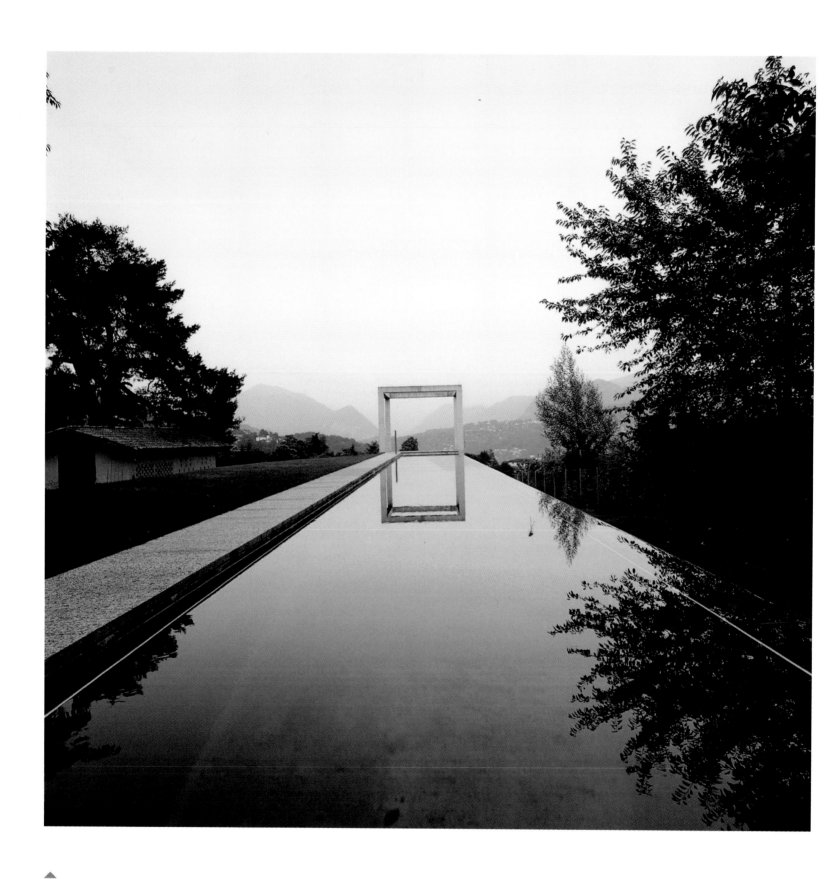

The architects decided to accentuate the dialogue with the peculiarities of the terrain through the path that unites the three pieces.

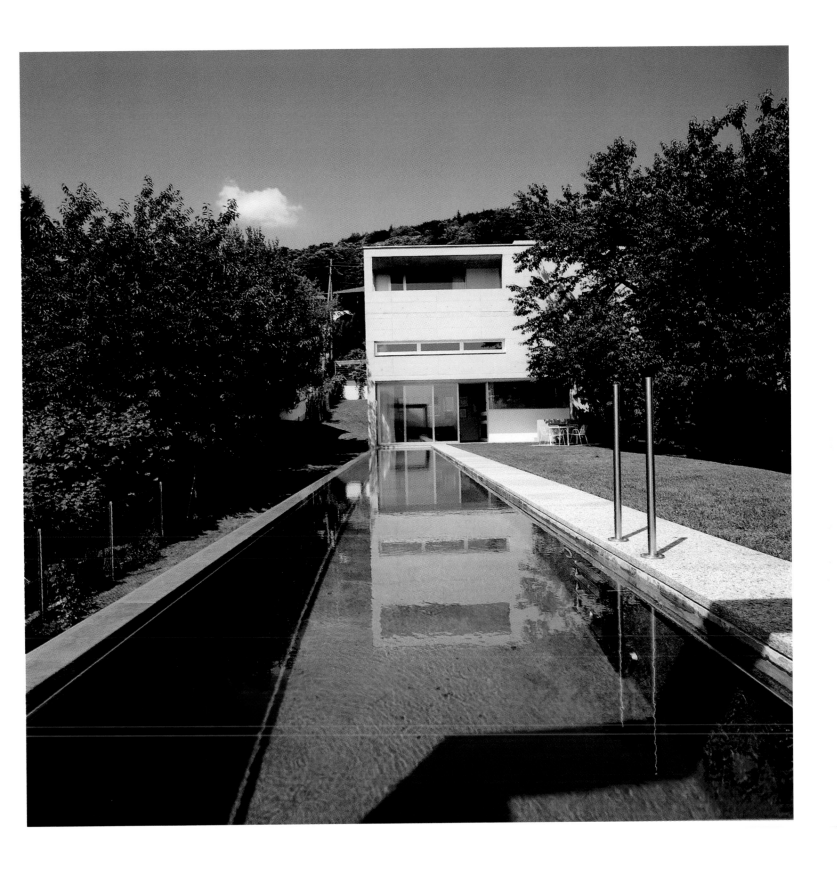

Jetty in Alicante Port

☞ **Javier García-Solera** | Collaborators: Déborah Domingo, architect; Marcos Gallud, quantity surveyor; Domingo Sepulcre, structure

▦ **Alicante, España** | Date: 2000

📷 **Duccio Malagamba**

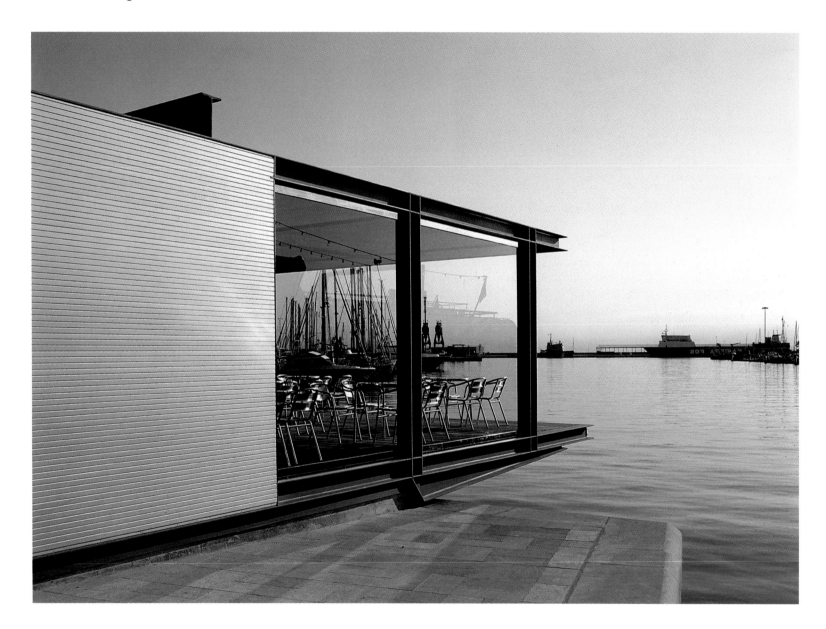

The commission consisted of a wharf for local service passengers and, on top of it, a building to house a kiosk and a shaded waiting area. It afforded a splendid opportunity to explore two opposite types of marine construction: the execution of a dock and its platform using civil engineering techniques, and a small-scale construction using the high-quality materials and precision like that of the best naval architecture. At first, the construction entailed masses of concrete and stone, earth moving, and underwater anchoring. Later, there was the above-water construction, as if it were a ship in a dry dock, using wood, metal, screwing, interlocking, and so on, in order to assemble it.

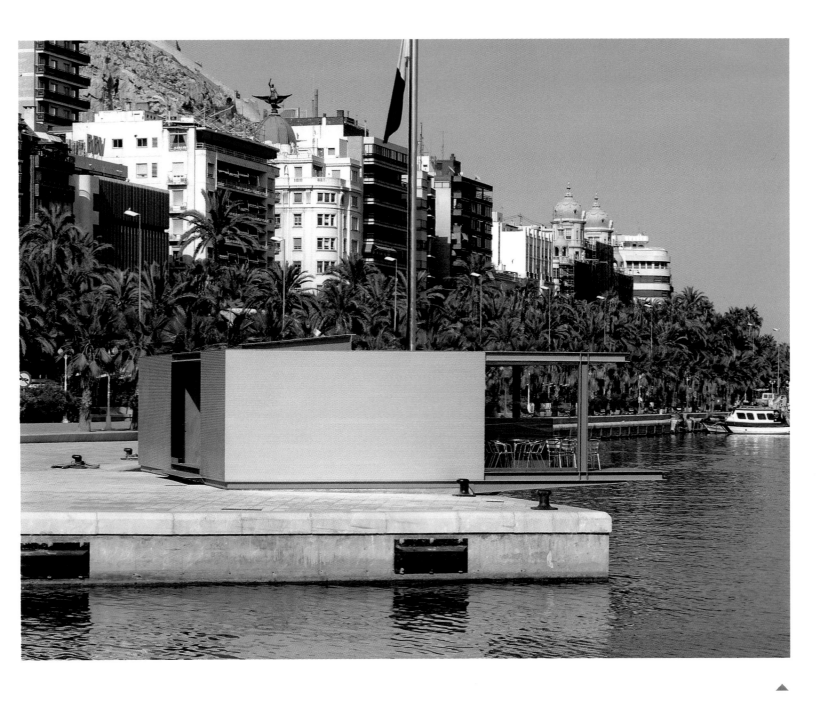

The project, which includes the wharf and the building, is the new starting point for commuter travelers.

The proposal was for an asymmetrical wharf, orientated in a particular direction, where the boats would not obstruct the view from the building.

Like in all port architecture, the height is kept to a minimum, and a horizontal aesthetic is sought. Nevertheless, its verticality greets those who arrive in the city and competes with the masts of the sailboats that populate the inner harbor.

They sought an ambiguous connection with the sea. The metal projection, the absence of railings, lightness, the lack of exterior–interior and land–sea definition provided all of this.

Texto: Javier García-Solera, architect

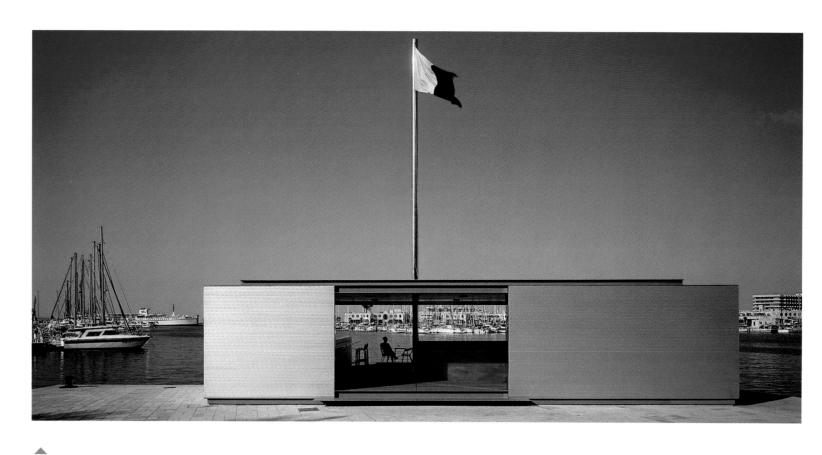

In order to maintain the characteristic appearance of port buildings, which is a "horizontal line," the small building has elongated proportions.

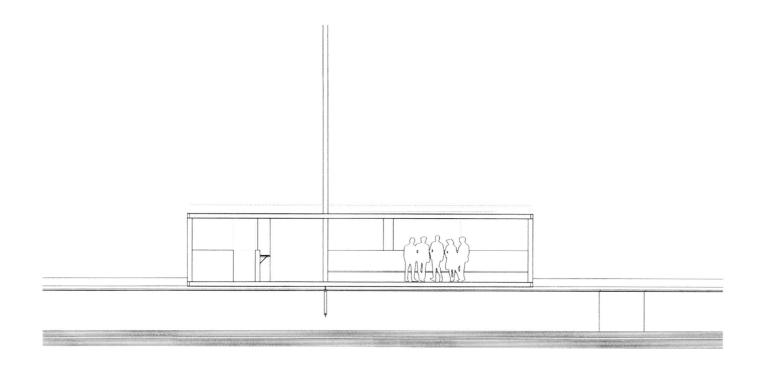

The construction system permits the execution of the project in such a way that all of the pieces of the building are easily assembled and screwed together.

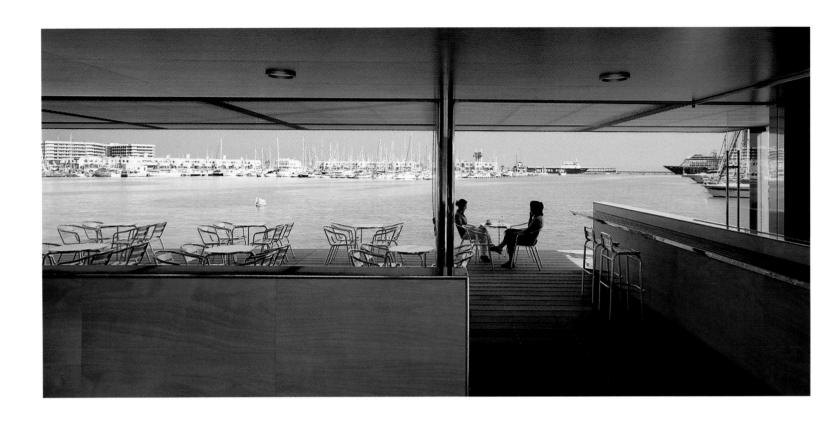

The wharf is built in an asymmetrical way so that the views from the building are afforded a specific direction.

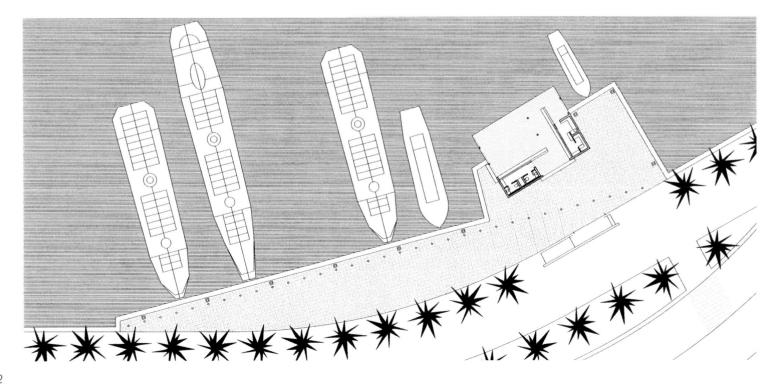

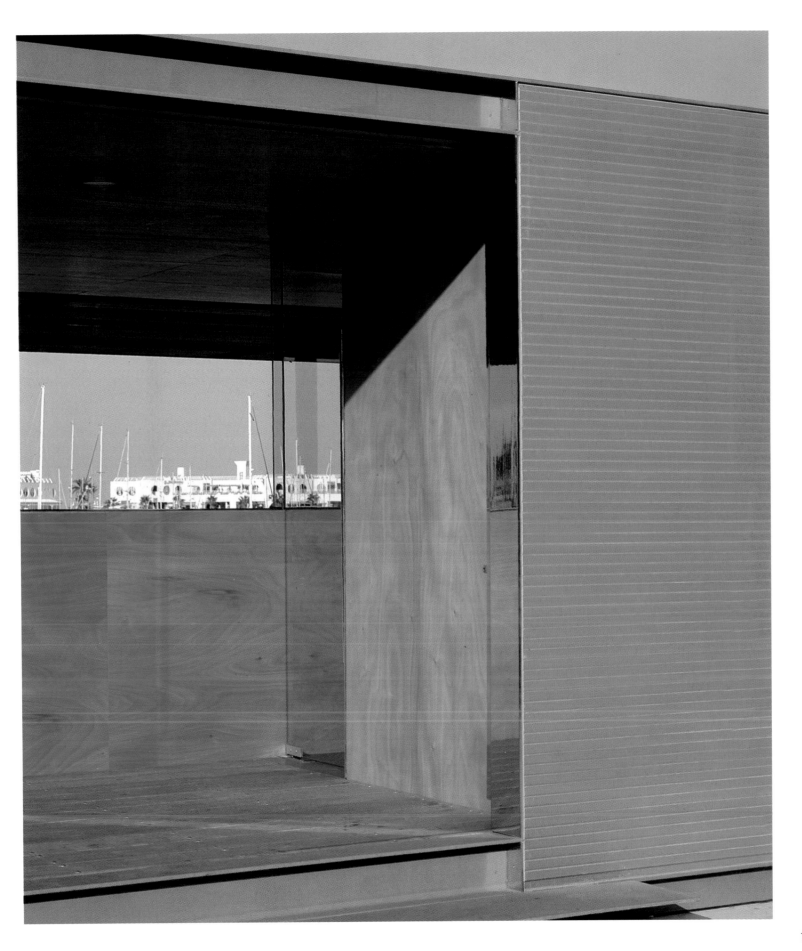

Fire station and cultural center

⌦ **cukrowicz.nachbaur architektur, Siegfried Waeger** | Collaborators: Matthias Hein, Markus Cukrowicz

▦ **Hittisau, Vorarlberg, Austria** | Surface area: 21,528.5 square feet | Date: 2000

📷 **Hanspeter Schiess**

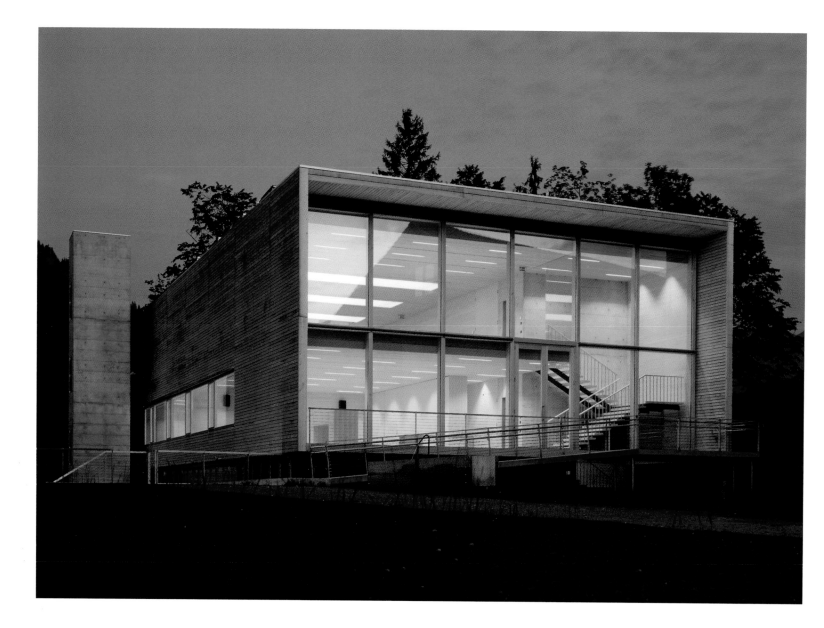

Something so unusual as the combination of these two functions in the same project does in fact make sense in this small Austrian community. The building fulfills the expectations of the town. The unusual concepts are perfectly adapted to the location, the materials, and the type of construction. It was designed according to the needs of the community. The new fire station and cultural center are located at the edge of what was once a pebble quarry, near the center of the town. The architecture reflects the polarity of the two uses, which are differentiated by the materials used in each zone.

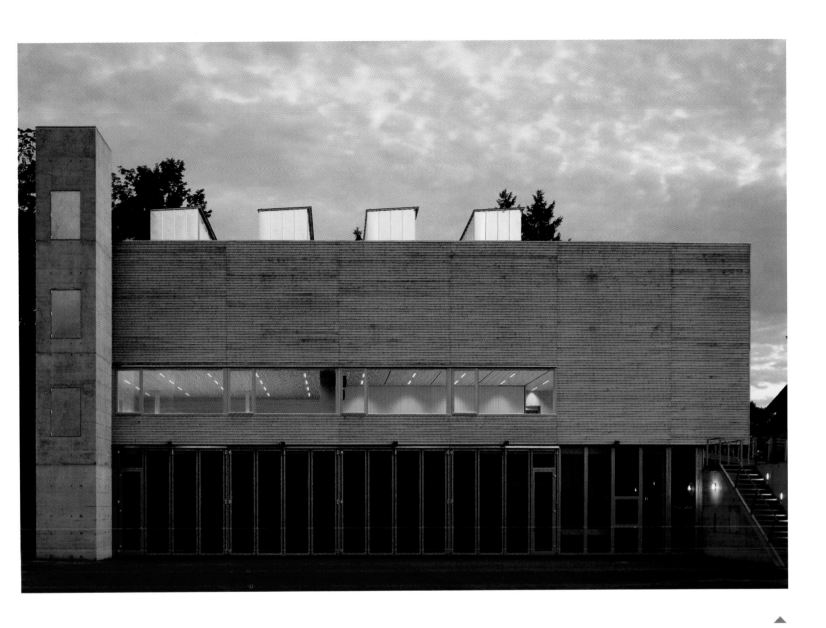

The single-body structure differentiates the various activities inside by means of subtle variations in the facades.

The part that houses the fire station consists of a basement made of concrete and glass, which is built into the slope. On top of it, a wooden box is erected, which is the hierarchical body of the project. One of the façades opens out, in a simple and radical way, through a large window and affords a view of the center of the town. The two parts are conceptually differentiated by the materials and by the way in which they are positioned in the terrain.

Technologically, the fire station is expressed with reinforced concrete, metal, and glass. The cultural center, on the other hand, is designed entirely of wood. The structural elements are contemporary, although their reinterpretation is based on local traditions. For the first time, a public building of this size was made of fir wood. The floor, wall and ceiling surfaces, and the stairs are made of this material. The different types of lighting—by means of the large sliding window, well-placed windows, and skylights—and the materials employed in the interior surfaces attempt to reflect the atmosphere of the old wooden buildings that were built in this area.

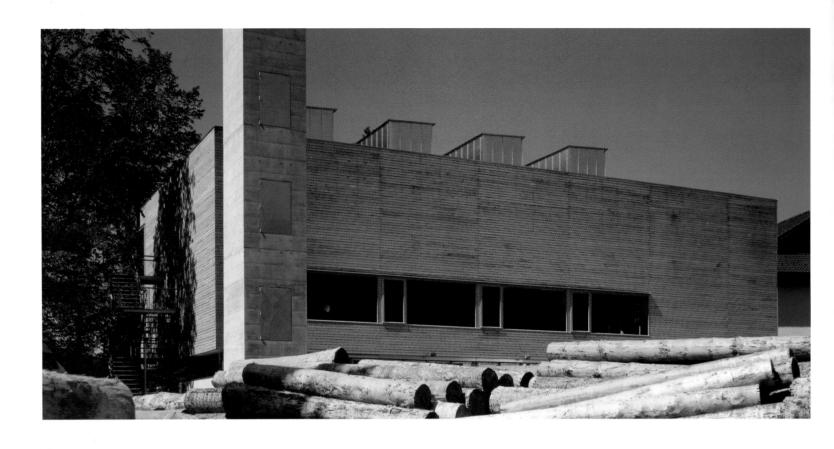

A wooden structure rises up from a concrete socle. This formal division corresponds to the differentiation of uses: the firehouse and the culture center.

The treatment of light in the interior spaces tries to recreate the treatment of light in the old, wooden buildings built in this area.

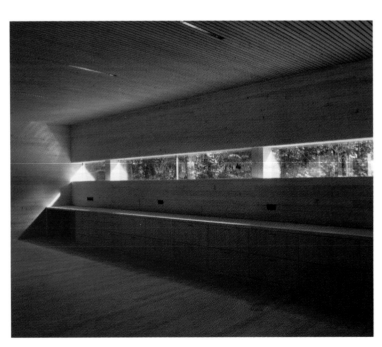

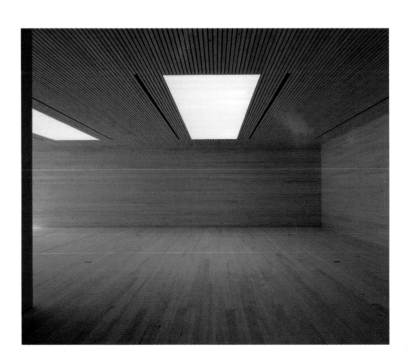

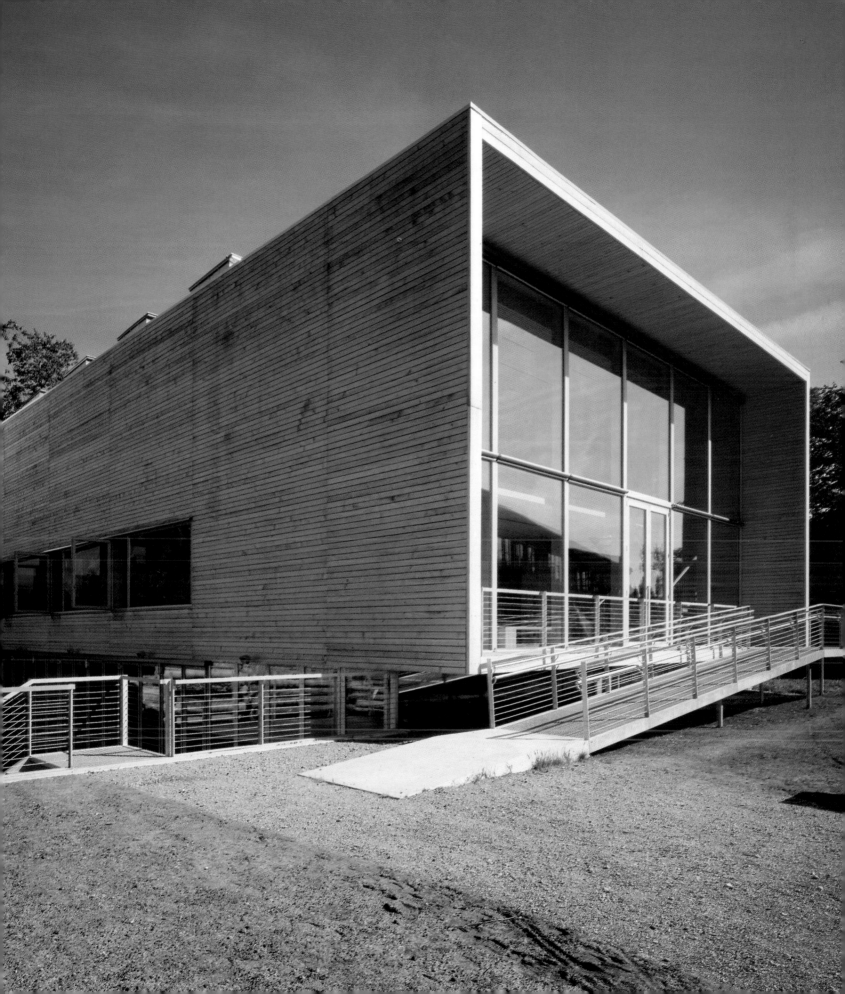

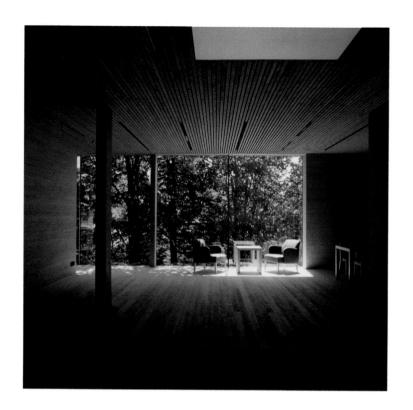

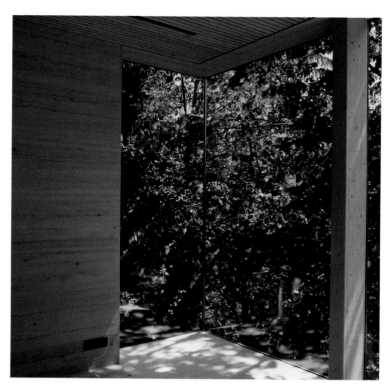

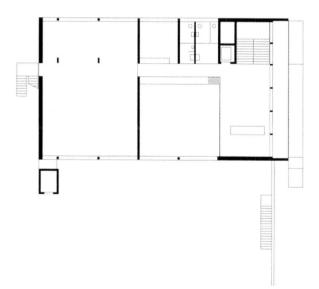

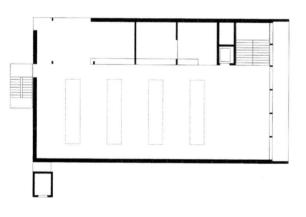

The peculiarity of the program is resolved in a single geometry in the floor plan, although there is a clear spatial division.

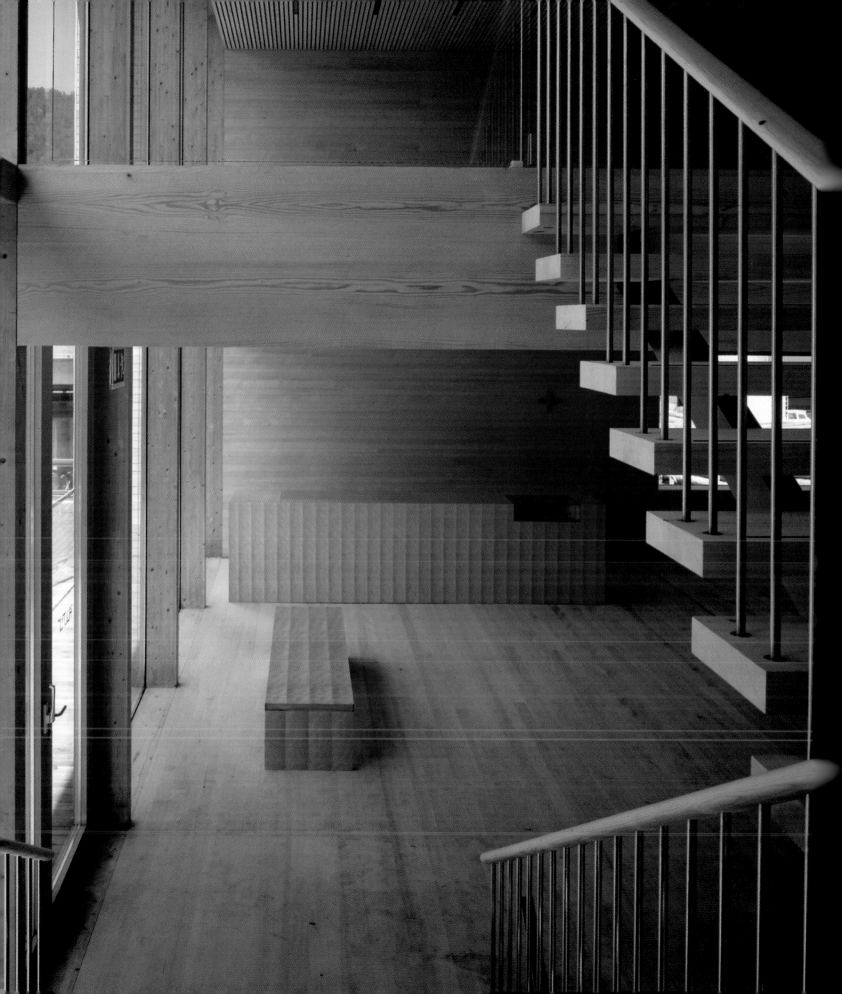

The differentiation of uses is clearly expressed in the section: The socle that fits into the slope has the firehouse.

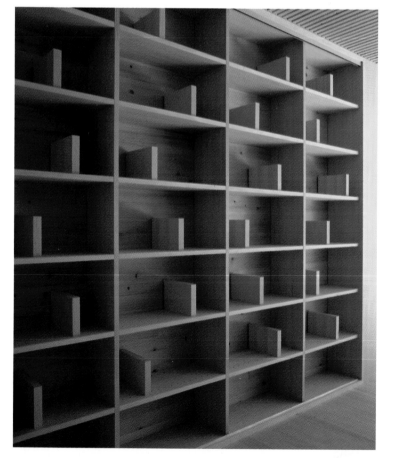

The use of wood affords great spatial warmth to the cultural center. The construction is entirely of fir wood.

The basement of the building is a broad, diaphanous space, ideal for use as a firehouse.

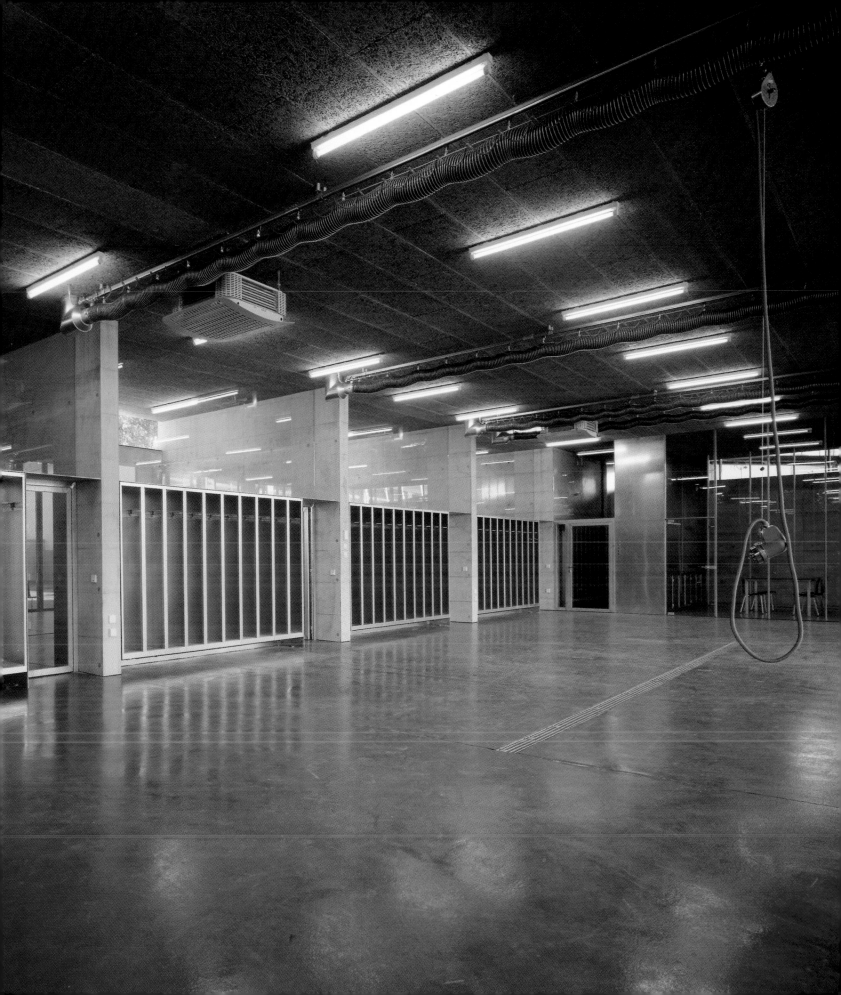

Valencia Museum
of Illustration and Modernity

Guillermo Vázquez Consuegra | Collaborators: Pedro Diaz, Iñigo Casero, Lola Reyes, Marcos Vázquez Consuegra, Pedro Caro y Sara Costa

Quevedo Street and Guillén de Castro Street, Valencia, Spain | Surface area: 86,114 square feet | Date: 2001

Duccio Malagamba

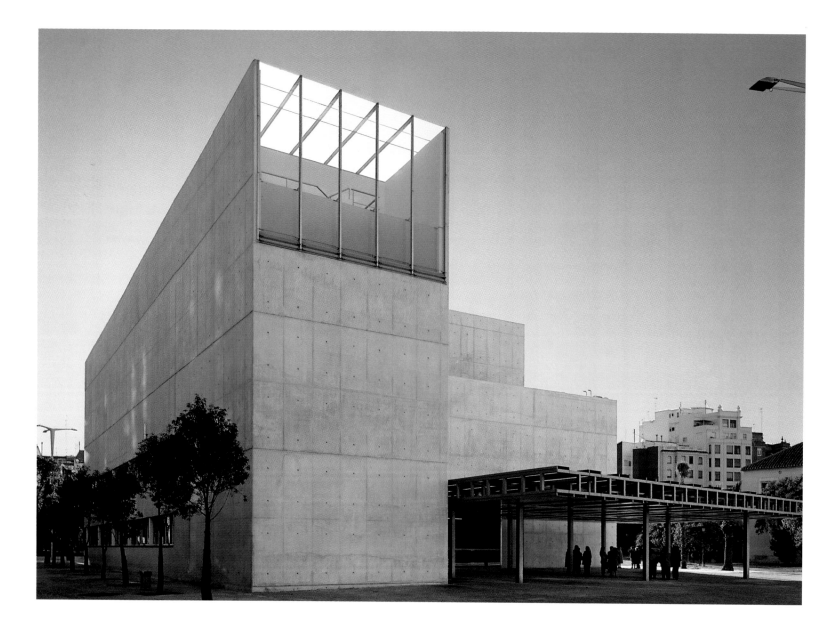

Regarding the items on exhibit, the Museum of Illustration sets itself apart from other museums, since it is not so much a museum of objects but rather a museum of ideas. The route through the museum is a path through scenes and spaces that are, above all, important for their literary, musical, and cinematographic references. During the development of the project, the initial plan was substantially modified, and the museum was not commissioned until 1997. The premises of the project indicated a plot with an angular and disjointed geometry with which the façades of the edifice would have to coincide.

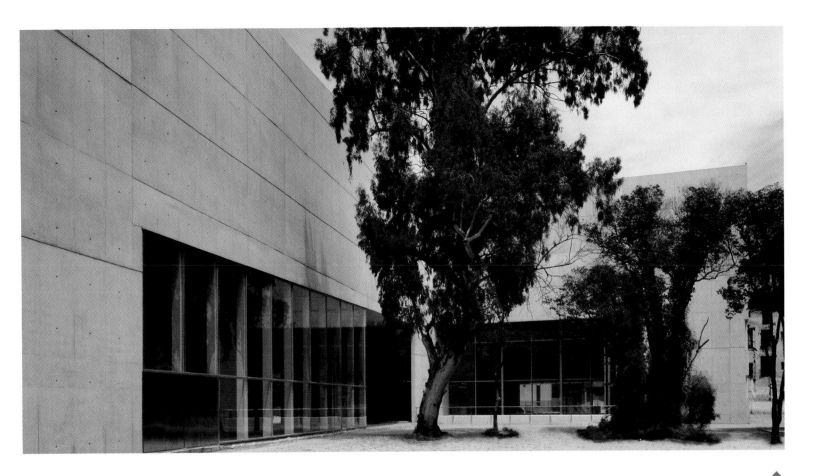

The wooded surroundings are visible from the vestibule of the museum. This is an example of the architects' wish to establish a flowing relationship between the building and its surroundings.

Maybe the shape and the volumetry of the museum were determined by the dictates of urban planning. Or maybe it was the path that the visitors take as they gently descend down ramps through numerous exhibition halls, which is what truly ended up dictating the organization of the interior space. The proposal was for a flexible, fluid architecture that was able to question the conditions of the place and that was capable of integrating all of the conflicting forces. But all of this, without the formal arrangement of the project, is a reflection of this conflict.

The building affords a unitarian and compact image in contrast to the fragmented concept evoked by the proposal and the approach to it. The general layout consists of two elongated volumes that are almost parallel to each other. The first, which is longer and more angular, houses the series of exhibition halls for the museum's permanent exhibitions. The second volume is basically space reserved for the museum's internal functions. The two buildings are connected by a zone in the middle, which includes a general lobby for the museum. It is an expansive space that is in consonance with the public–institutional character of the building, and it is open to the luxuriant green of the surrounding garden.

In spite of the urban planning requirements and demands, the museum attempts to satisfactorily resolve the relationship between the building and the setting.

The main entrance is situated under the building, which meant opening up the largest structure, in order to afford easy communication with the two garden areas. This is proof of the architects' interest in granting the project a certain urban character, a kind of manifestation of the urban quality of the architecture. This building–landscape partnership allows a fluid and permeable relationship with the tree-filled setting, and at the same time, becomes a backdrop for the view of the gardens from the hospital.

In summary, it is a building that lies somewhere between two poles. At one extreme, it is an object lost in its own self-indulgence, an isolated artifact, a pavilion in a park conditioned by what it is meant to be used for; and at the other extreme, the desire to take on an active role in the shaping of its urban environment.

Text: Guillermo Vázquez Consuegra, architect.

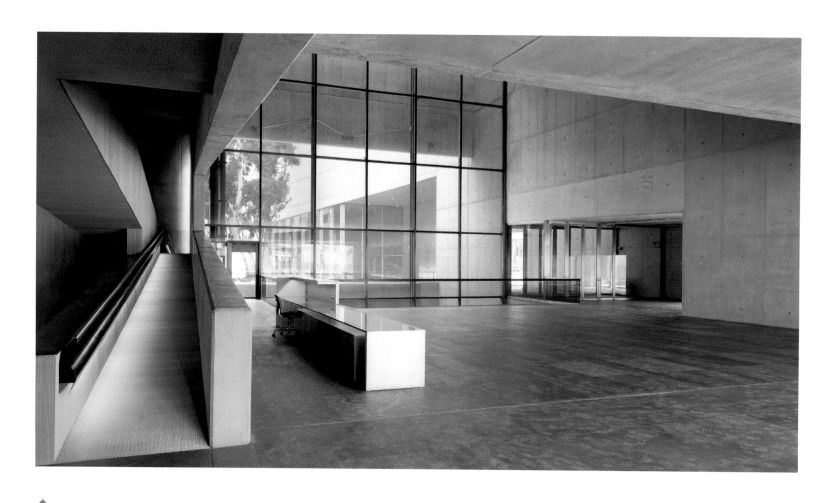

The bare concrete, visible in the construction of the building, gives it a sober and compact appearance. The vast glass surfaces allow much light to enter and open the spaces to the exterior.

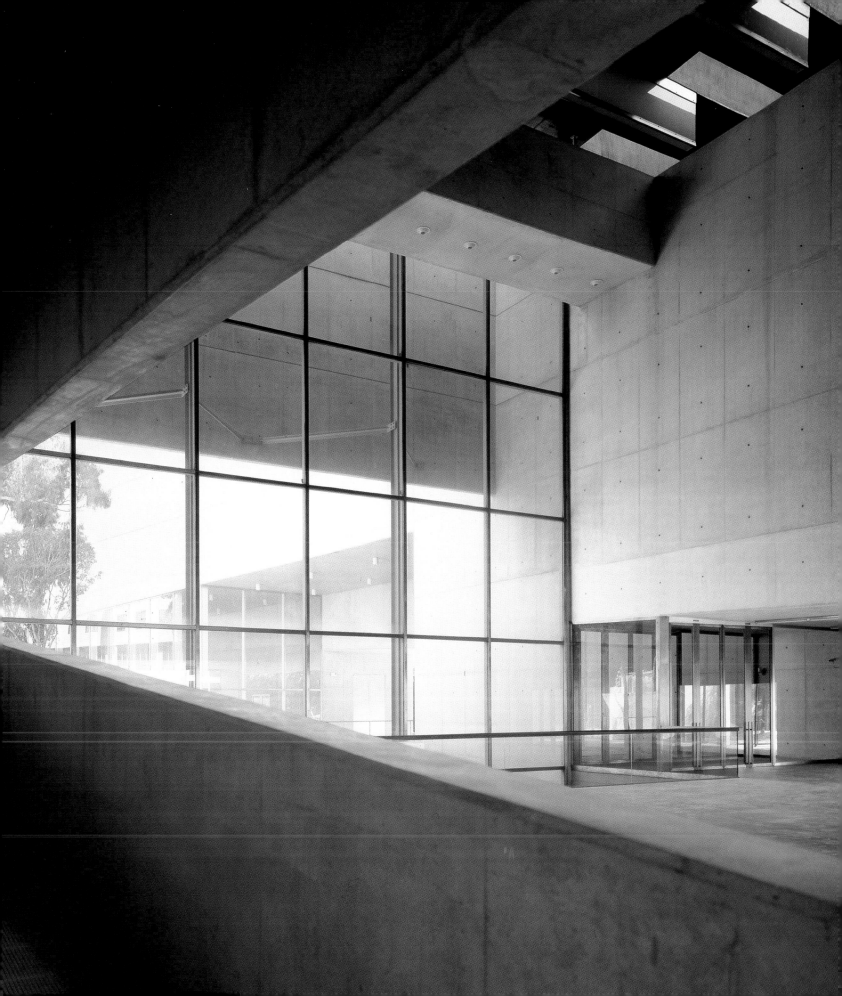

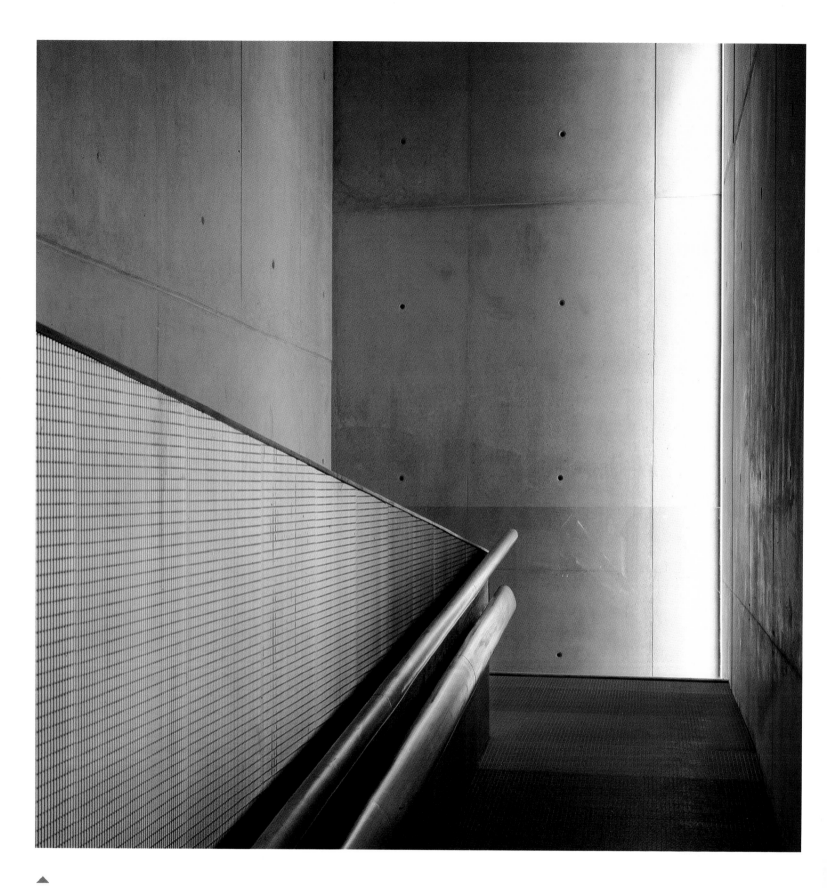

The exhibition halls are organized in spaces with very gradual ramps. One of the principal premises of the project is flexible architecture.

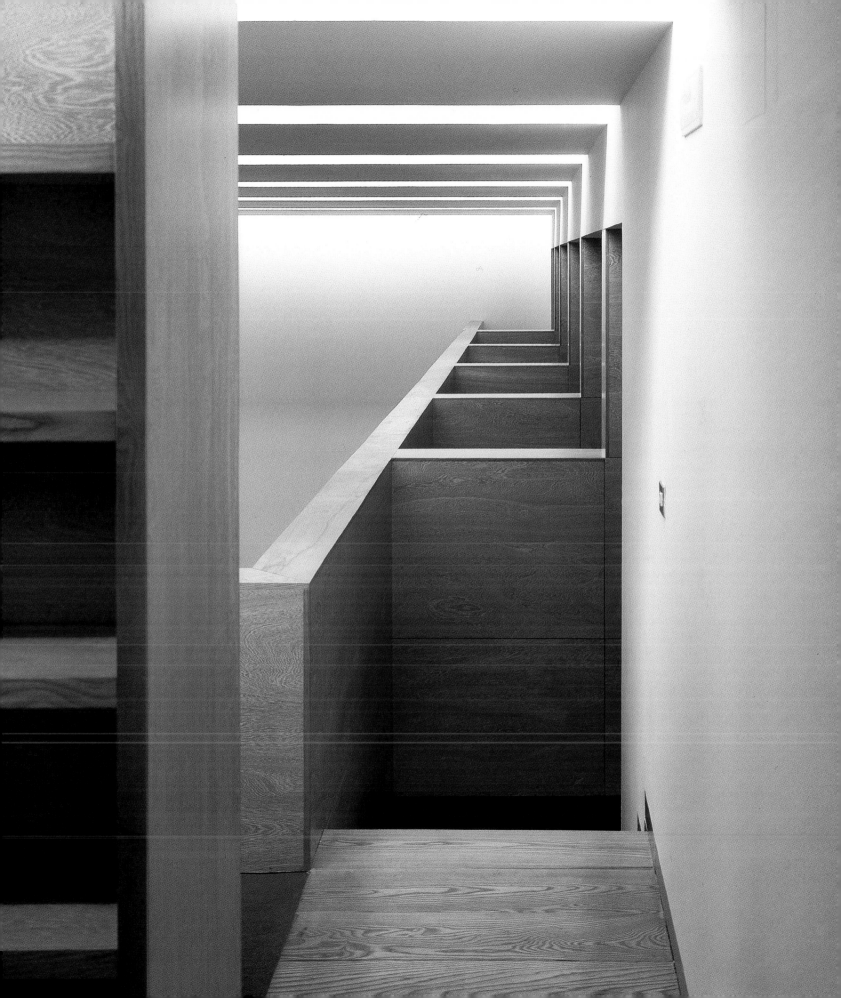

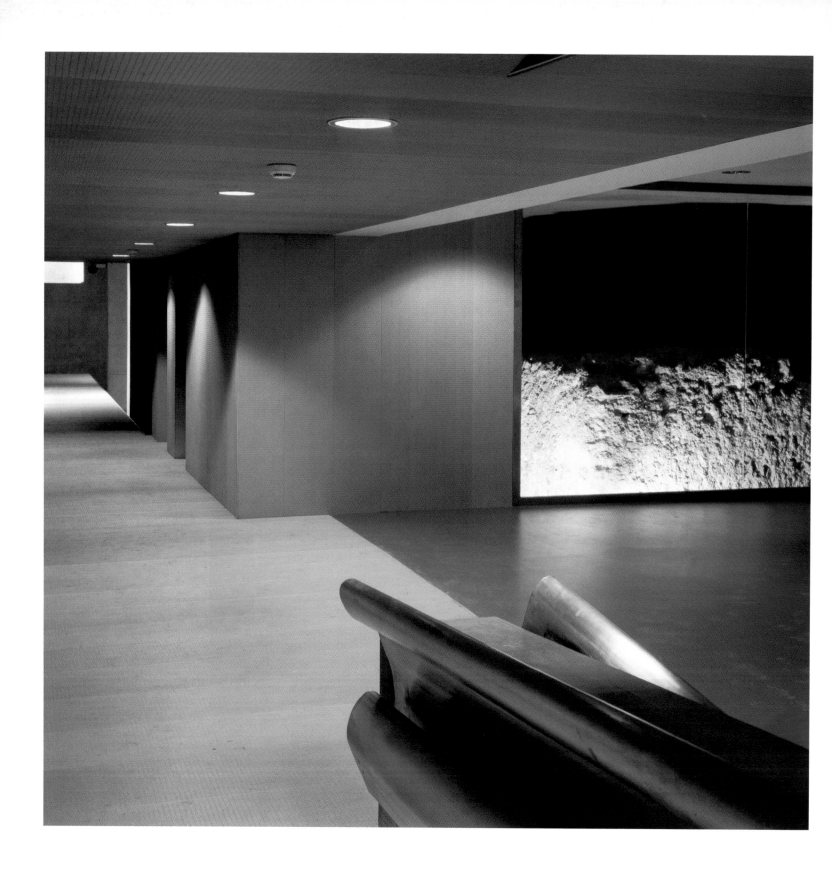

The route through the museum is expressed by means of scenes inspired from literary, musical, and motion picture references. This was one of the aspects that determined the character of the building.

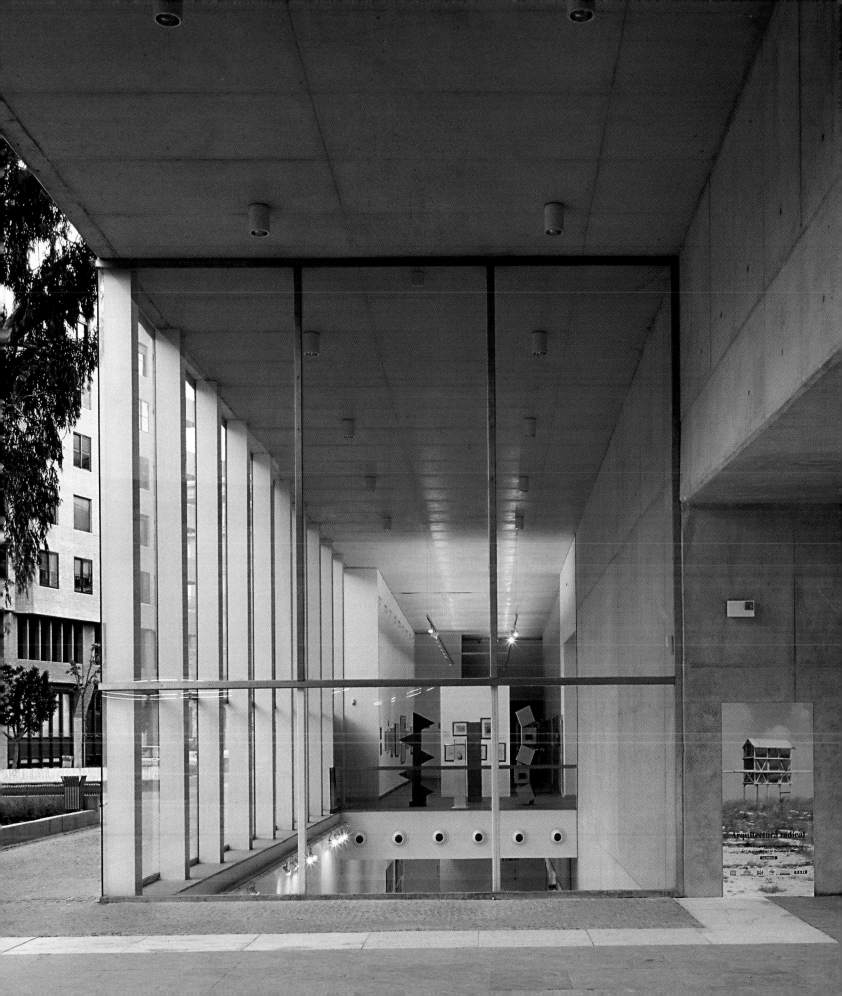

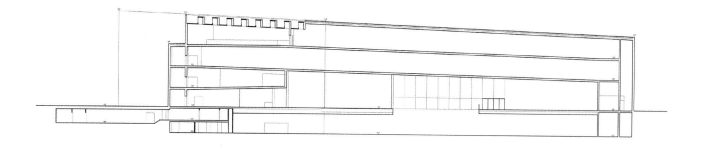

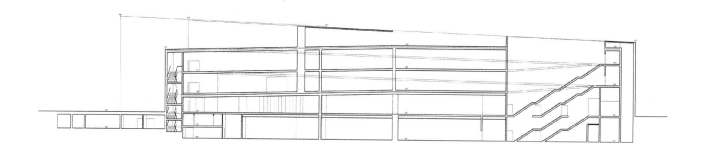

The project consists of two elongated, almost parallel structures that house the main halls and services of the museum, such as the area of temporary exhibitions, an auditorium, a library, a shop, and a cafeteria. The vestibule is in the middle space that connects the two structures.

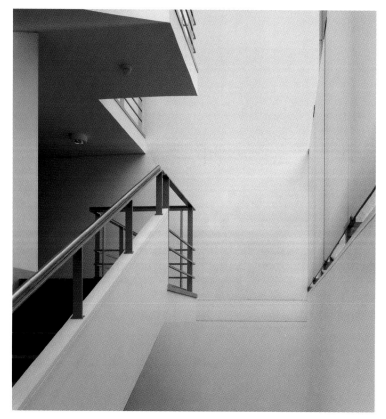

The shape and the volumetry of the project is strongly conditioned by urban planning demands and by the need to build different areas that could function independently.

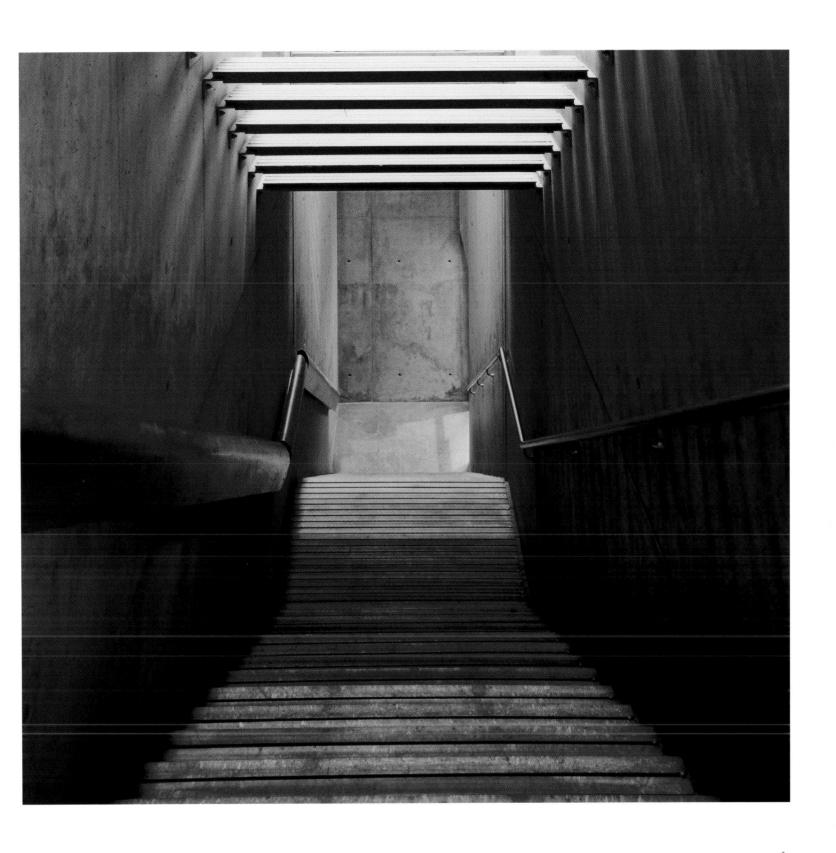

The architects designed the areas so that they shared the same unitary image. The access areas and the ones that connect the different levels are designed to fulfill this objective.

Block of offices and Apartments

Eduardo Souto de Moura | Collaborators: Tomás Neves, José Carlos Mariano, Laura Costa (landscape design)

Rua Clotilde Ferreira da Cruz – E.N. 14, Maia, Portugal | Surface area: 69,020.5 square feet | Date: 2002

Duccio Malagamba

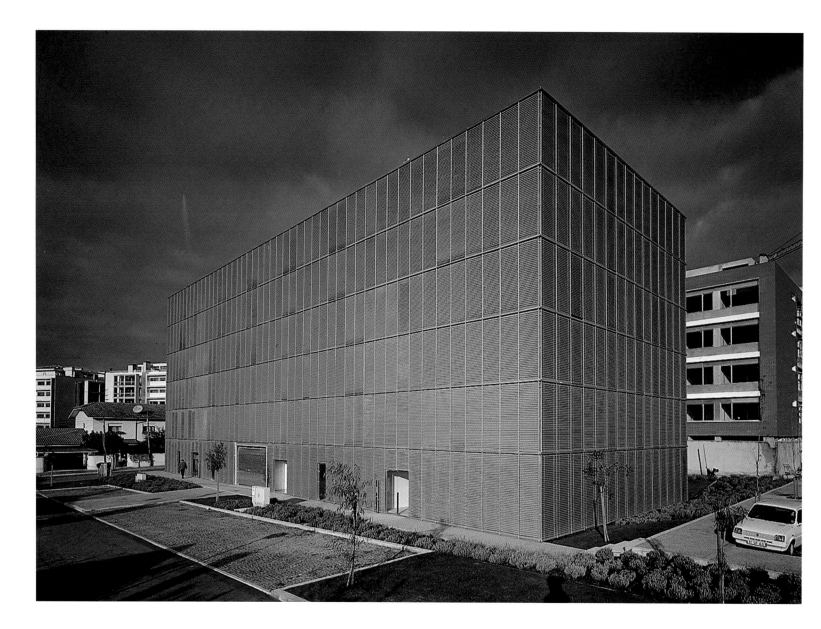

The building was designed for housing and commerce. It is a pure and isolated volume that consists of commercial locales on the ground floor and five floors of apartments on the upper levels. Altogether, it houses thirty-two apartments and eight commercial locales. The edifice is a 147.6 foot x 55.8 foot elongated rectangle that is divided by the transversal axis that creates two separate, continuous, and symmetrical bodies. They are independent in terms of access and circulation. The elevators, the stairs, the bathrooms, and the storage areas make up the central structure of the building, which facilitates the organization of the interior space.

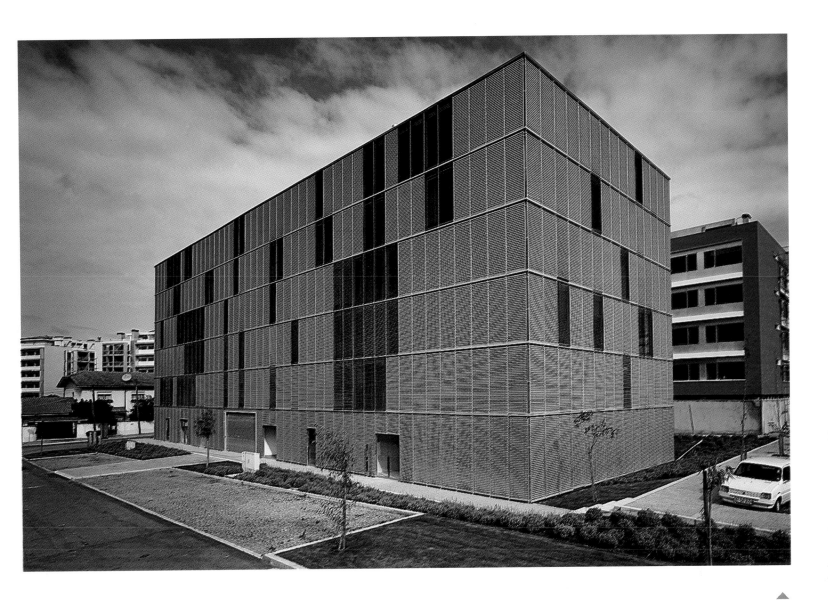

The unusual physiognomy of the façade makes us perceive in the same way the locales on the lower floor and the dwellings on the upper floors.

The east façade has two accesses, one to an underground car park and a corresponding entrance to the four eastern commercial locales. The west façade affords direct access to the four western locales.

The layout of the apartments has the kitchen near the entrance, next to the living room and bedrooms. This makes a linear front that is structured by a 4.5 foot wide hall. The metric dimensions are a 19.4 foot square. Consequently, the front sides of the bedrooms are 9.7 feet, which is the same width as the parking spaces.

A system of venetian-type blinds or shades are the slits that form the "waves" on the façades. The system provides two types of blinds: one is fixed and immovable on the exterior wall, the other is an ordinary venetian blind on the windows, covering the openings in the laundry rooms. The same system is used for the commercial locales.

The apartments are available with one, two, or three bedrooms. The interiors of the apartments have been carefully designed. The doors have no lintel, which means the entire leaf reaches the ceiling. The door frames are the same width as the wall partitions, and so it appears as if they are incorporated into them. The floors are made of wood, and all the walls and doors are white.

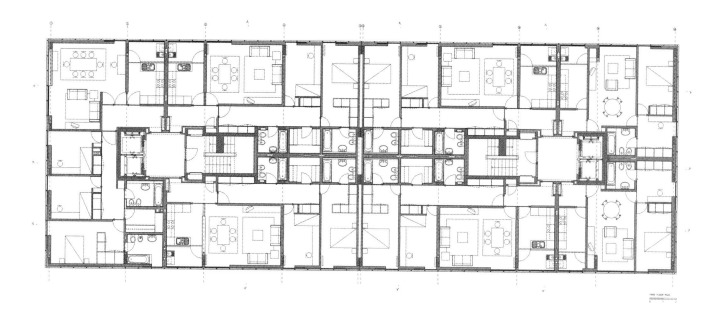

This section of the building allows us to see the interior distribution. The elevators, the stairs, the bathrooms, and the storage area make up the central structure of the building, whose transversal axis divides it into two separate bodies.

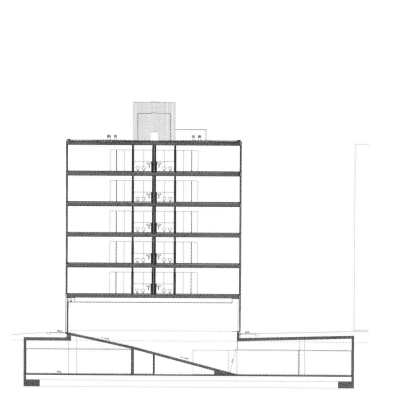

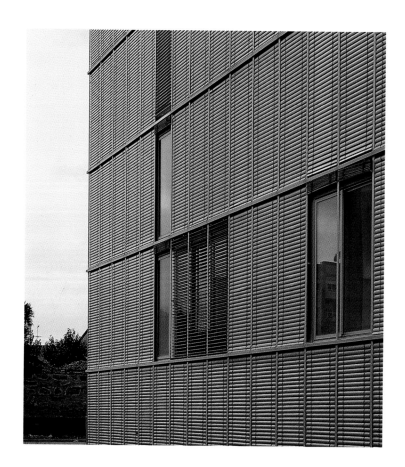

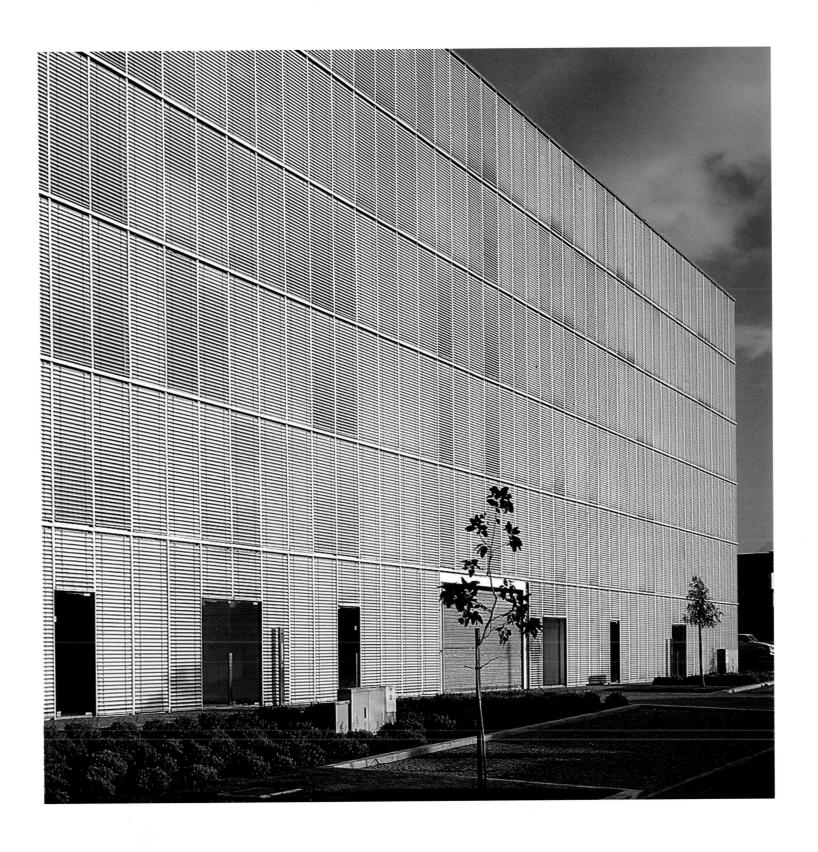

The façade is finished off with a system that incorporates two types of blinds or shades: one is attached to the exterior, and the other is attached to the windows on the interior

Sports Center in Zug

☞ **Bétrix & Consolascio Arquitectos y Eric Maier, Erlenbach** | Collaborators: Harald Ecshe and Nathalie Rosetti, architects

▦ **Zug, Switzerland** | Surface area: 65,974 square feet | Date: 2001

📷 **Guido Baselguia**

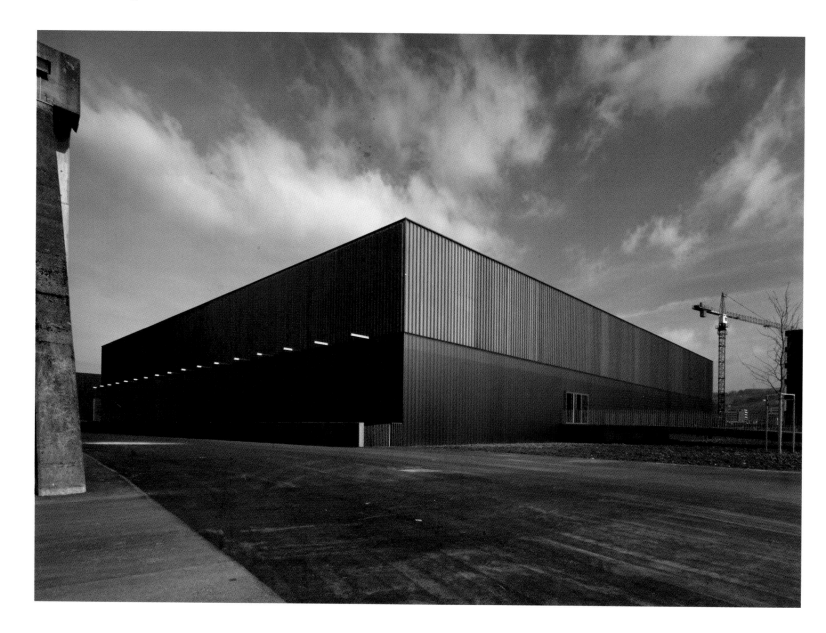

In the old days, the railway lines formed an inlet inside of which different residential areas were situated. In the middle, there were irregular-shaped extensions of industrial areas. The complex has the appearance of an uninterrupted series of empty and filled areas. The new sports center was erected in this setting. To the left, there was a vast platform built to contain different sports and recreation structures. The objective was to conserve the preexisting structures but at the same time allow a bit of breathing space to the neighboring buildings by leaving space between them.

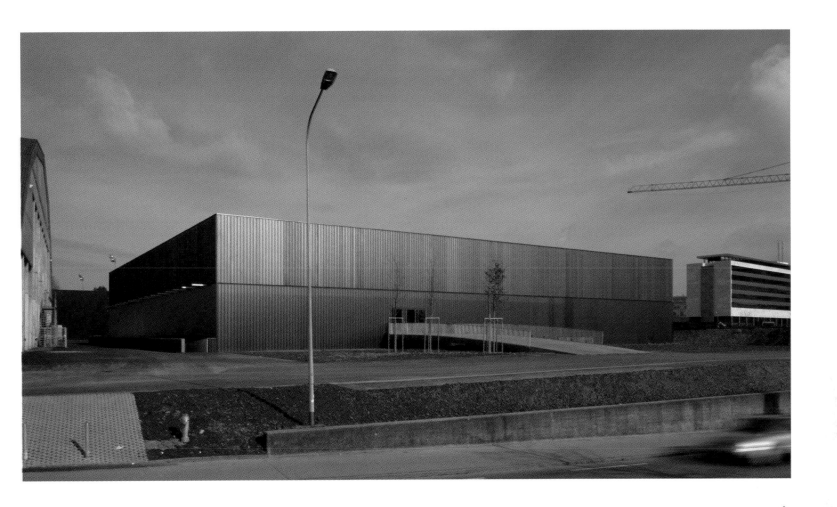

The straight lines of the floor plan of the building are not parallel to the ones of the adjacent buildings. This is the response of the architects to the traditional principle of orthogonality.

The building was erected on top of a kind of terrace or low platform. Although there is a kind of aesthetic dialogue between the two elements, each has a life of its own and its own independent reality. There is no attempt to make the new building representative or descriptive of anything. Noteworthy also is that what is happening inside is in no way perceived on the outside.

Amethyst, orange, pink, lilac, and bright green glass cover the façade and grant the surface an intense coloring. Thanks to the reflection from the façade, the platform on which the building is erected is also full of colors. It varies depending on the time of the day, the amount of light, and the climatic conditions. Whether contemplated from up close, from far away, from the front, from the side, or from a static or moving position, no surface relief is perceived.

The exterior covering is much more than simply a protection. It is a colorful, sparkling surface with depth. With the first rays of sunlight at the break of dawn, it becomes ephemeral, and at sunset, it takes on the appearance of a water mirror placed vertically. At times, viewed from the street, the volume takes on the appearance of a mysterious golden cube.

From the outside, no hint is given as to what lies within. It is a completely sealed and impenetrable body. From inside, however, you can see the platform, the street, and the fields without being seen from the outside.

The square floor plan is slightly off center with respect to the neighboring buildings. This is a gesture of defiance in respect to the traditional principles of orthogonality, frontality, and symmetry. To afford access, a slightly curved platform penetrates the interior.

The vast interior is an expansive space surrounded by columns. The mission of the columns is that of sole support for the broad roof covering the building.

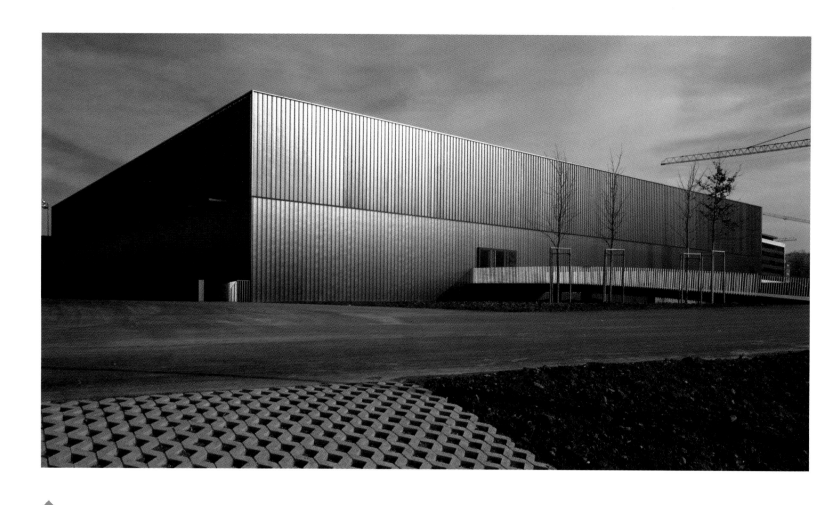

There are no exterior indications to let us know what type of activities go on in this building. From the street, we see only a sealed structure, with no telltale signs.

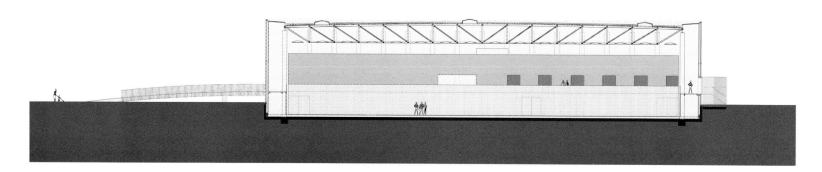

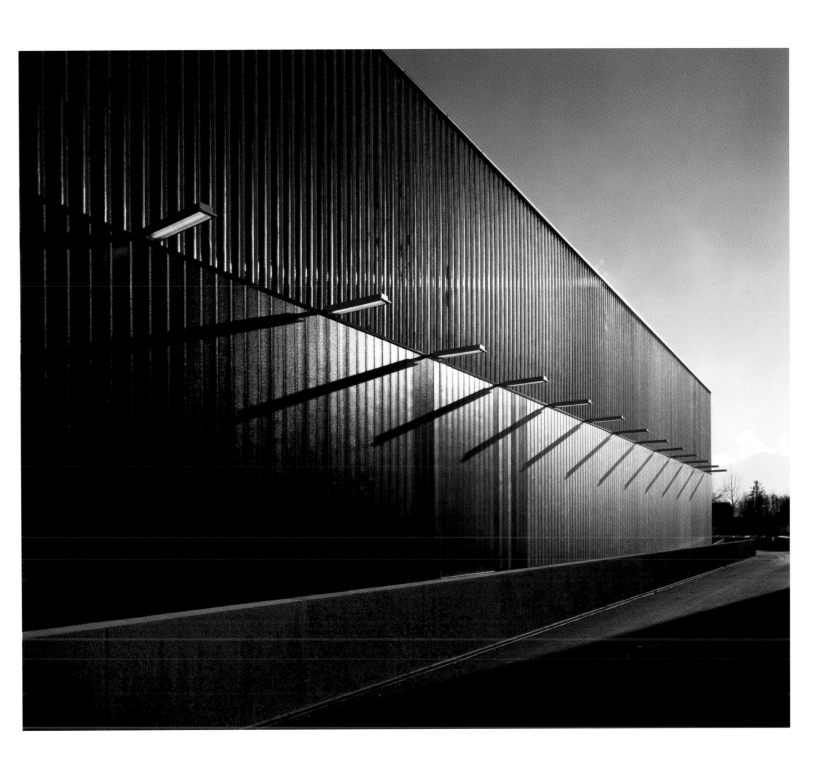

The lights on the façade stick out from the structure and make the use of streetlights unnecessary.

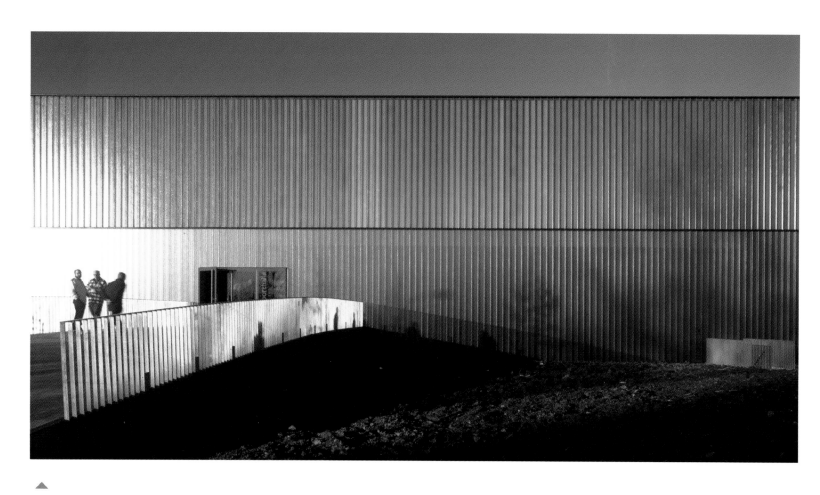

▲

The different-colored glass used on the façade allows the exterior appearance to change during the day, depending on the amount of sunlight and the atmospheric conditions.

A cross-sectional view shows us that the interior of the building is practically empty and that the only volumes are in the entrance area.

▼

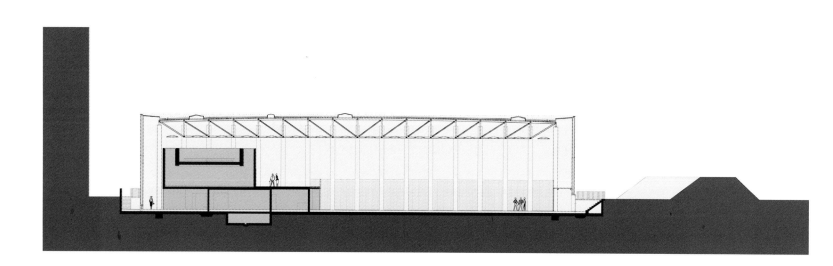

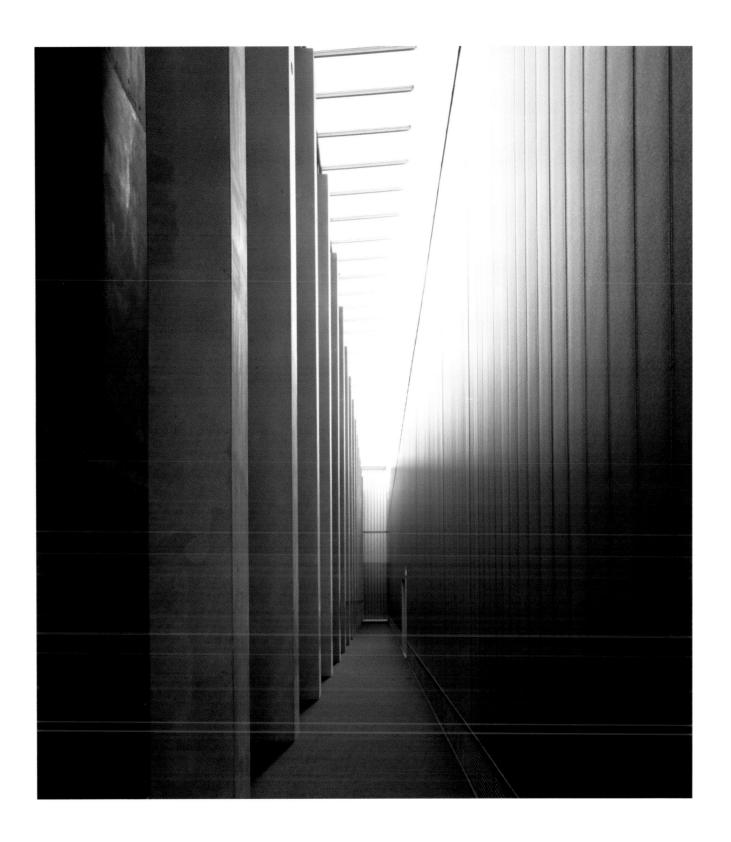

The columns are the structural elements that hold up the roof of the building. They are only visible from the interior, and they give a classical touch to the aesthetics of the complex.

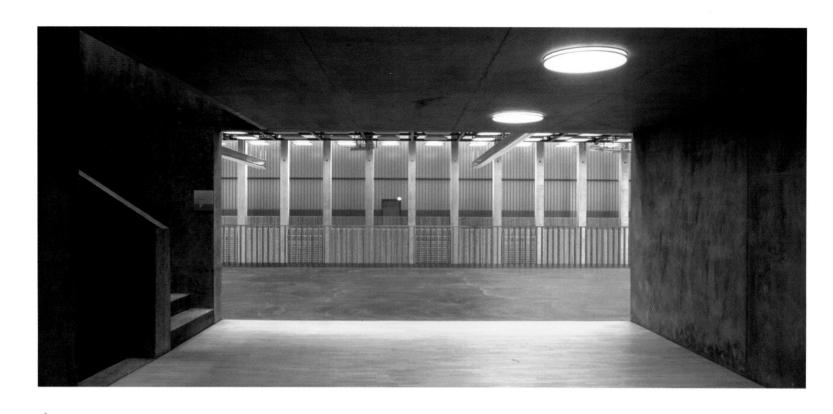

The accesses to the main court are spacious, and the vestibules are broad so as to avoid overcrowding.

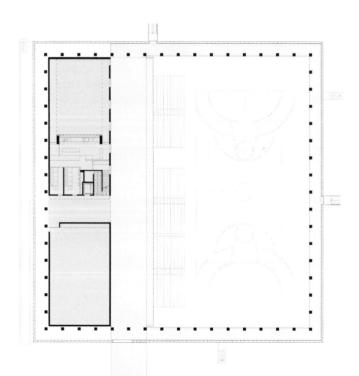

The columns encompass all of the floor. A vast court, which easily adapts to the necessities of each sport, occupies three quarters of the building.

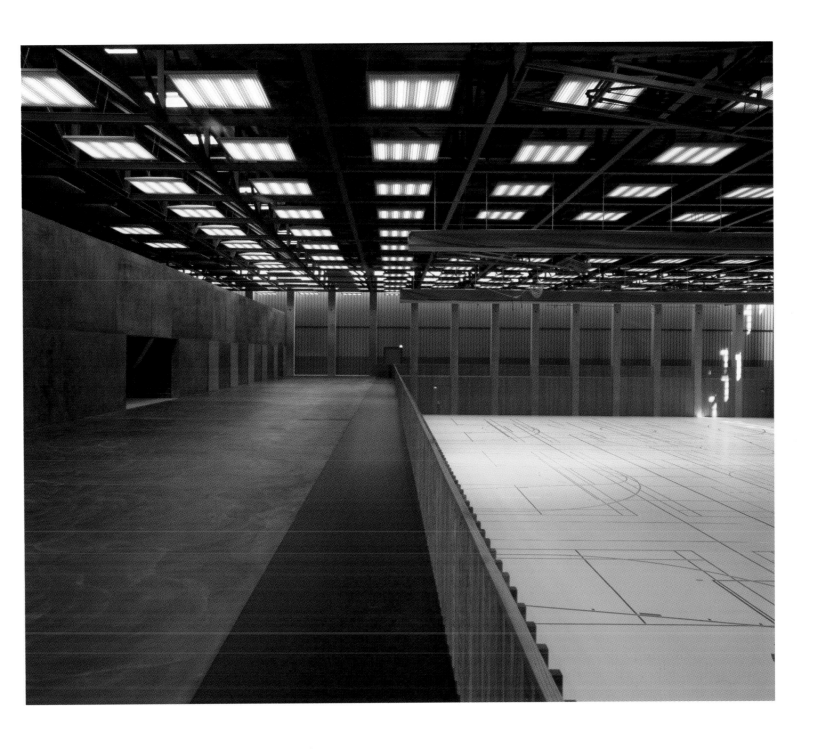

A change of level separates the spectator area from the sports area. The distribution of the spaces is characterized by a perfect view of the sports area afforded to the spectators.

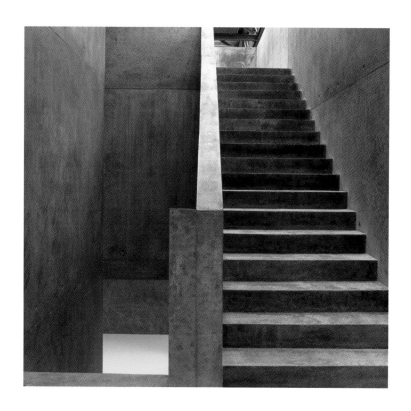

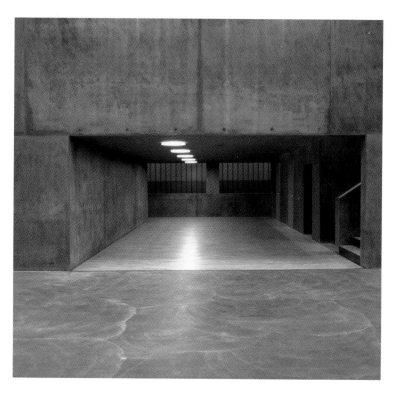

Refined lines are manifested all throughout the design and construction of the building. The absence of ornamentation and other elements that distract from the basic shapes of the design mark the aesthetics of the building.

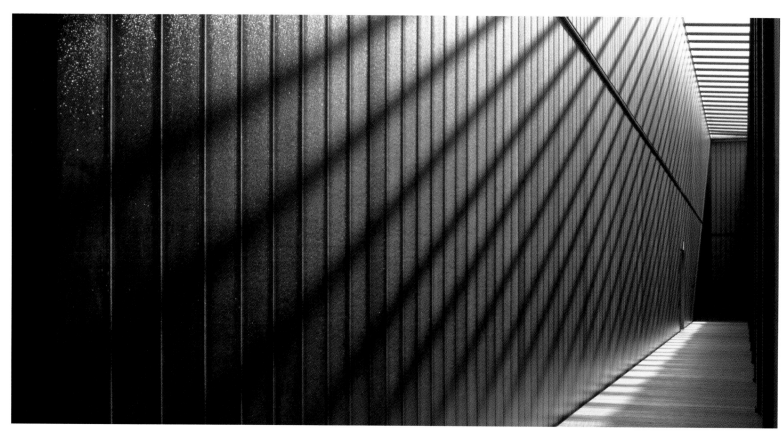

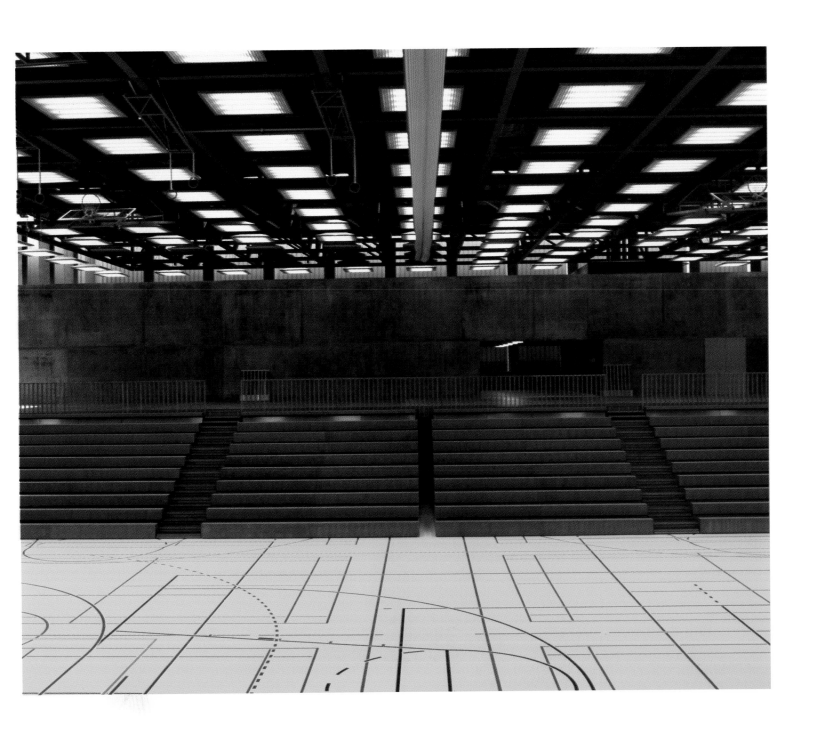

The raised level houses the service areas (locker rooms, restrooms, offices, etc.) and affords the spectators access to the stands.

White temple

⊙ **Takashi Yamaguchi & Associates |** Collaborator Taiki Maehara: SD Room

▦ **Kyoto, Japan |** Surface area: 796.5 square feet | Date: 2000

📷 **Takashi Yamaguchi & Associates**

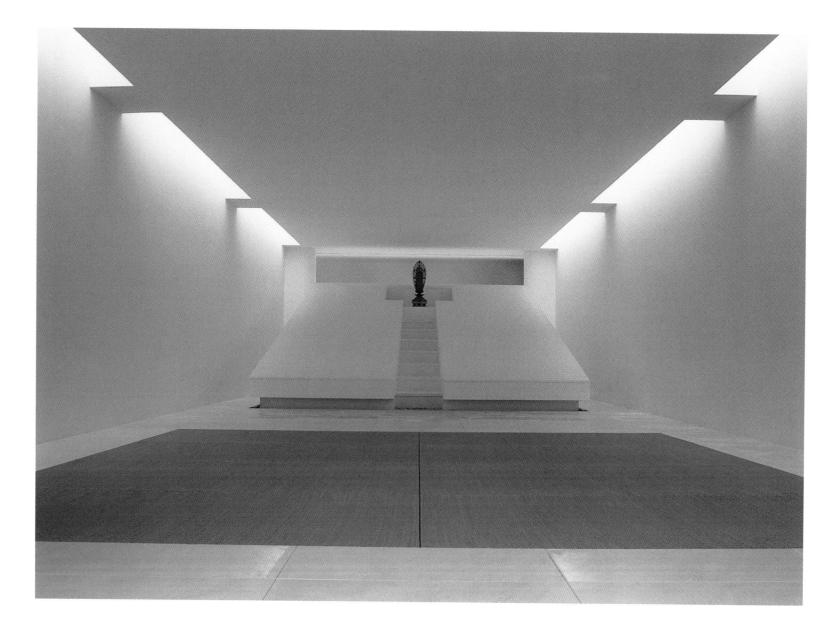

The plot lies northeast of Tokyo about two hours from the center of the city. This region of great beauty is also a national park. The building lies next to a broad lake surrounded by mountains. In Japan it is traditional to consecrate and pray for the ancestors of the paternal line only. Thus, the maternal ancestors are excluded from the religious services. This project arose from the recognition of the need to give thanks to the maternal ancestors in the same way as the paternal ancestors. The building is a sacred place to honor the maternal ancestors.

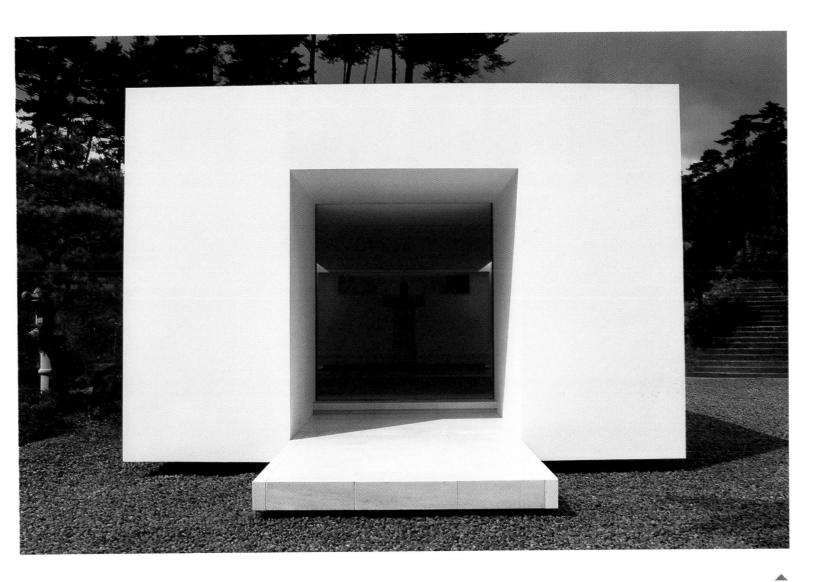

The treatment of light takes on architectural properties, as a different perception of the interior space is created depending on the amount of light that enters.

Buddhist funeral tablets are kept here. The tablets have the names of the people that they want to be remembered so that the priest can lead the prayers in their names. Inside, the architect created a space that envelops the visitor in an atmosphere reminiscent of a uterus. One experiences the sensation of floating like a fetus in amniotic fluid. The idea of the movement of time is also evoked in this ambience.

The interior light becomes more intense or faint depending on the light of the sky, which conveys the sensation that the space is breathing. In other words, with each change in the brightness of the sunlight, the space appears to swell or to shrink.

This movement is similar to what you would experience inside the womb. It softly envelops you. The geometrical dimensions are fixed, but the appearance changes dramatically depending on the density of the light. The greatest light penetrates a white plaque where the funeral tablets are. It shines in from behind the Buddha, where it is obstructed by the altar. Transfigured by the divine image before it, the light becomes a golden halo around the Buddha. Divine presence is brought in by the light and consecrated on the altar.

During the day, the building seems more like a volume that announces its presence. On the other hand, at night, it sheds its shape and gets lost in the darkness, and you can only make out the interior luminosity.

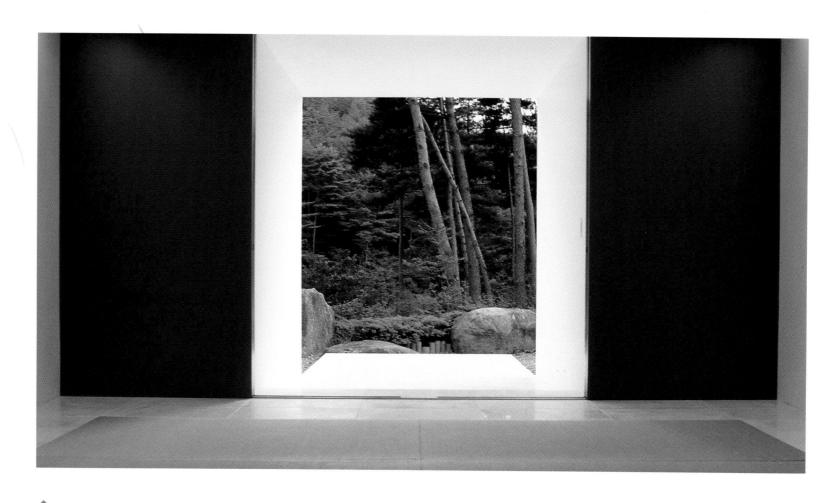

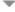

From the outside, the entrance door is the only aperture that you can see, and it is situated in front of the altar.

During the day, the volume of the building is accentuated as it beckons its presence. At night, the shapes soften, as light can only be perceived from the inside.

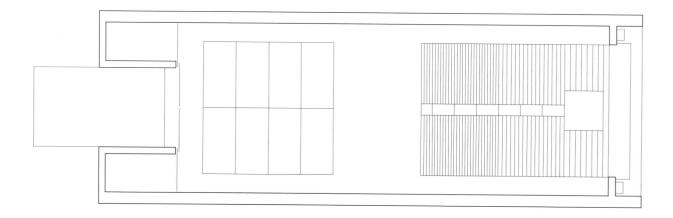

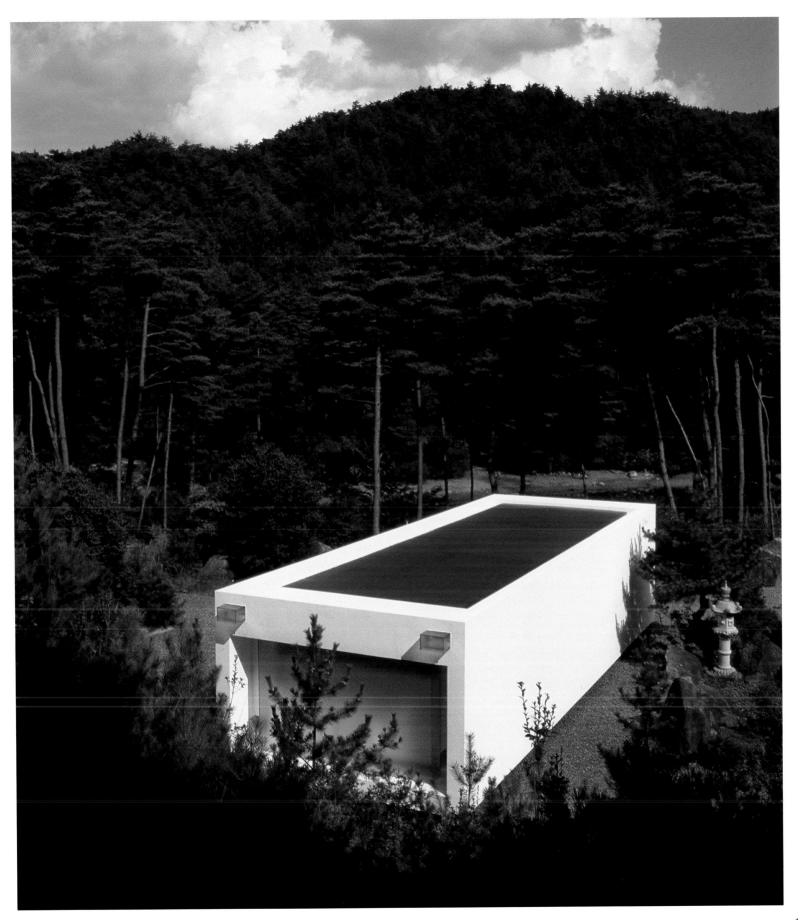

Convention center

Carlos Ferrater, José María Cartañá | Collaborator Alberto Peñín

Barcelona, Spain | Date: 2000

Alejo Bagué

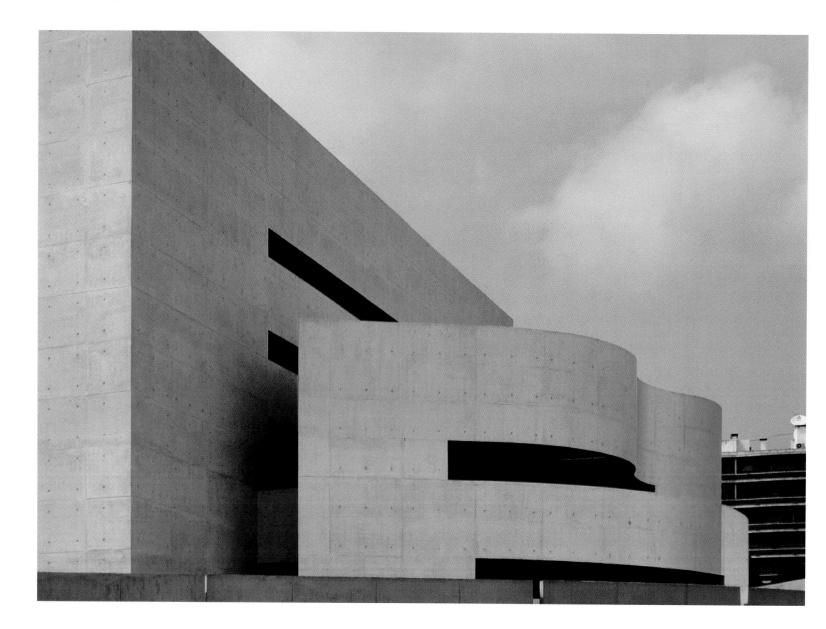

The Convention Center of Catalonia lies at the far southeast corner of Barcelona, where the A-2 tollway makes its entry into the city. It is situated next to the Juan Carlos I Hotel and its surrounding gardens, the Fitness Center, the Turó Tennis Club, and the Polo Club. The two main façades open onto Torre Melina Street on the west and Diagonal Avenue on the north. It is a setting halfway between the country and the city, and it is erected on a high terrain, which affords a view over the city, Mount Montjuïc, and the coast.

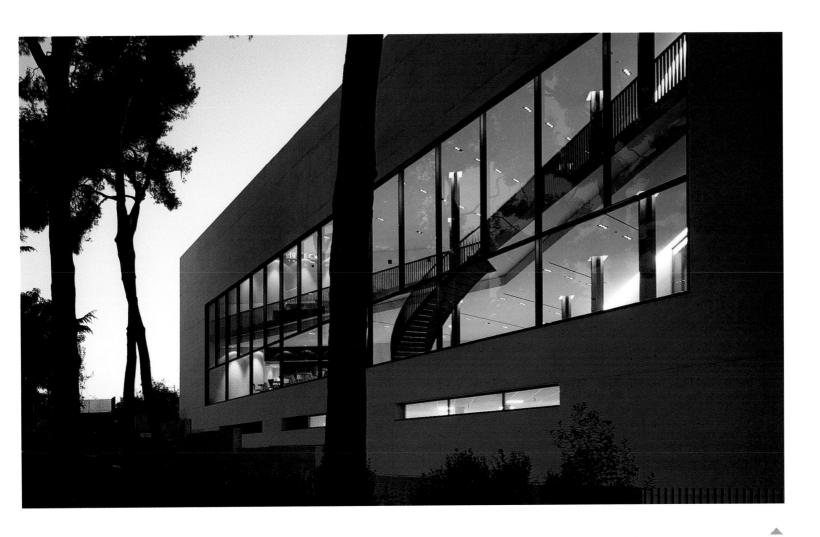

The great apertures in the volumetry of the structure establish an important relationship with the green areas that surround the building.

The building is laid out in three bodies, which helps to distribute it onto the sloping topography that extends from Diagonal Avenue to the adjacent gardens. This design allows for a very large structure to be built while at the same time maintaining a more human-size scale. From the outside, it is aesthetically fragmented. In contrast, inside, you are surprised by the volumetrical and spatial unity. The use of white concrete as the sole exterior covering accentuates this contrast and affords an aggregate composition style.

The building consists of three bodies separated by two interior streets, which afford visual communication between Diagonal Avenue and the gardens. At the same time, they provide the rooms with natural light. These streets divide the complex into longitudinal strips or sections. Also, there is a lobby, a foyer, and two streets on the garden floor, which lead to entrances that complement each other. The complex is not so much an arrangement of autonomous, functional elements but rather a system of imbricated pieces that are interconnected like the elements of a mini city.

The path through the complex begins in the hall and continues in the street as a preamble to entering the vast auditorium, which seats more than 2,000. Next, we come to the foyer, where the landscape is strongly present. Then, we come to the exhibition hall, which is easily recognizable as such from the exterior. Here, the light is exquisitely designed. The path then descends to the floor below, where the dining rooms and complementary services are situated.

Most noteworthy here are the cafeteria-restaurant, the offices, and the complementary areas corresponding to the third sector of the building. The longitudinal cross sections show us that the arrangement of the different pieces has diversity and functional autonomy. But we can also notice seemingly nonfunctional spaces: streets and plazas. The whole arrangement, though, functions like a well-thought-out plan and a small city.

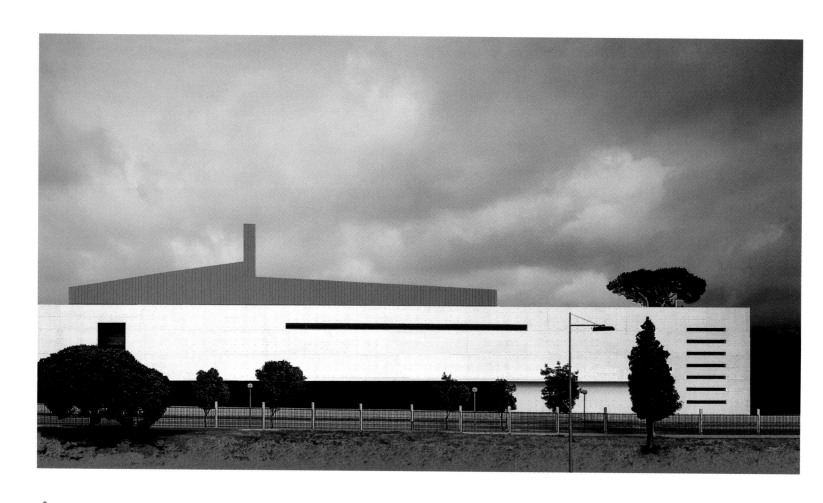

Although the structure has several small-scale volumes, the image that the façades afford is a unitary one.

This section of the project clearly reflects the spatial hierarchy, and even the "nonfunctional" spaces, like the streets and squares.

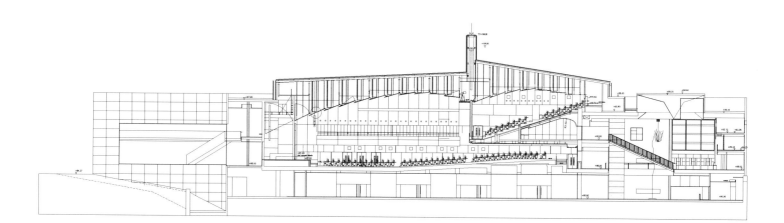

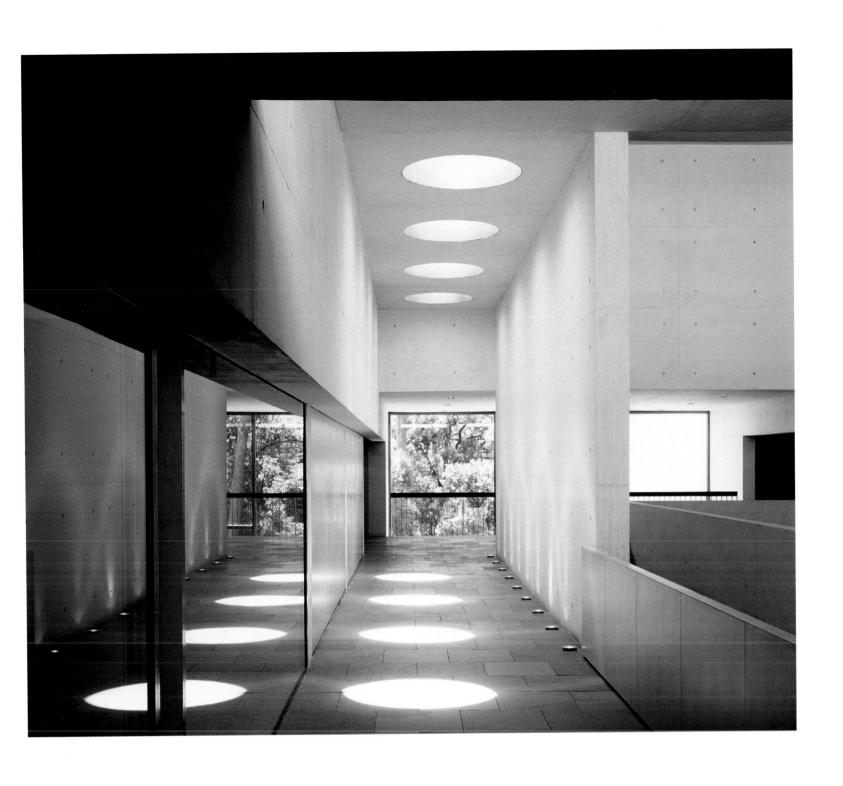

Splendid sunlight flowing in and the omnipresent exterior characterize a walk through the building.

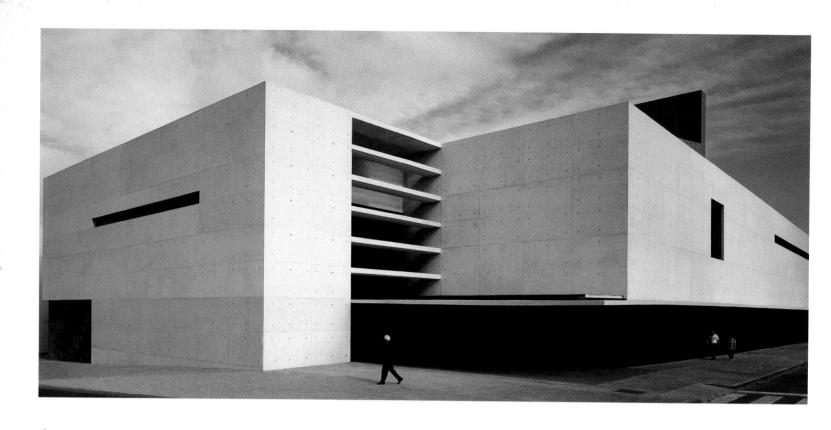

The volumetric fragmentation affords interesting solutions where the different pieces meet.

The façades gives a unitary sense that is strengthened by the predominant use of the color white.

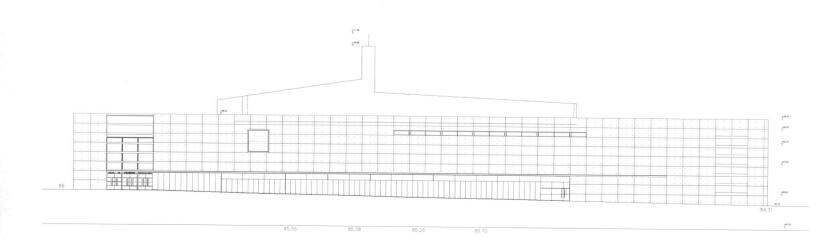

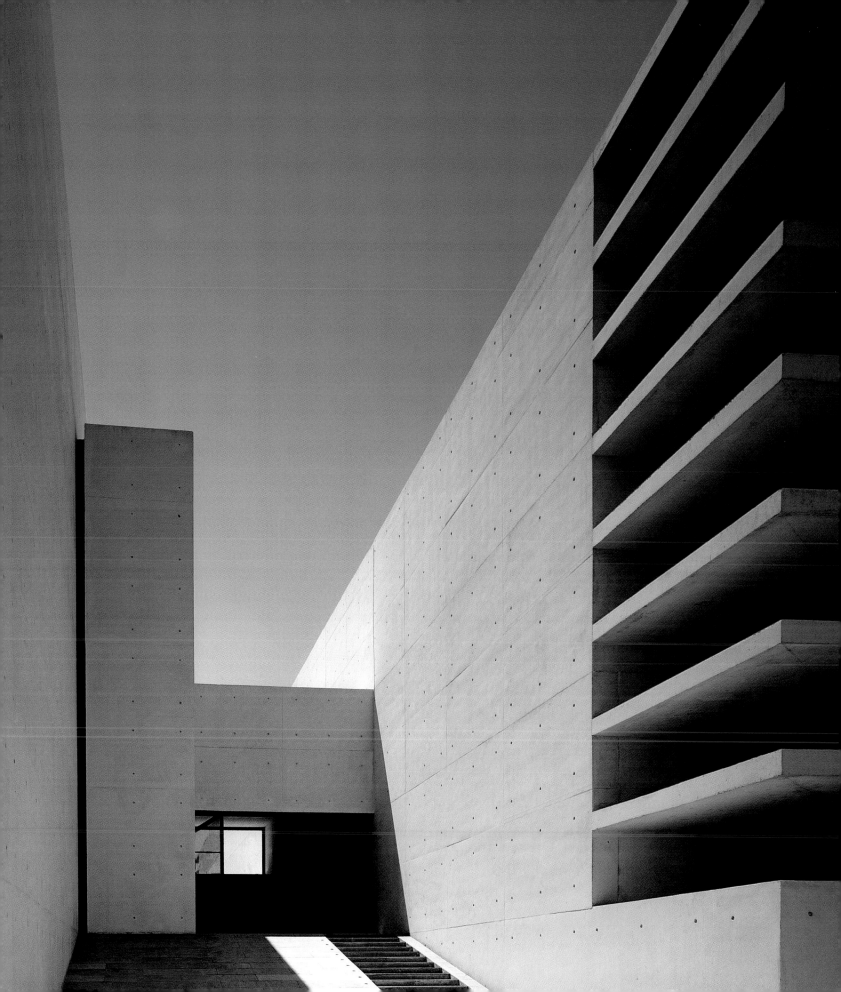

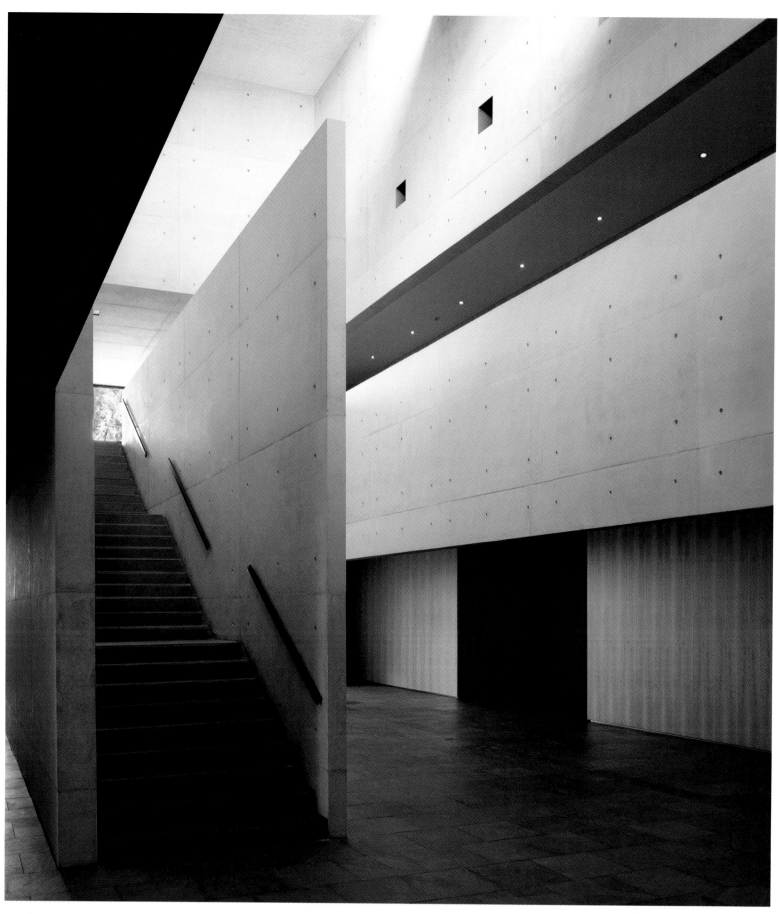

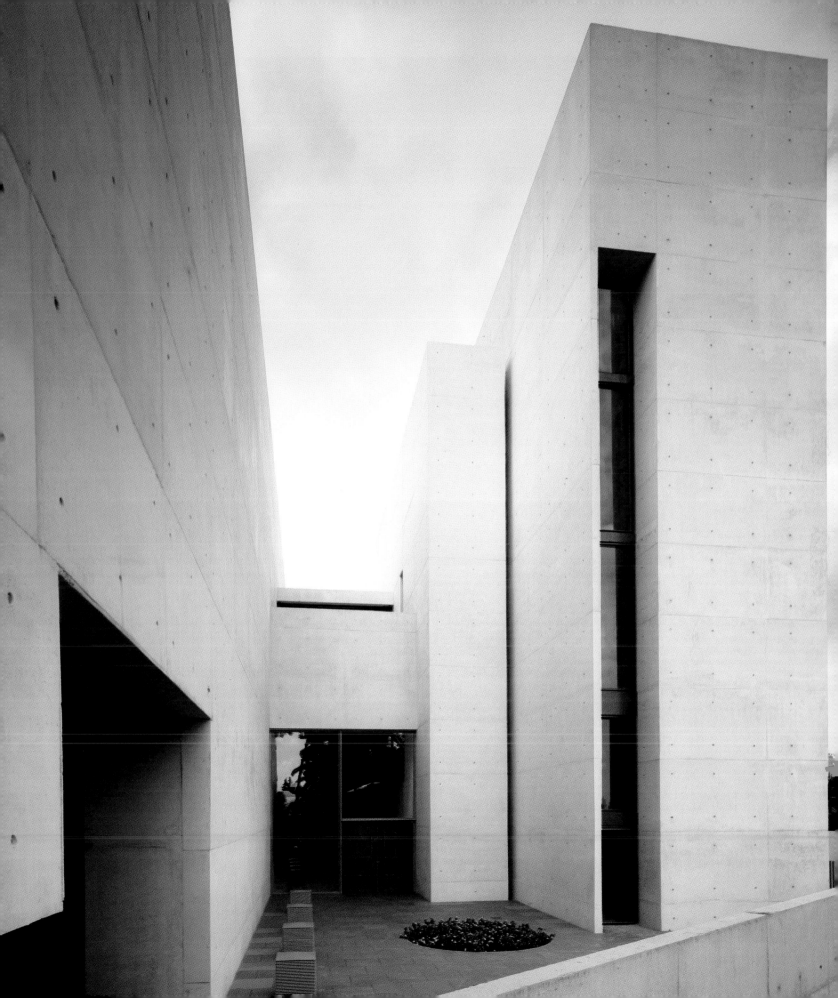

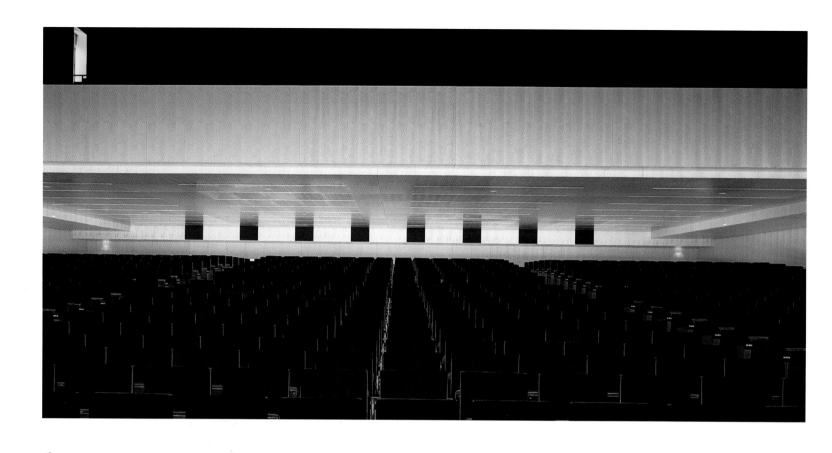

The large window surface covering a great part of the building maintains a constant reference to the exterior.

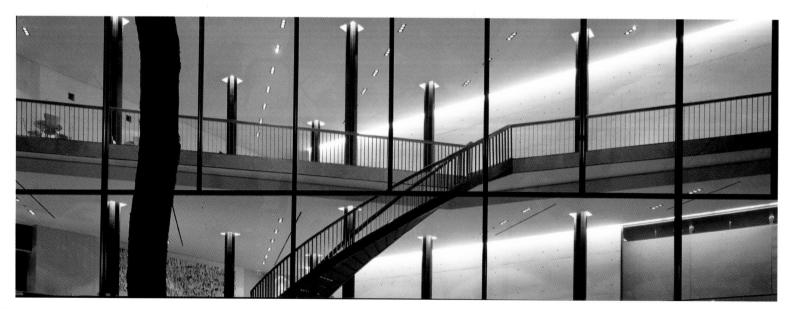

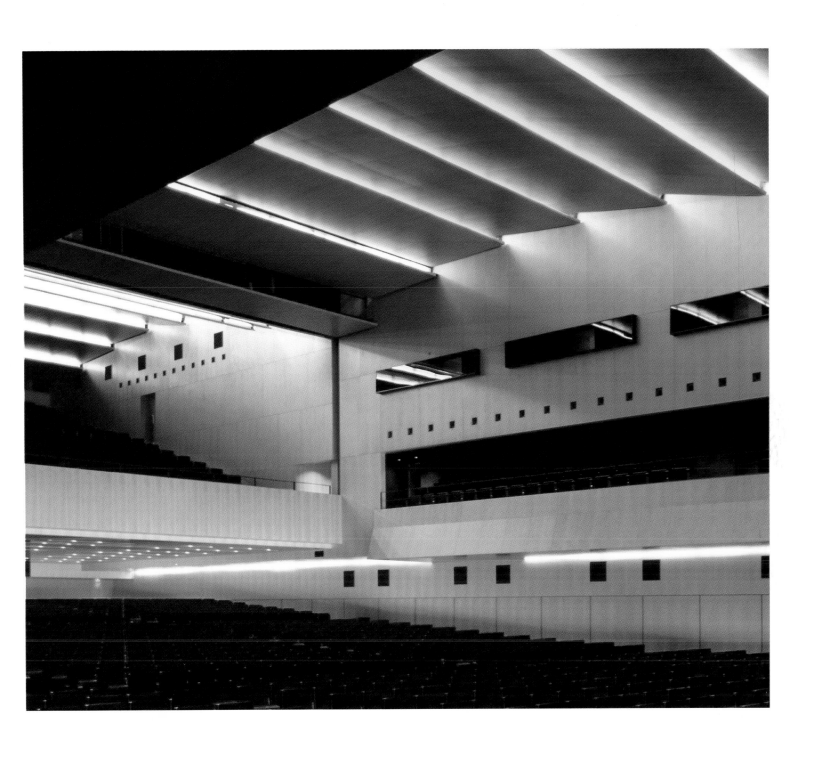

The volume of the main hall is the most important in the project. Although it has the greatest dimensions, it always maintains scale.

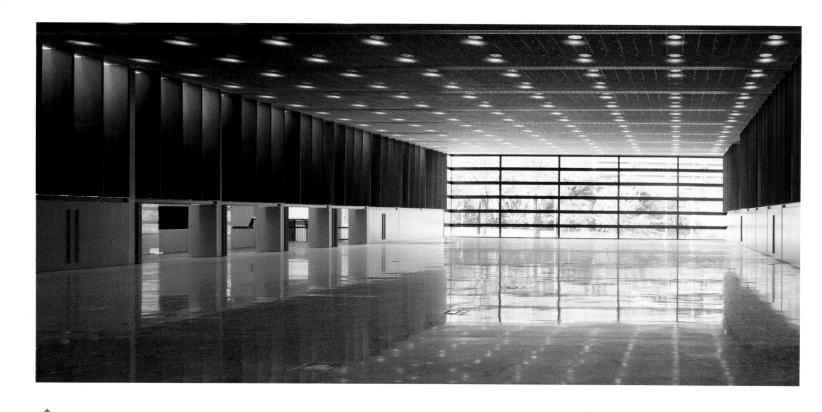

▲

The continuous search for a relationship with the exterior is reflected, in this case, by a great aperture, which allows a visual connection.

◀

Careful attention to details is one of the characteristics of the work of this architect.

▶

Lighting, both artificial and natural, is the key element present all throughout the building, giving a sense of continuity.

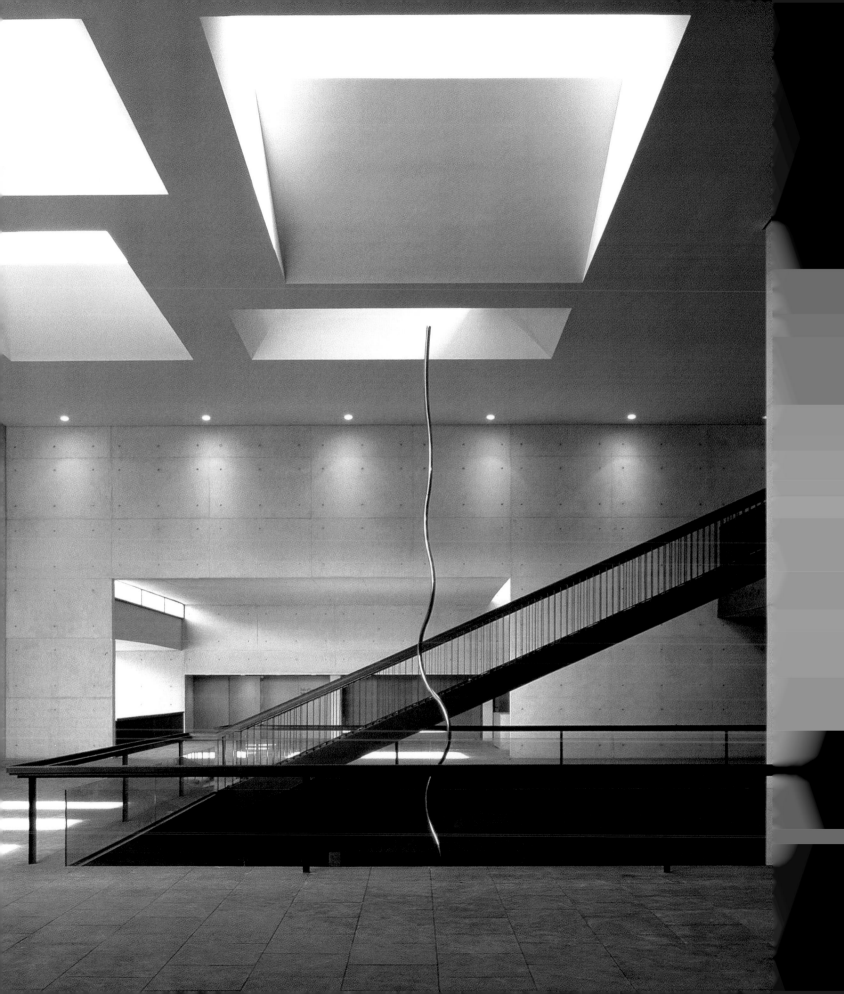

Multi-purpose lecture hall

↪ **Aurelio Galfetti, Jachen Könz**

▦ **Lugano, Switzerland** | Date: 2001

📷 **ORCH Orsenigo Chemollo**

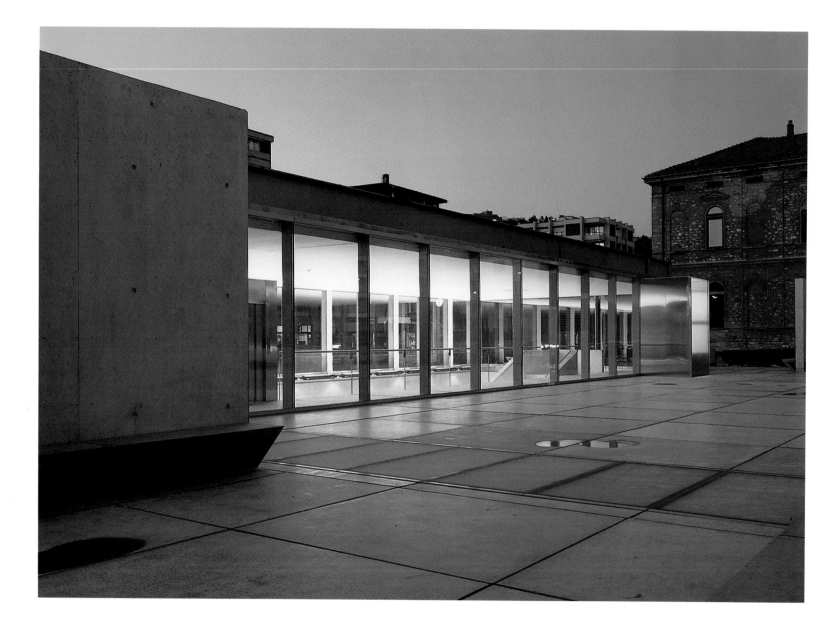

It is located at the southwest corner on the University of Lugano campus. One of the premises of the project is that it does not break the spatial and visual continuity of its green setting. With this in mind, part of the building was erected underground, freeing up surface area on the ground floor, which could be turned into a plaza. Apart from serving as an access atrium to the hall, it was designed to be the public zone of the university in its relationship with the city. Likewise, it would serve as a meeting place for the students on campus.

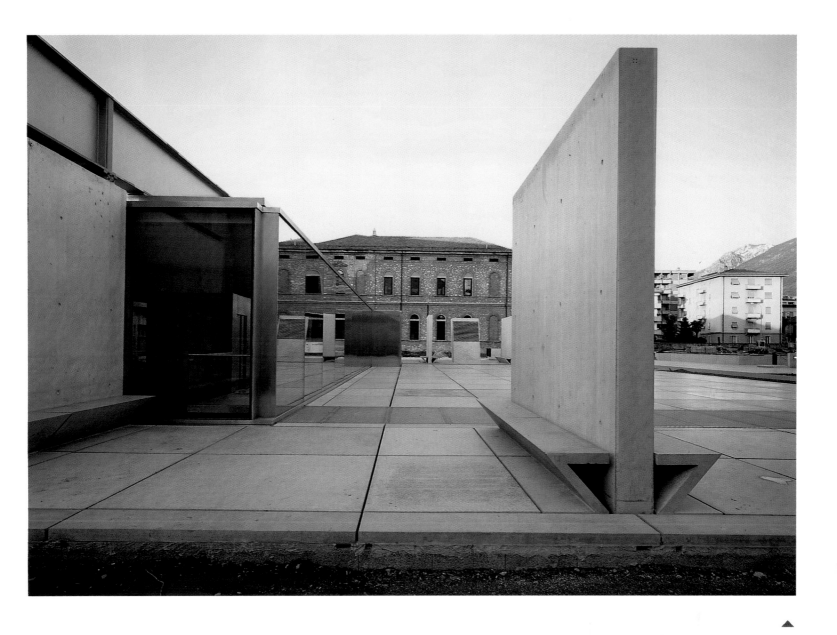

The architectural language used in this project contrasts with the style of the preexisting buildings.

At first sight, the building stands out vividly from its immediate urban setting, owing to the location, the shape, the materials used for the construction, and the contemporary artistic style. The approach to the location is simple and clear: create a building to which access is afforded by way of a plaza, which is situated in a preexisting park.

The basement floor houses the auditorium, the cafeteria, and a series of side facilities around the main space. On the ground floor, two evocative blocks make up the foyer of the hall. Also, there are a series of planes, which are the prolongation to the exterior of the subdivision walls of the basement rooms.

The elongated shape of the "visible" part of the building helps to delineate the perimeter of the ensemble of constructions that make up the campus, which orients the access plaza towards the interior of the campus. Concrete, steel, and glass are the materials chosen, materials which grant an undeniable contemporary image to the project. This contrasts with the classical style of the other buildings of the complex. The general simplicity of the design, the cleanness of the elements that comprise it, and the honesty of the materials grant the building a rational aesthetic. This is only broken by the variation in the orthogonal geometry of some of its elements and by the life and activity that the visitors bring to it.

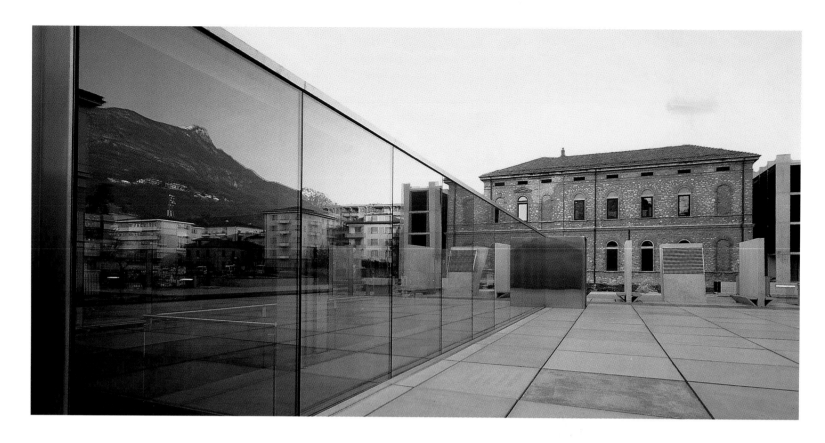

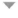 Materials such as concrete, steel, and glass reinforce the impact of the new architecture.

To maintain the spatial flow with the green zone of the campus, the project is partially sunken, thus creating a square.

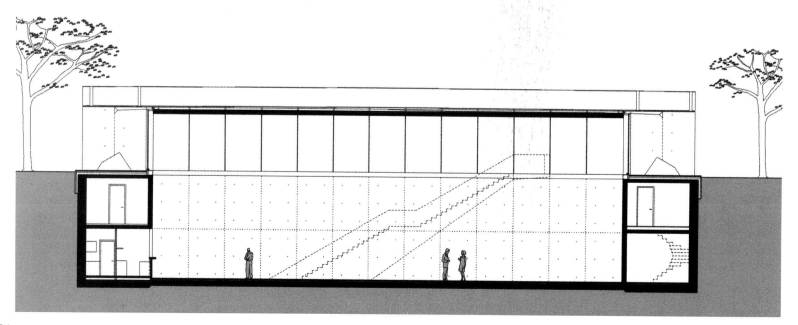

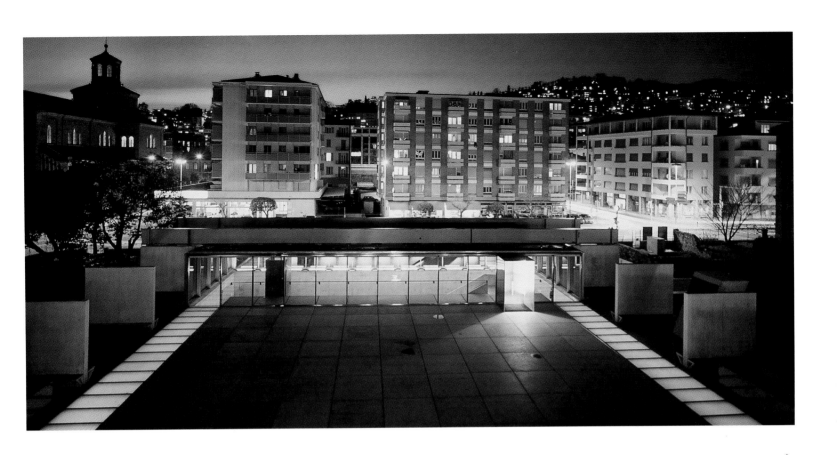

The plaza becomes the element that connects the entire complex. Apart from serving as the access to the classrooms, it is a meeting place for the students.

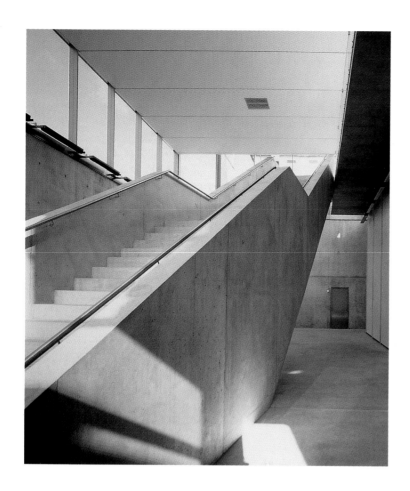 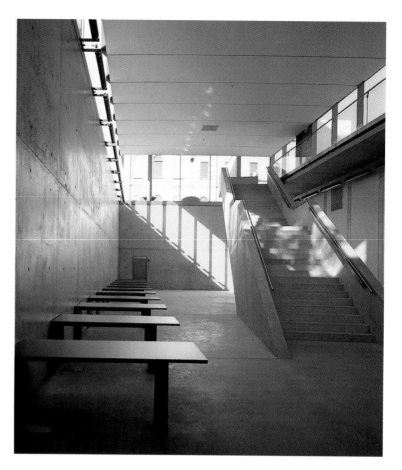

The spatial conception generates an interesting visual continuity between the access area and the basement area.

Due to its elongated proportions and its situation in the complex, this building becomes one of the important elements that delimit the plaza.

FACCIATA EST

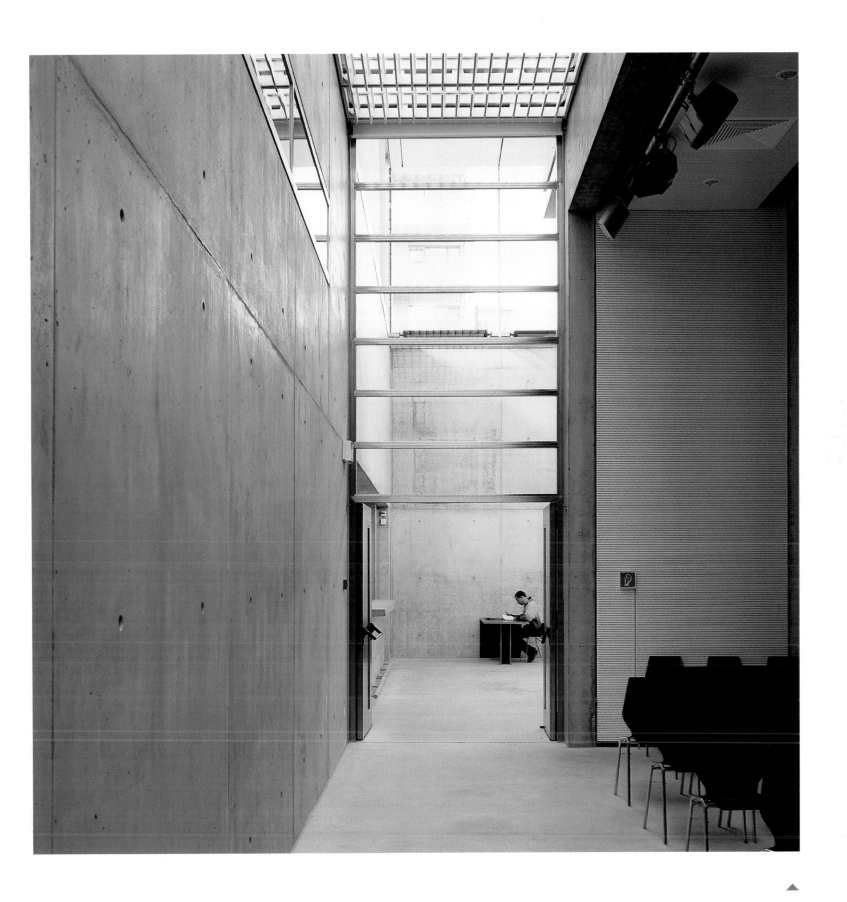

On the basement floor, the "closed-in" activities take place in the conference room with its respective installations.

School in St. Boi

🖎 **Mario Corea, Lluis Moran** | Collaborators: Gisella Planas, Emiliano López Mata, Josafath Renteria

▦ **Sant Boi de Llobregat, Barcelona, Spain** | Date: 1999

📷 **Jordi Miralles**

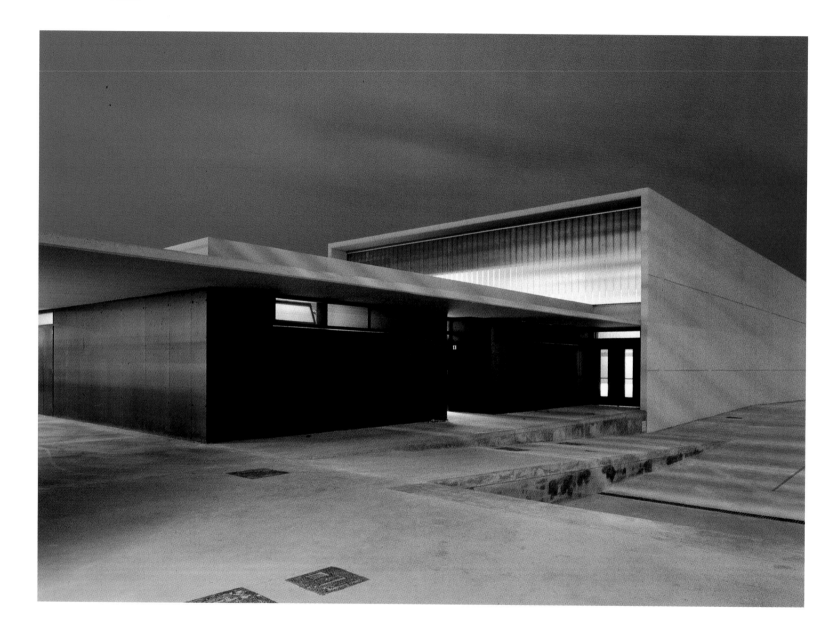

The architectural and urban plan of this project was strongly influenced by the conditions of the plot. The project consists of two main structures situated in a perpendicular way and a smaller third one that houses the vestibule of the entrance and the administrative area of the school. The two bigger structures surround an exterior space, where the two sports courts and a patio are situated. The gymnasium and the service entrance are located on one of the side streets. This same entrance is also used for entering the locker rooms, the sports courts, and the gymnasium. From the highway, you can see three floors, the sports area, and the green zone that acts as a buffer for the noise and activity. On the

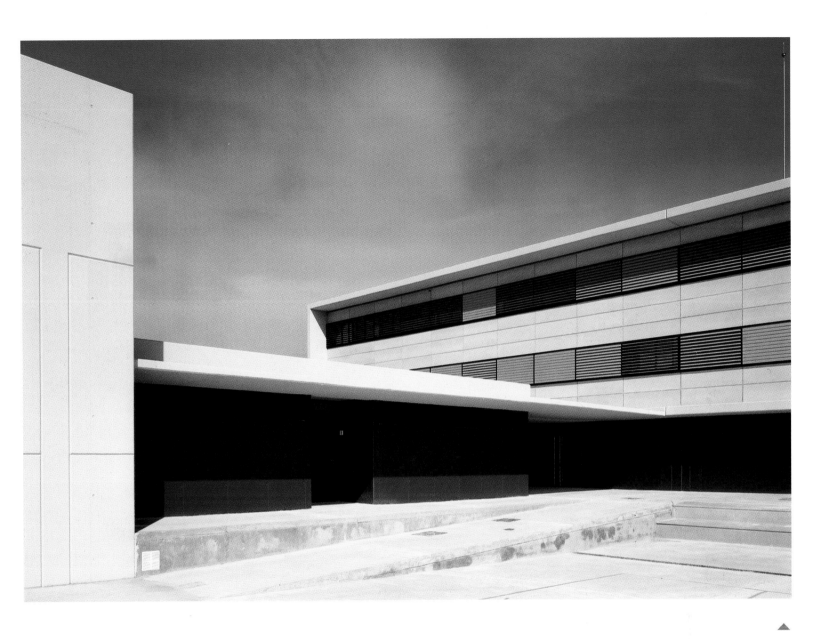

The use of dark tones on the ground floor of the building, makes the principal box structure "float" on the terrain.

side streets, the smaller structures, which are interconnected, are situated.

Taking advantage of the slope in the terrain, the entrance is on the middle floor. In this way, the number of stairs that the students must go up or down is reduced. There is a main central longitudinal corridor that gives access to the majority of the classrooms and that is finished off at both ends with large windows.

It is a horizontal complex with elongated dimensions. The volumes are simple parallelepiped. The smallest ones are made of bare concrete, and the façades of the classroom area are covered with stone slabs. The lower floor of the classroom is made of bare concrete but painted black, which gives a visual effect of a body floating over the ground. The volumes are designed to encircle the interior space and enclose it from the two opposite sides. This allows light to flow in from the other two façades, which are drawn in from the perimeter and shielded from the sun and rain by long continuous eaves.

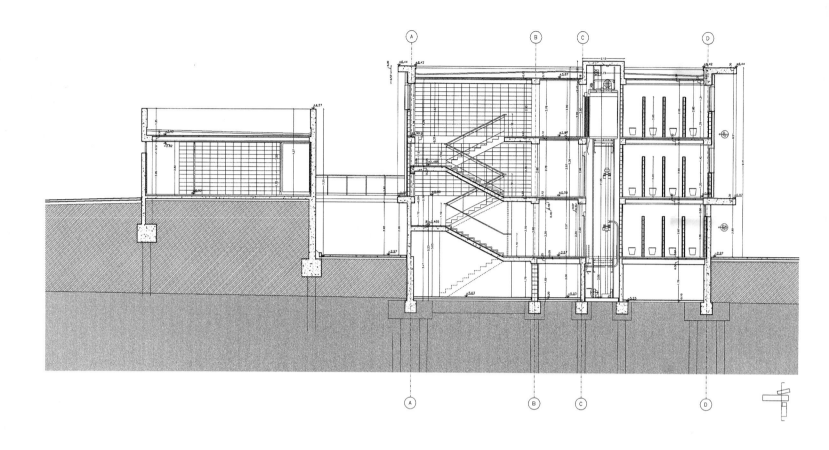

Access is by means of the middle floor of the building. In this way, the distance students need to walk is reduced, since they only have to go up or down one floor.

Lined up with the street, we find the structure (of smaller dimensions than the others) that has the access and the administration offices.

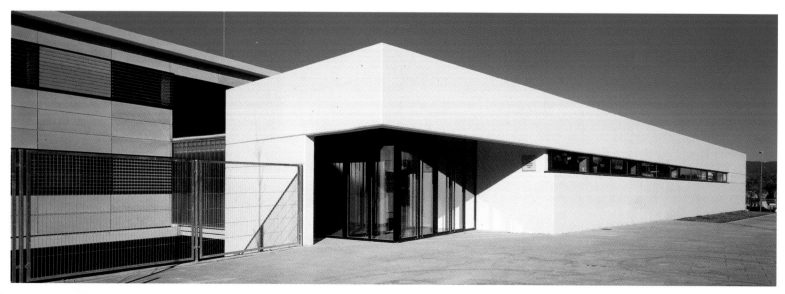

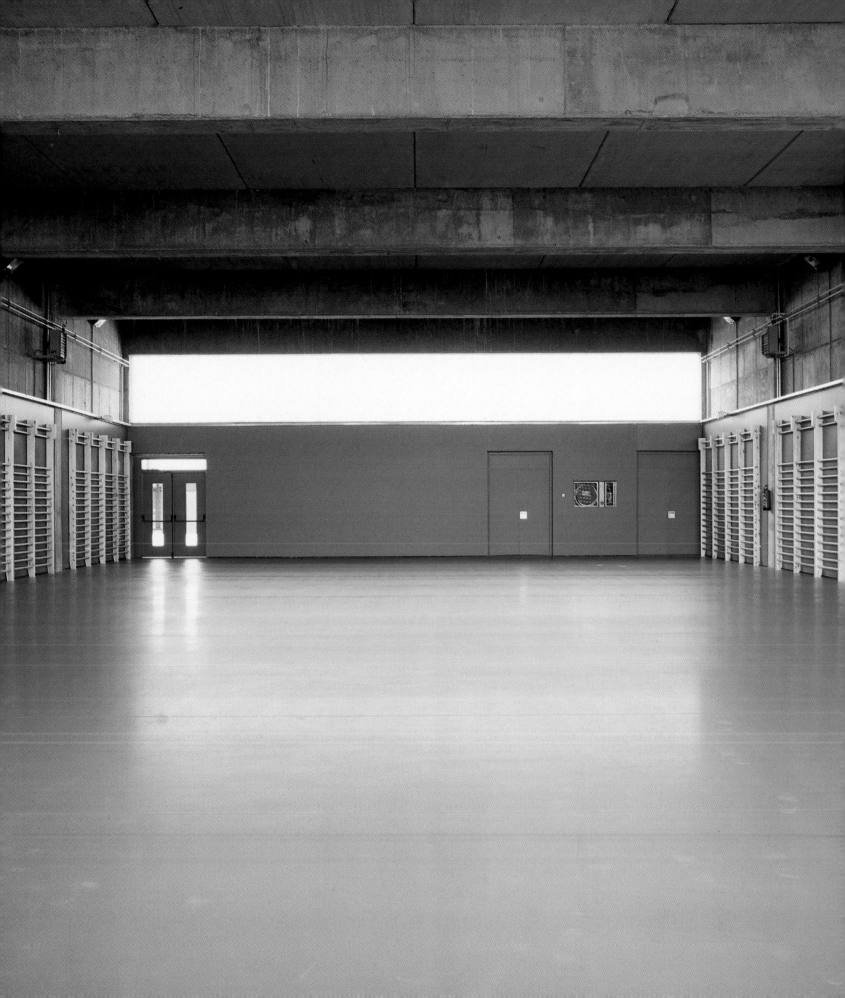

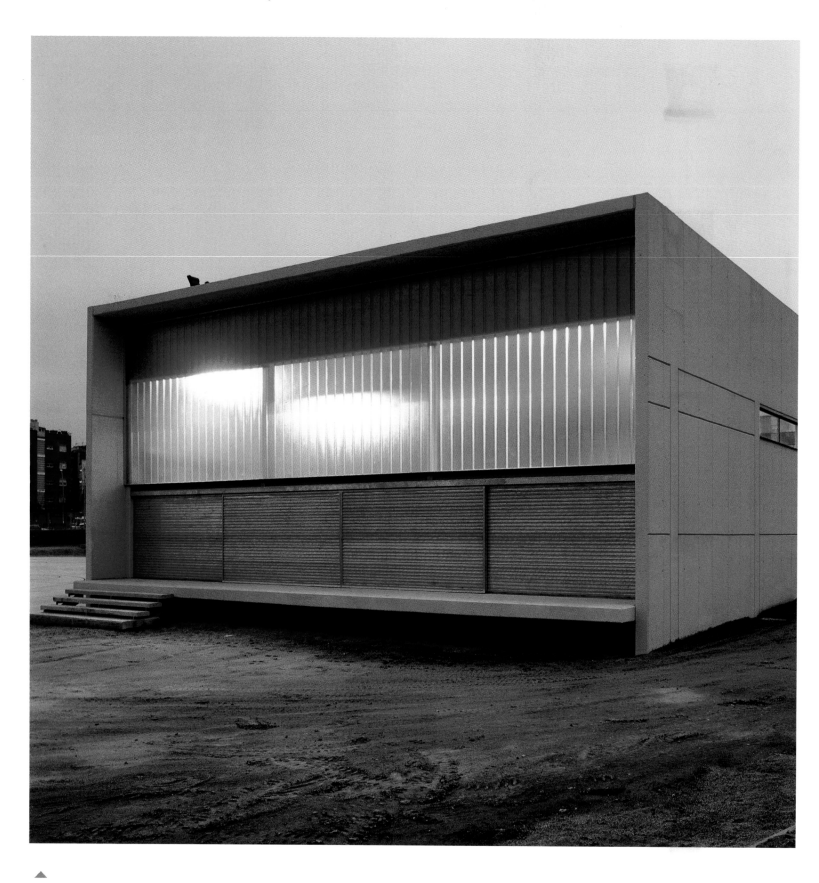

The translucent enclosure elements, in conjunction with various other materials, afford attractive compositions.

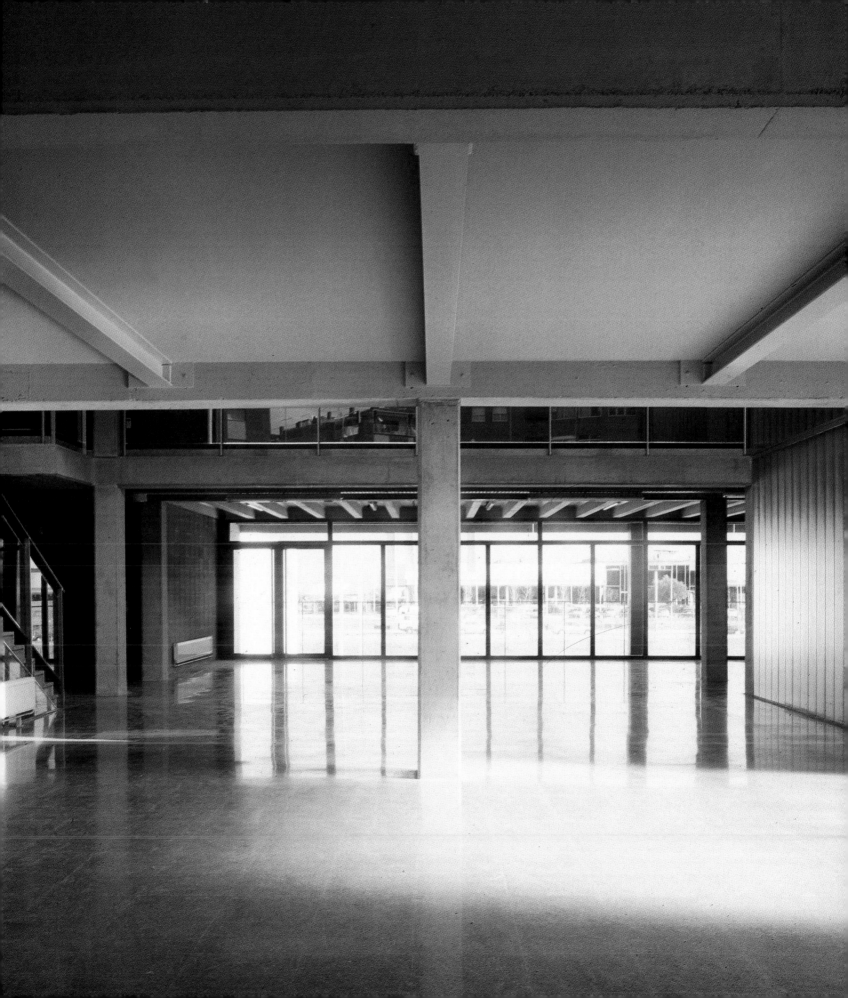

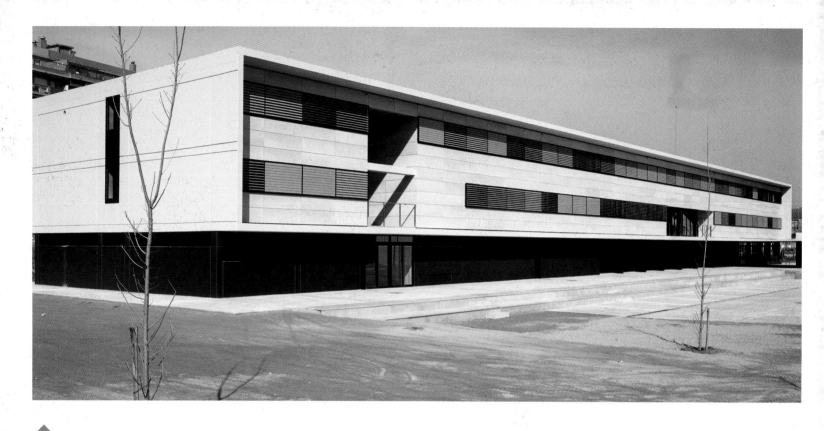

The proportions of the buildings give the complex a marked horizontal appearance. This is strengthened by the lines of the windows.

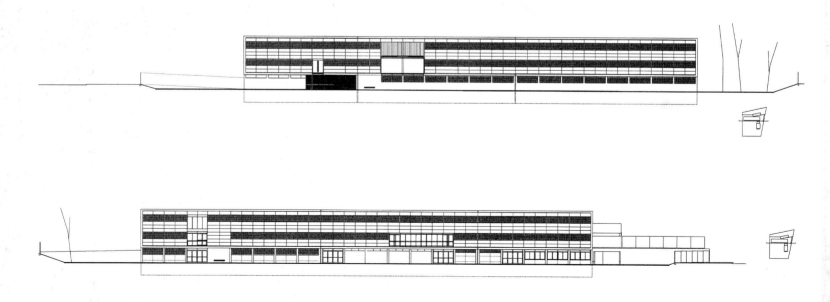

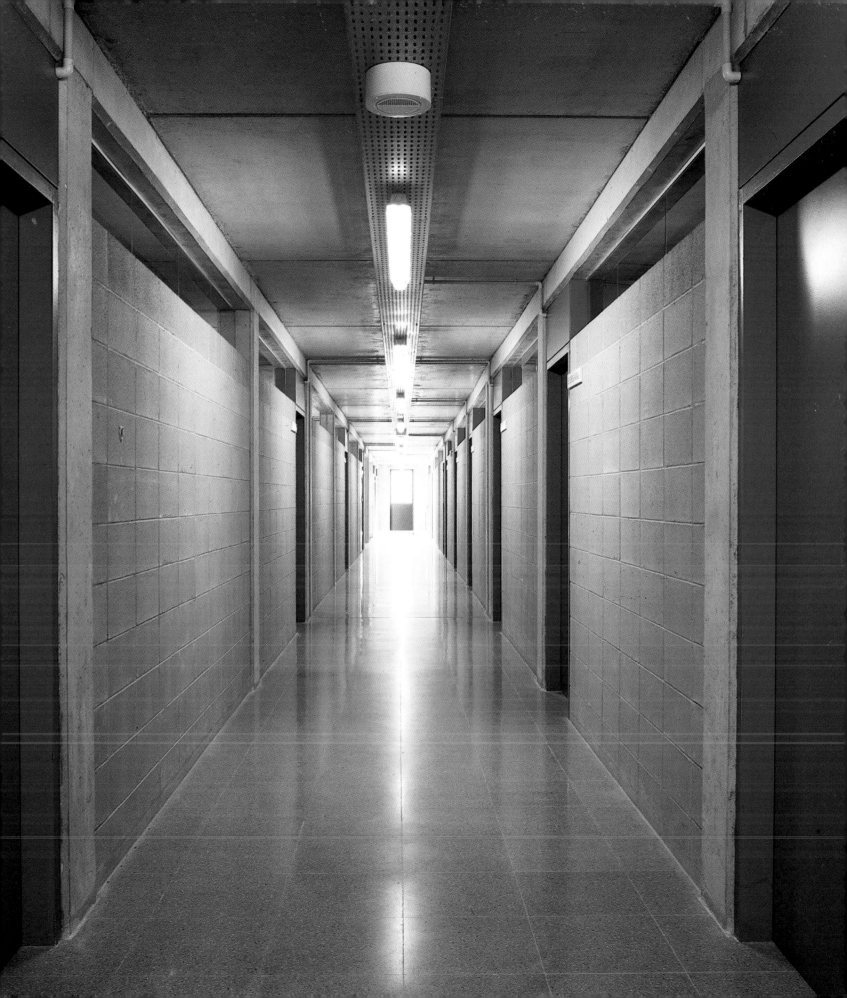